IMAGES
of America

LAUDERDALE-
BY-THE-SEA

1924

JUST PLAIN

FACTS ABOUT BEAUTIFUL

Lauderdale:
By-The-Sea

The Ocean Beach Suburb

of Ft. Lauderdale

an established City that is

growing larger and more

prosperous every day.

William F. Morang promoted a land boom with this 1924 Lauderdale-By-The-Sea advertisement, characterizing the "city" as an established suburb of Fort Lauderdale that was growing and prospering. In reality, the community was then inhabited by fewer than 27 people, who lived without the amenities of modern life.

IMAGES
of America

LAUDERDALE-BY-THE-SEA

Frank J. Cavaioli

ARCADIA
PUBLISHING

Published by Arcadia Publishing
Charleston, South Carolina

Library of Congress Catalog Card Number: 2002114927

For all general information contact Arcadia Publishing at:
Telephone 843-853-2070
Fax 843-853-0044
E-mail sales@arcadiapublishing.com
For customer service and orders:
Toll-Free 1-888-313-2665

Visit us on the Internet at www.arcadiapublishing.com

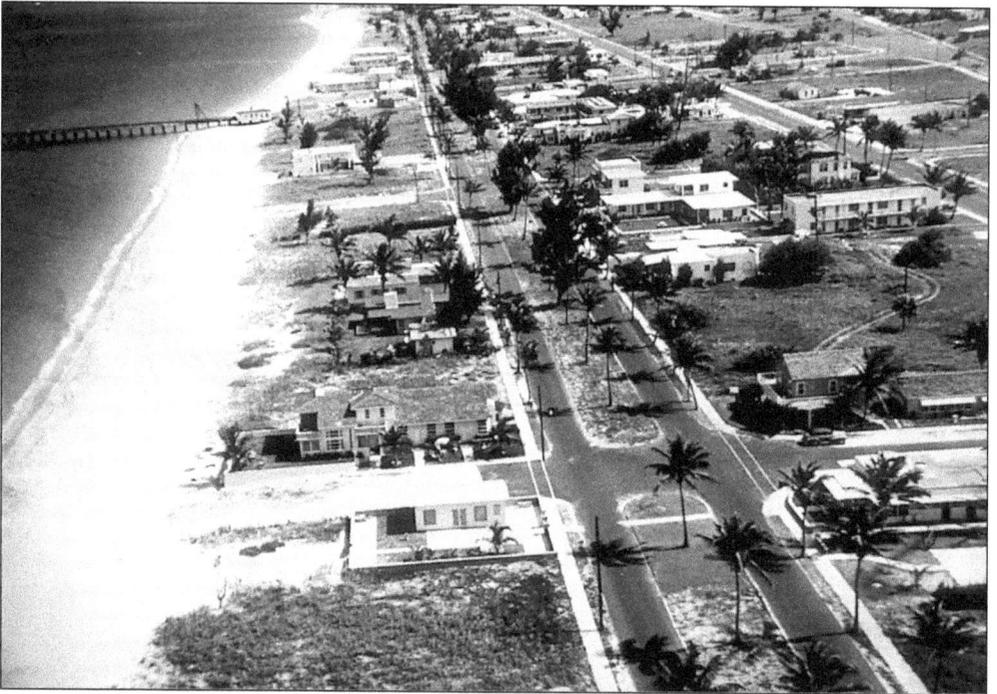

This 1954 view looking south depicts an image of a peaceful town. The pier is at the left. El Mar Drive is at the center with SR A1A (Ocean Drive) running parallel at the top right. In the foreground is El Prado, which ends at the ocean. Tourists were picked up at the Broward Boulevard railroad station and remained at their hotel in town where all their needs were met. The area, which extended westward from the ocean to Poinciana Street and Bougainvilla Drive, comprised the original plat executed by William F. Morang in 1924.

CONTENTS

INTRODUCTION

The Town of Lauderdale-By-The-Sea is noted for its beach activities, its living reef system, and its family-oriented community lifestyle. The population triples in wintertime as "snowbirds" from the North come to enjoy the warm climate. Year-round tourists also have discovered this quiet seaside resort community. Lauderdale-By-The-Sea is located on a barrier island on South Florida's Gold Coast at the northern edge of Fort Lauderdale and the southern border of Pompano Beach; the Atlantic Ocean lies to the east and the Intracoastal Waterway to the west. The town has set height limitations to three residential stories, making the town unique at a time when high-rise development has dramatically altered the natural beauty of neighboring cities. Shops, intimate restaurants, and small motels add charm to the community.

The completion of the Intracoastal Canal southward to Biscayne Bay in 1890, and the arrival of the Flagler East Coast Railway six years later, spurred population growth in south Florida. Towns grew along the railroad tracks, with Miami, Dania, Pompano Beach, and Fort Lauderdale leading the way and becoming cities in 1896, 1904, 1908, and 1911, respectively. Broward County, of which Lauderdale-By-The-Sea is a part, was formed out of parts of Dade and Palm Beach Counties in 1915. Since the town was not situated at a railroad depot, it experienced slow growth. Its early years were characterized by marshes, mangroves, thick vegetation, and wild animals.

Nevertheless, there were pioneers who saw this as a challenge, and attempted to establish a community and simultaneously turn a profit. They included William F. Morang, an entrepreneur from Boston; Melvin I. Anglin, a contractor/realtor from Indiana; and Glen Freidt, a businessman from Michigan. To the north, William L. Kester had built Pompano into a tourist attraction after he arrived in 1923. Others, such as William S. Edgemon, E.K. Bludworth, Arthur Galt, Robert H. Gore Sr., Steve Calder, and Jim Hunt, contributed to the region's growth. During the Roaring Twenties, anything seemed possible in this wilderness.

In 1924 Morang platted the land from the ocean to Poinciana Street for what became the basis of Lauderdale-By-The-Sea. Further platting westward to the Intracoastal Waterway completed the process. The Morang real estate company sold lots in Pompano, as well as in Lauderdale-by-the-Sea. One of Morang's sales brochures of 1924 invited potential clients to attend "AN OLD FASHION FISH FRY," and added, "We are extremely proud of Lauderdale-By-The Sea and extend to you a most cordial invitation to visit it as our personal guest." In the 1920s, however, there were no roads, wells, sewers, or government services—just swampland and animals. One early settler at nearby Lake Santa Barbara complained that "mosquitoes were so thick then that you had to scrape them off your arms. When you traveled beyond your yard you either walked or rowed."

Anglin purchased land and laid the foundation of the town. He helped incorporate Lauderdale-By-The-Sea in 1927 and was elected its first mayor. His wife served as one of the five commissioners. At the time, 70 people resided there. This was an inauspicious time because the year before, on September 18, a massive hurricane destroyed much of South Florida. Another hurricane (this time in 1928), the collapse of the real estate market, and the ensuing stock market crash in 1929 resulted in economic hardship and revocation of the town charter in 1933.

Anglin, however, held on as long as he saw a future for Lauderdale-By-The-Sea. In 1941 he and his two sons built the fishing pier at the east end of Commercial Boulevard, extending it 800 feet into the Atlantic Ocean. A huge success, Anglin's Fishing Pier today remains one of the town's distinctive attractions. Frank Myatt and Everett Sorensen bought the pier and

rebuilt it to its current 876-foot length, and opened it to the public on the day President John F. Kennedy was shot, November 22, 1963. In the 1940s, Anglin built the town's only gas station at the southwest corner of State Road AIA and Commercial Boulevard, the present site of the Texaco service station now named "Pump by the Sea."

In 1938, another pioneer named Glenn Friedt Sr. settled in Lauderdale-By-The-Sea with his wife Lucy after having vacationed and worked in Florida. He established himself as a successful businessman by investing in land and purchased the famous Villa Serena. The land on which Town Hall, Friedt Park, and Friedt Fellowship Hall stand was donated by the Friedts.

Robert H. Gore Sr. (1886–1972) was born in a log cabin in Kentucky and became a multimillionaire before he was 40. He helped build the Fort Lauderdale and Lauderdale-By-The-Sea area at a time when these two towns were merely brief stops for travelers between Miami and Palm Beach. After settling in Fort Lauderdale in 1935, he built the Governors Club Hotel in the downtown area two years later. In 1939 Gore built the Sea Ranch Hotel at 4700 North Ocean Boulevard, Fort Lauderdale, just north of Pine Avenue. This land is now in Lauderdale-By-The-Sea, where the present Sea Ranch Condominiums A, B, and C stand. He had bought the ocean frontage for $25,000 and hoped to develop tourism. As it turned out, Winston Churchill stayed there in 1942 and Kate Smith broadcast programs "from the fabulous Sea Ranch Hotel" to a national radio audience in the same year. The Sea Ranch Hotel closed in 1978 and the land was sold to Sea Ranch Properties. The Village of Sea Ranch Lakes, on the west side of SR A1A, was developed while retaining a parcel of oceanfront property (north of the Sea Ranch condominiums) that would become the Beach Club for Sea Ranch Village residents. Nearby, on the site that was the Sea Ranch Hotel employee barracks, the Sea Ranch (Publix) Shopping Center opened in 1966 with 25 stores and 400 parking spaces.

Jerry Brinkley, from Indiana, was another early pioneer. As a barber in the elegant Lauderdale Beach Hotel he gathered information from his wealthy customers about the importance of real estate investments, which led to his investment in Lauderdale-By-The-Sea property in the late 1940s. He built his barbershop at 108 Commercial Boulevard and lived upstairs at 108 1/2, and built a restaurant for Geraldine Murphy, who migrated with her husband from Petoskey, Michigan. Murphy's Restaurant became a favorite dining spot, and since it did not serve liquor, customers went to the Village Pump next door for drinks while waiting for a table at Murphy's. Dinner cost five dollars in 1950, and Mrs. Murphy served a compelling salad bowl and key lime pie. The restaurant was not open during the day, so as she prepared for the evening crowd, people lined up from noon to one o'clock to buy her huge prime meat hamburgers (old-timers still rave about them). Brinkley also built the Village Pump and the Market Basket grocery store next to his barbershop, which was run by the Behan family. The permanent town population in 1950 was 254.

After the nation emerged victorious from World War II, the townspeople adopted a new charter in 1947, which was validated by the state legislature two years later. Mrs. Margaret Linardy was elected the first mayor, along with four other commissioners: Walter Bartels, Ralph Wolfe, Kenneth Anderson, and Jerry Brinkley.

The town was helped by the following civic-minded groups, which formed to advance its development and maintain its intimate communal spirit: LBTS Improvement Association, Businessmen's Association, LBTS Apartment Building Association, Women's Club, Hibiscus Club, Kiwanis, Lions, Rotary, Volunteer Fire Department, Young At Heart Club, Citizens Club, and the Women's Association of the Community Presbyterian Church. The Chamber of Commerce was chartered in 1956 and today is located at the beautiful site where State Road AIA (Ocean Drive) meets Bougainvilla Drive.

After the second incorporation of the city in 1947, the habitable land was doubled due to dredging and deepening of the Intracoastal Waterway. The land at the water's edge was cleared and platted for the settlements of Silver Shores, Beverley Shores, and Lauderdale Surf & Yatch Estates. Beginning in 1952, William S. Edgemon and E.K. Bludworth developed the Silver Shores community.

Town Hall was built in 1958. The 15-story Caribe (1963) and the 17-story condominium complex Fountainhead (1965) were then built at the town's southern boundary. They were the only high-rise buildings until 1999, when the Sea Ranch Lakes condominiums, north of Pine Avenue, were annexed. The completion and opening of the Commercial Boulevard Bridge in October 1965 took place amid a grand parade and other ceremonies. Local opposition could not prevent its construction, which made the town easily accessible to those people living west of the Intracoastal Waterway. Traffic, tourism, and commerce increased dramatically, helping to form an economic base. The 1960 population reached 1,327.

In 1966, Jarvis Hall was opened and named for Ernest Jarvis, who donated money for the building. This period witnessed the installation of storm and sanitary sewers and the replenishment of beach sand. Gilbert H. Colnot served as mayor during these growth years of 1958 to 1978, when the town was nearly completely built up. Colnot's election ended a series of turbulent town administrations. As mayor, he inherited a treasury that contained $1,500 and a $75,000 mortgage for its new town hall. Under Colnot's leadership the mortgage was paid off in two years. The U.S. Census recorded the 1970 population at 2,879.

In 1972 the town was zoned to height limits of three stories, or 33 feet. However, in 2001 the newly annexed areas to the north included high-rise condominiums that had been part of unincorporated Broward County. At the same time, areas of Bel Air and part of Terra Mar Island that comprised individual residences (west of A1A [Ocean Boulevard]) were also annexed. As a sign of further growth, and to the chagrin of many townspeople, the 23-story luxury condominium Aquazul was planned to replace Trader's Motel and Restaurant. (The Aquazul had been granted a variance by Broward County before the area was annexed.)

Lauderdale-By-The-Sea has established itself as the "Dive Capital of South Florida." Three unique limestone reefs extend 100 yards from the beach to more than a mile, and depths range from 10 to more than 100 feet. Divers are dazzled by the colorful and abundant tropical fish, corals, sea fans, sponges, and other marine life, and are attracted to the sparkling ocean waters all year long.

Despite the opening of the Commercial Boulevard Bridge and the annexation of areas to the north, Lauderdale-By-The-Sea, having successfully defeated attempts at over-development, has retained its small-town atmosphere. This achievement has made it unique when compared to other cities throughout South Florida's Gold Coast, and its population has stabilized. The U.S. Census reported 2,639 permanent residents in 1980; 2,990 in 1990; and 2,563 in 2000. Town leaders have questioned the lower 2000 Census population count, especially since the Sea Ranch condominiums and population base had been annexed in 1999. Also, the annexed areas that were added to Lauderdale-By-The-Sea in 2001 more than doubled the decennial count.

ACKNOWLEDGMENTS

I wish to thank the following people for their assistance in making this book possible: Florence Behan, Charles C. Burton Jr., Frances Clark, Joan Dolci, Dillon-Reynolds Aerial Photography, Marc Furth, Leona Gore, Geraldine Murphy, Jim Pollack, Robert Polyasko, Lucke Ricciuti, Louie Sabatini, Don Shawver, Everett Sorensen, Lee C. Travelstead, Catherine Wirth, and Debra Wirth.

One

GETTING STARTED

Lauderdale-By-The-Sea would grow upon the original plat (shown above) created by William F. Morang. He and others promoted real estate throughout South Florida. In this advertisement, which certainly stretched the truth, Morang extolled the new community as the "Gem of All Beach Properties between Jacksonville and the 'Keys'."

This is the real South Florida "Gold Coast" as it looked at the beginning of the 20th century. The Atlantic Ocean is left in the distance and an undeveloped Intracoastal Waterway runs through swampland just north of Lauderdale-By-The Sea.

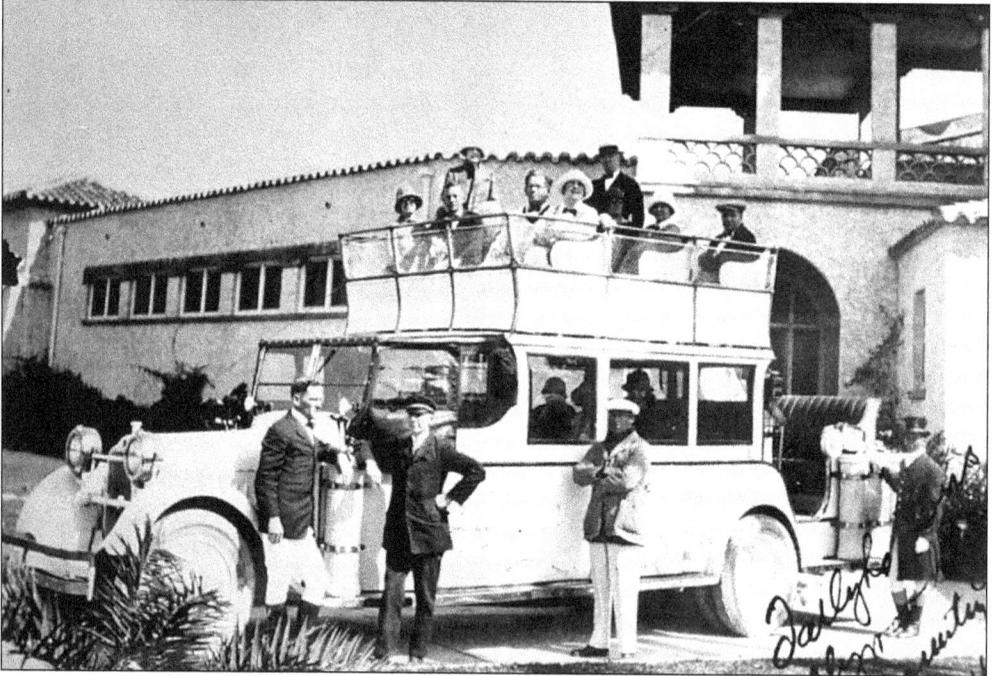

A Tallyho bus at the Hollywood Country Club prepares to take a group of Northerners on a tour of land sites for possible sale in 1924, the year that William F. Morang platted Lauderdale-By-The-Sea. Hollywood was then known as Hollywood-By-The-Sea but eventually shortened its name.

Contributing to the early land boom in South Florida was heavy promotion by land speculators and developers. This advertisement offered incentives to those who would buy land in nearby Pompano, which had become an incorporated town in 1908. Pompano, however, was also covered by swamps, animals, and insects.

COME TO POMPANO

Free Auto Trip! Free Presents!

The Season's Opportunity in Land Values!

Autos Will Leave
HOTEL GILBERT 11:30 A. M.
Friday, January 22. The Trip is Free!

Dinner will be Served by the Ladies
of the Pompano Civic Association

Free Pianos, Guaranteed Ladies' and Gentlemen's Gold Watches and Other Presents will be Distributed Absolutely FREE!

But the Biggest Inducement is your opportunity to buy at Your Own Price a piece of valuable Florida Real Estate. Business Lots in the Thriving Town of Pompano, and Farm Property nearby, at Your Own Valuation.

Do Not Forget
CASSEL'S HAMMOCK
the Finest Citrus Fruit and Vegetable Land to be found in Palm Beach county. Land no better sells at one to two thousand dollars per acre. You make the price on this. Everything must go at bidder's figure.

Sale will be conducted by
DAMMERS & GILLETTE
Famous New York Auctioneers.

Remember the Date: JANUARY 22 and 23.
If the weather should be bad, the Sale will be held the first good day.

1924

We Invite You to
BE OUR GUEST
without obligation to
AN OLD FASHIONED FISH FRY
In Our Open Air Dining Room
Overlooking the Broad Atlantic
from the Most Beautiful Beach
in Florida

Lauderdale-By-The-Sea

—We are extremely proud of Lauderdale-By-The-Sea and extend to you a most cordial invitation to visit it as our personal guest.
—Kindly call at our Miami office and make your reservation, or arrange by telephone. The trip from Miami to Lauderdale-By-The-Sea, going one route and returning another cannot be surpassed for interest or charm—We entertain daily at lunch—a feature that you will enjoy immensely after you drive along the Atlantic Ocean Boulevard.

W. F. MORANG & SON Inc.
Owners and Developers
MAIN OFFICE: 162 E. FLAGLER ST., MIAMI, FLA.
PHONE 6884

Though based in Miami, William F. Morang extended his interests northward as he continued to advertise and promote land sales in Lauderdale-By-The-Sea with this picturesque advertisement.

11

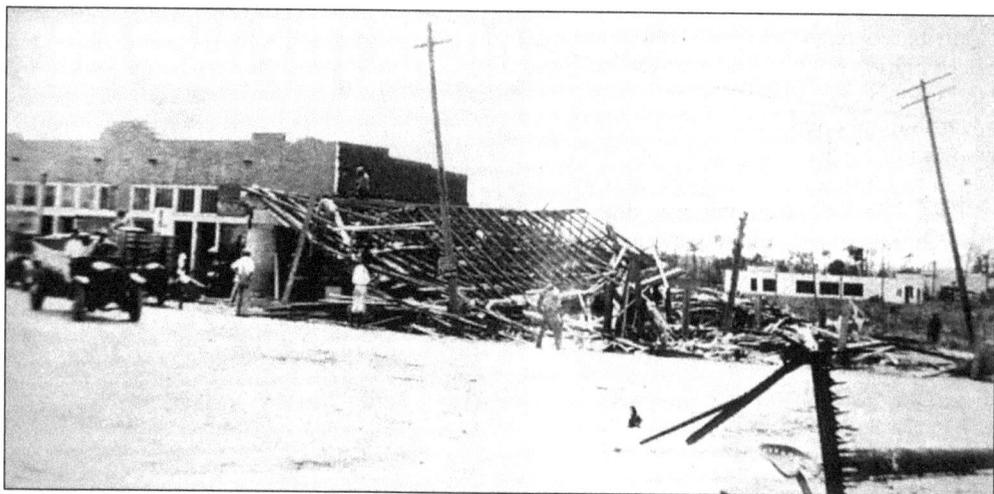

Two hurricanes devastated South Florida: one in Pompano in September 1926 (shown here), and another two years later. The resulting chaos and losses contributed to the demise of the land boom.

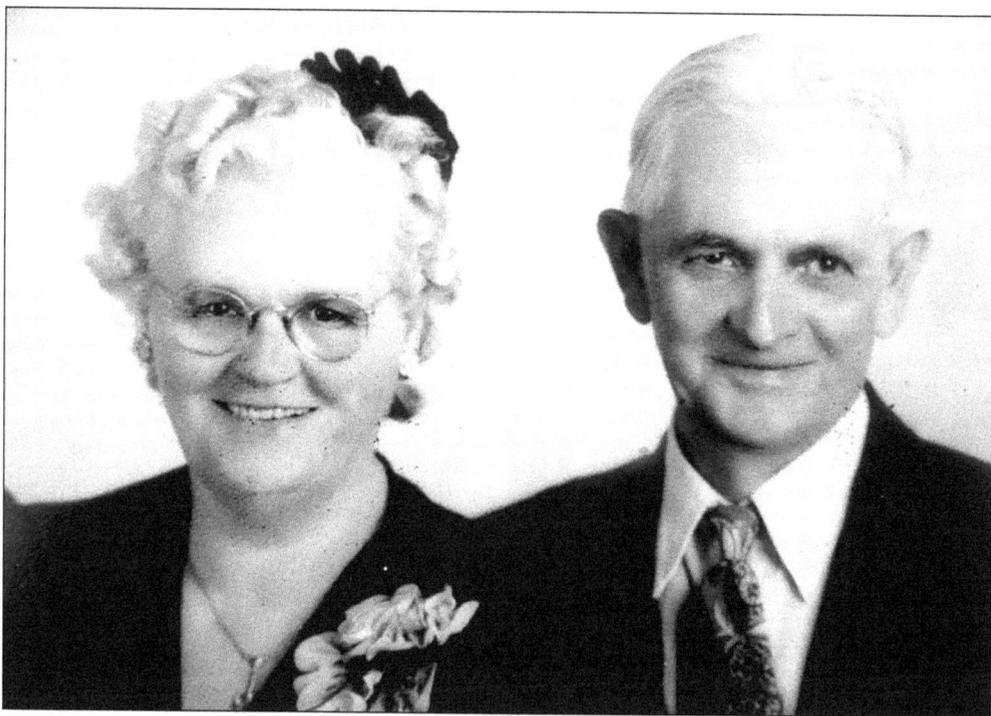

Sarah and Melvin Anglin, above, left the Midwest in search of fortune and began to buy lots in Lauderdale-By-The-Sea around 1924. These early settlers helped to incorporate the town in 1927, and Melvin became the town's first mayor. The first incorporation lasted until 1933 when the charter was revoked.

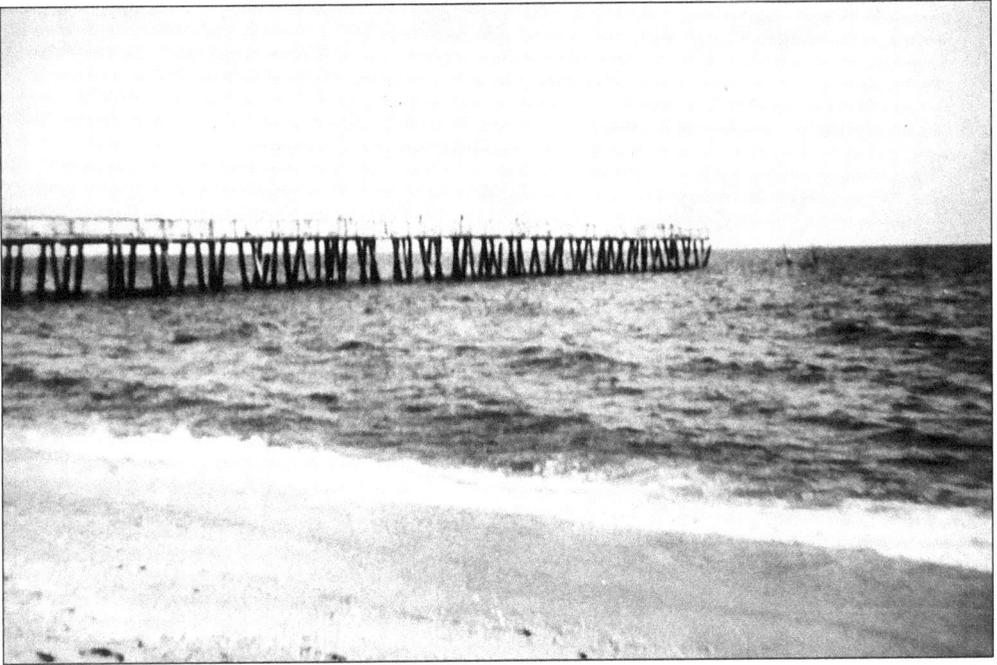

This rustic structure is the old fishing pier soon after it was built by Melvin Anglin in 1941. The pier extended 800 feet into the Atlantic Ocean. Anglin was wise enough to realize the value that the ocean offered to residents and tourists.

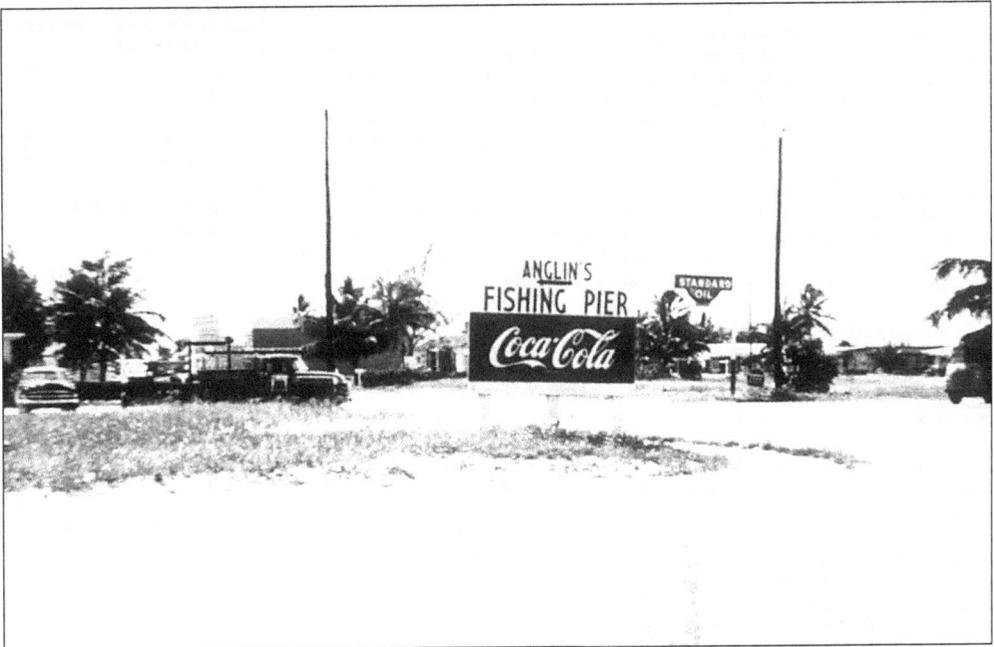

Melvin Anglin was no fisherman but he appreciated the sport. The pier became an instant success as people used it to fish and enjoy the natural beauty of the ocean. He attracted visitors with this sign in the 1940s.

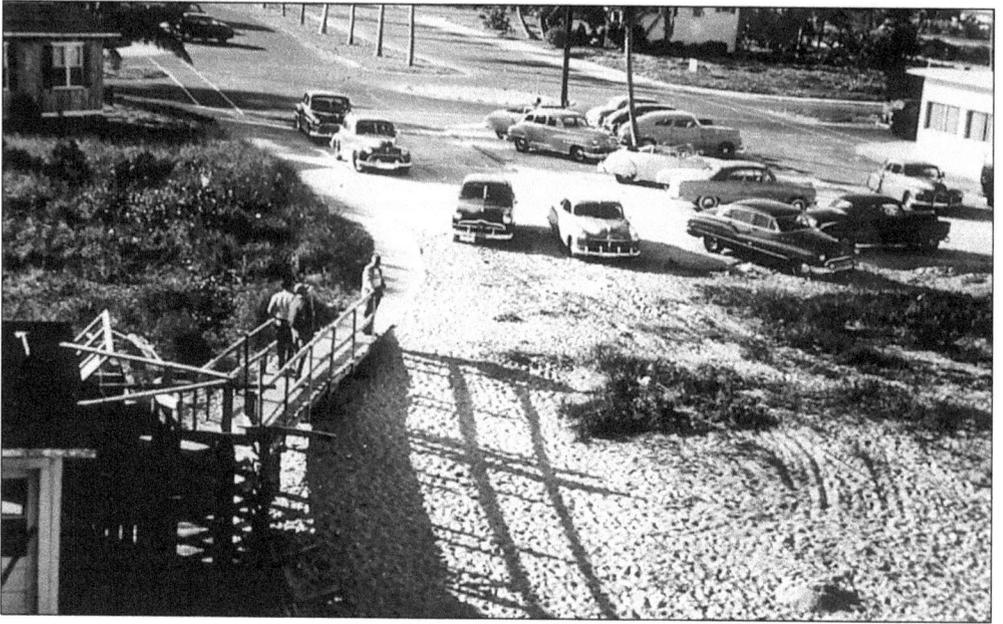

Looking west from the pier along Commercial Boulevard in 1949, the cedar cottage at top left was originally used for fishermen's lodging; it then became Lord's Realty. The building on the right is Murphy's Restaurant. Anglin's wood cottage can be seen in the background. The circle of land is now where the Flying Pelicans monument is located.

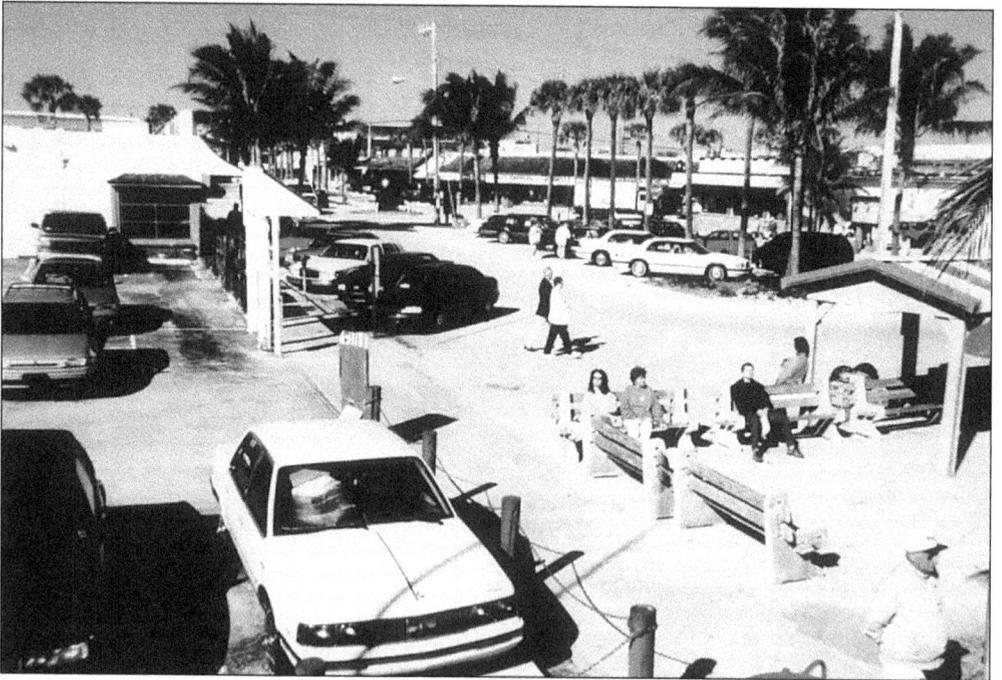

A more recent view in the 1990s from the pier reflects the development that has occurred over the years. This area is the most popular, and most congested, place in Lauderdale-By-The-Sea, attracting tourists and residents alike.

14

Longtime resident Ward Keesling stands at the old Anglin Fishing Pier in 1956 before it was rebuilt. Keesling was a popular town resident, and much of his time was spent serving as a handyman. Here, the beach appears in a pristine state.

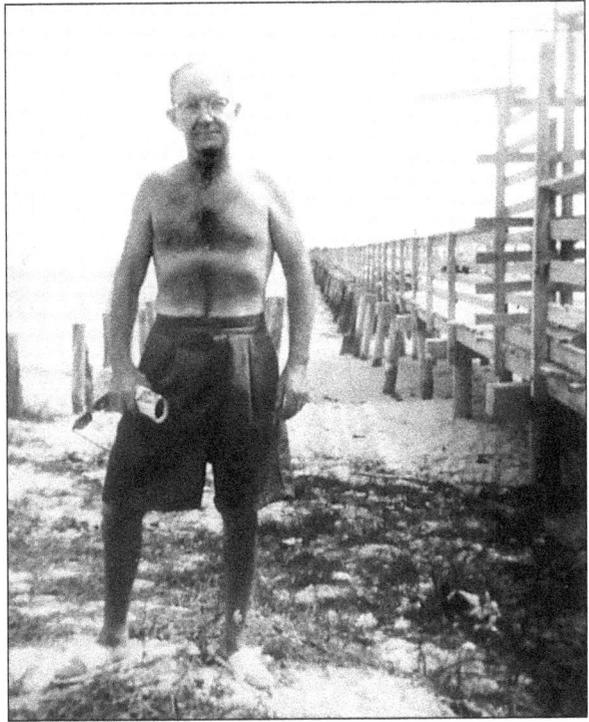

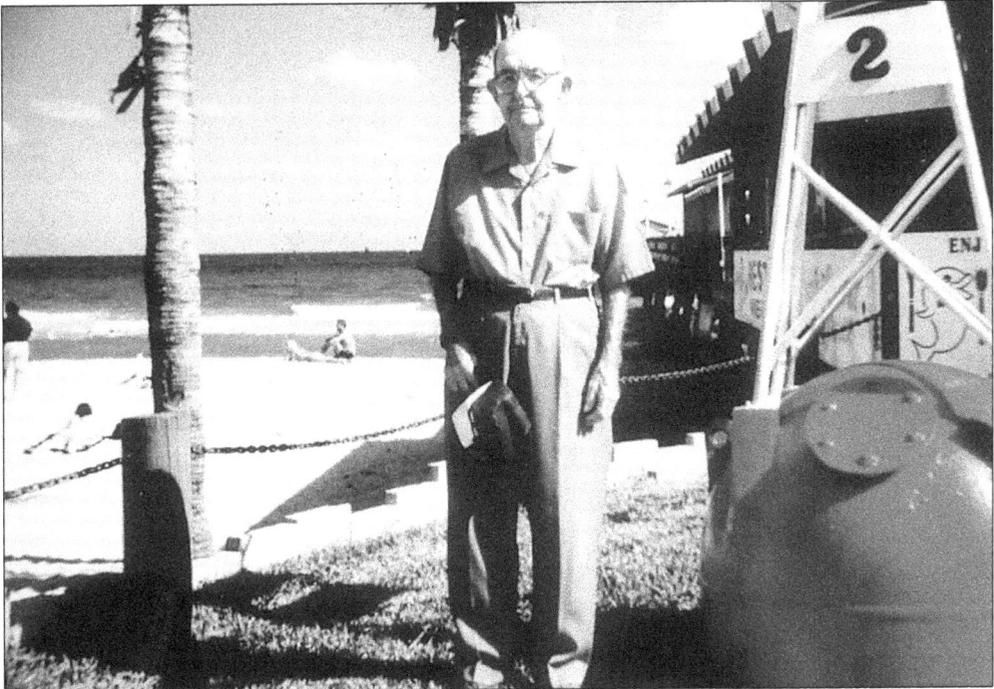

Forty-one years later, in 1997, Ward Keesling reappeared to stand at the identical spot next to a renovated Anglin Pier and a developed beach. Note the similarities and differences between the two images. Keesling died in 2001 soon after he reached the age of 100.

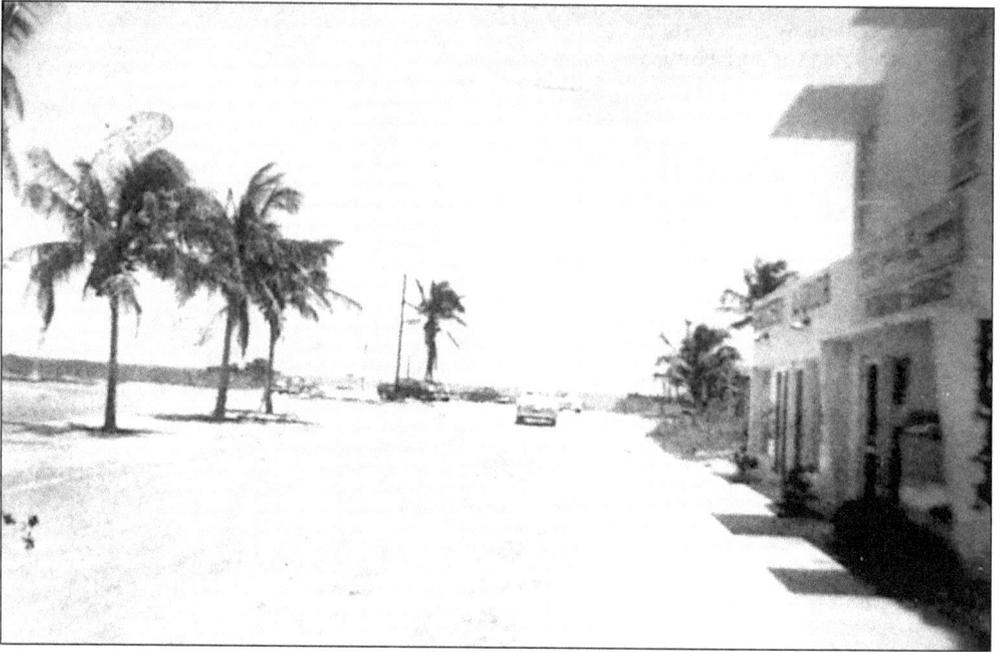

This view looking eastward depicts a deserted Commercial Boulevard in the late 1940s. The beach can be seen in the distance. Lauderdale-By-The-Sea lacked an economic base in this period and was considered a sleepy village by the sea.

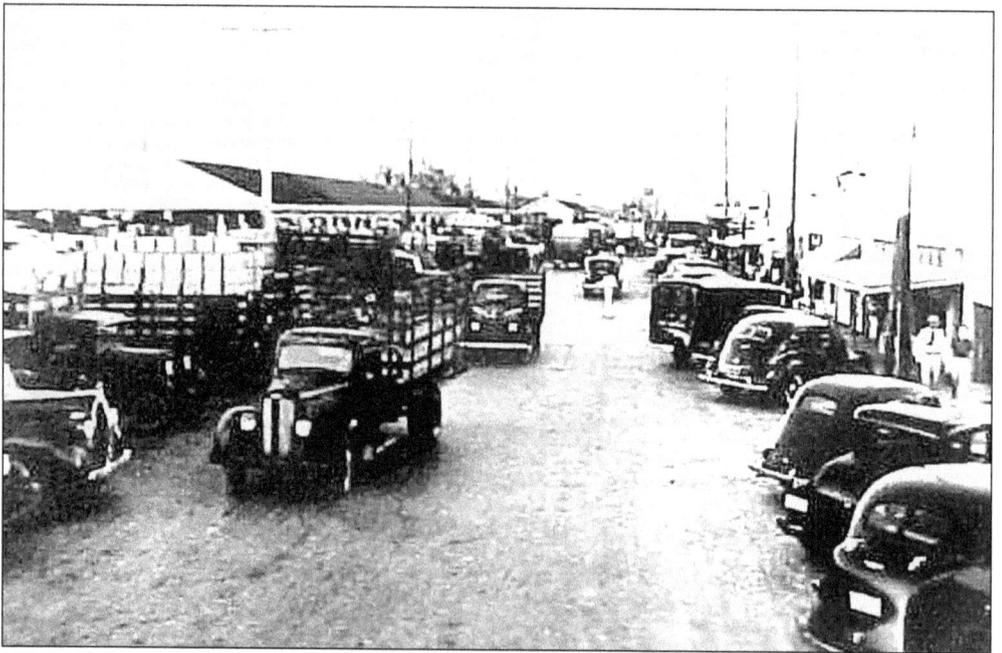

While Lauderdale-By-The-Sea was struggling to survive in the 1930s, nearby Pompano was prospering. This photograph shows a busy Flagler Avenue at the railroad station just north of Atlantic Boulevard. Pompano's agricultural economy and railroad station were key elements in its growth.

Town pioneer Melvin Anglin was a builder from Indiana. By 1925, he began constructing houses on the lots he owned, and some have survived. This house, photographed in the 1940s, is located on SR A1A (Ocean Drive), south of Commercial Boulevard.

This is the same Anglin house as it looks today. It is located opposite the Burger King on SR A1A (Ocean Drive).

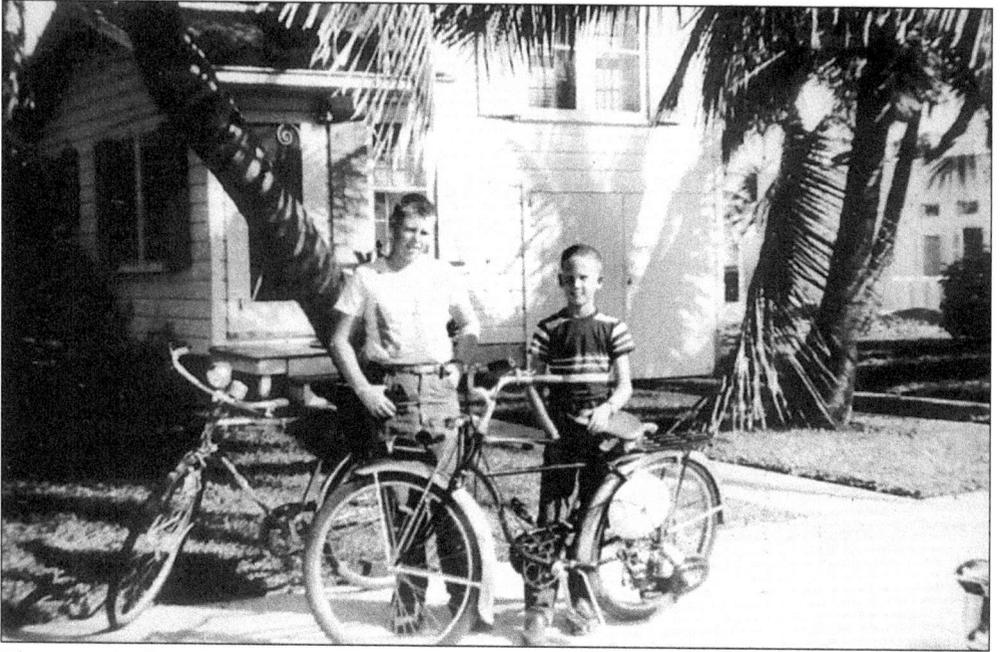

There was little construction during the Great Depression. This modest wood house was built for Bill and Allene Marshall Anglin (whose uncle was the first mayor of Fort Lauderdale). Ray Anglin (left) was born there. It was located at the northeast corner of Commercial Boulevard and SR A1A.

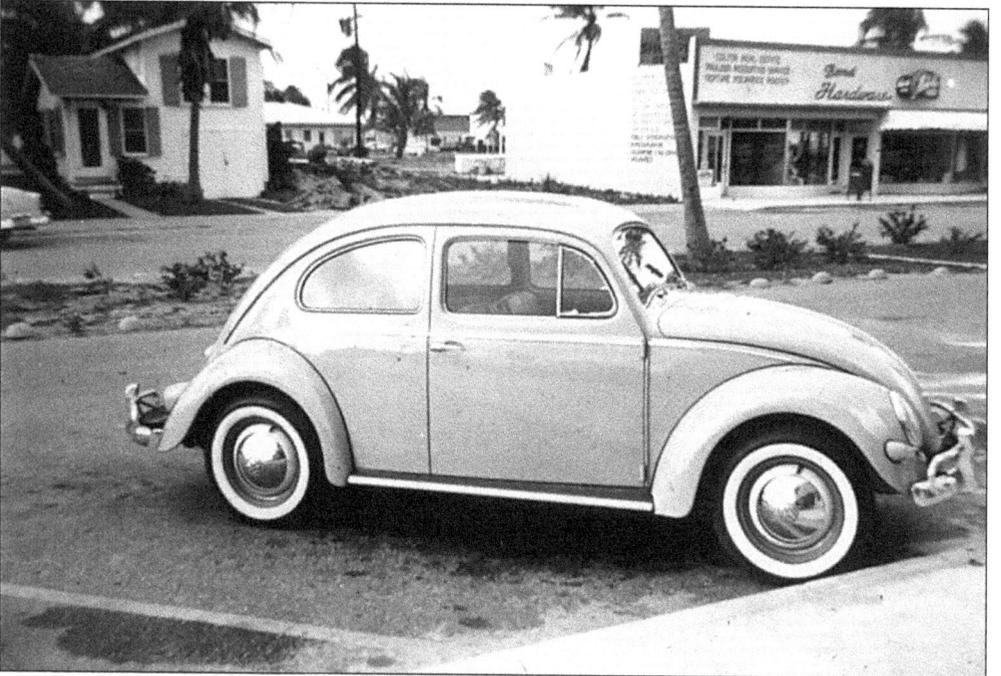

One of the first Volkswagens imported into the United States is parked on the south side of Commercial Boulevard in May 1956. The Anglin home can be seen at left. Today the Athena Restaurant has taken its place.

Melvin Anglin built a gas station diagonally across the street from the wood house on the corner of Commercial Boulevard and SR A1A. Bill and Allene Anglin were the operators and even lived there for a while with young Ray.

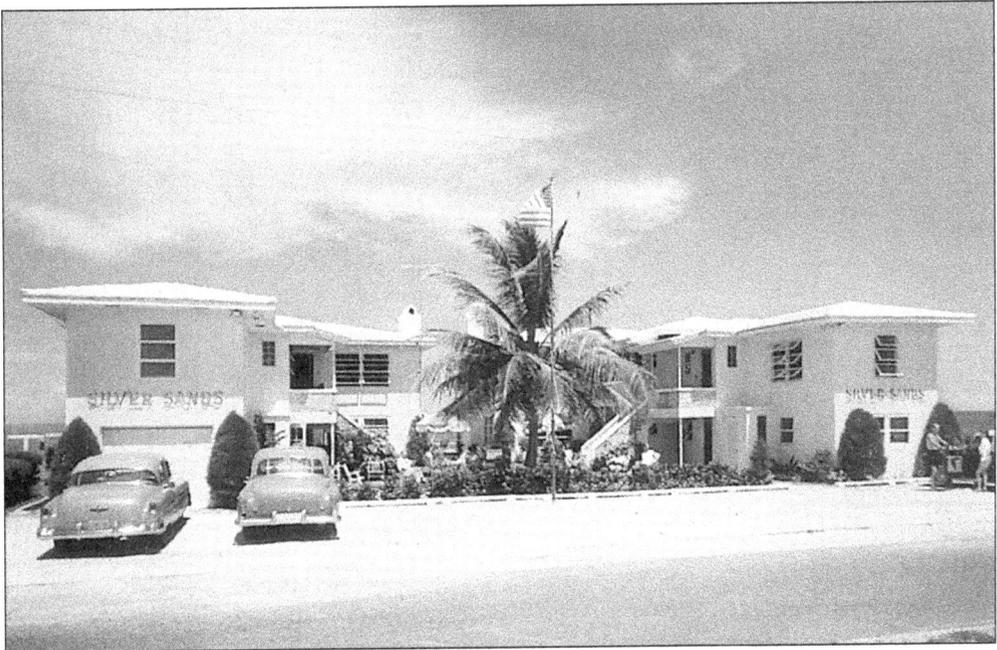

Tourism was important to the town's economic development. The Silver Sands Apartments, as seen above in the 1950s, contributed to this growth. Located at 4448 El Mar Drive, the motel was owned by Sarah and Karl Fife.

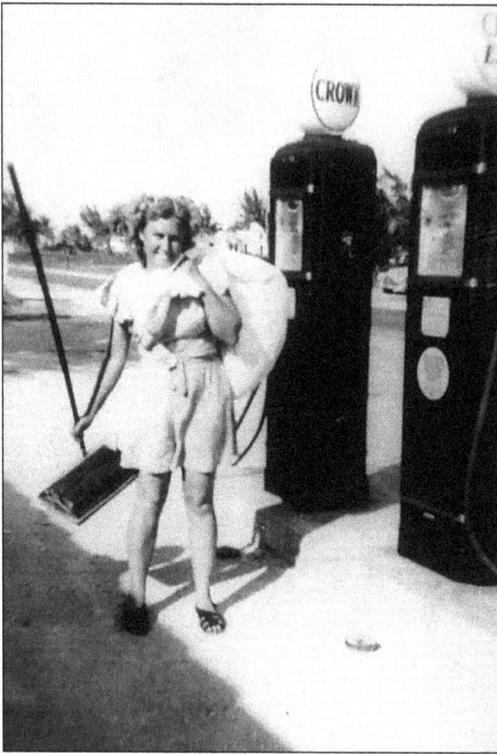

In 1935, Allene Marshall married Bill Anglin in Fort Lauderdale and moved to Lauderdale-By-The-Sea. Here she is working at the gas station her father-in-law built, which at the time was a Crown franchise at the southwest corner of Commercial Boulevard and SR A1A. Occasionally Bill did farm work in Pompano. There was little time for recreational activities during the World War II era.

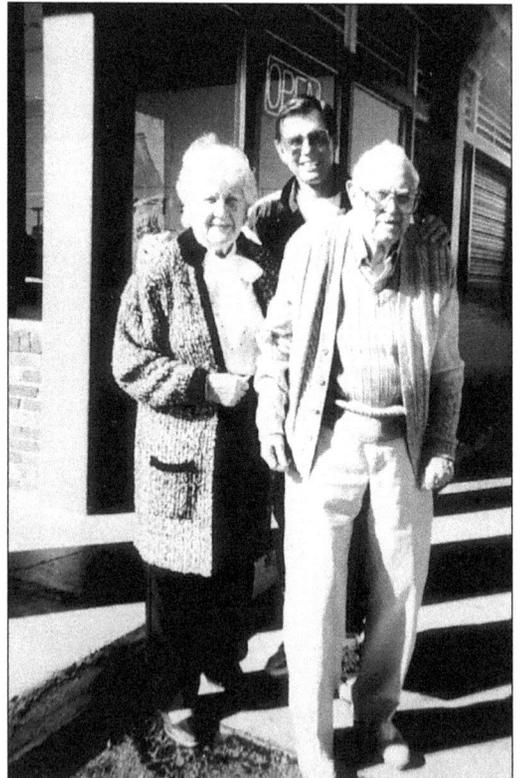

Five decades later, in 1997, Allene and Bill Anglin joined with son Ray to reminisce about the past. They remember well how it was contrasted with a more modern Lauderdale-By-The-Sea.

Glen Friedt (right) traveled to Florida during the 1930s, settling in Lauderdale-By-The-Sea by the end of the decade. In 1947 he organized the Lauderdale Surf and Yacht Club, north of what is now Galt Ocean Mile. He also organized and expanded the Lauderdale Yacht Basin. Friedt was a Detroit industrialist who led one of the largest plating companies in the world. He began his career as assistant personal secretary to Henry Ford.

The Villa Serena Apartments at El Mar Drive and El Prado (shown as it appeared in 1939) was developed for half of a century by Glen and Lucy Friedt. They helped to shape the history of the town, and as time went on, others followed the Friedt's lead in developing a motel industry.

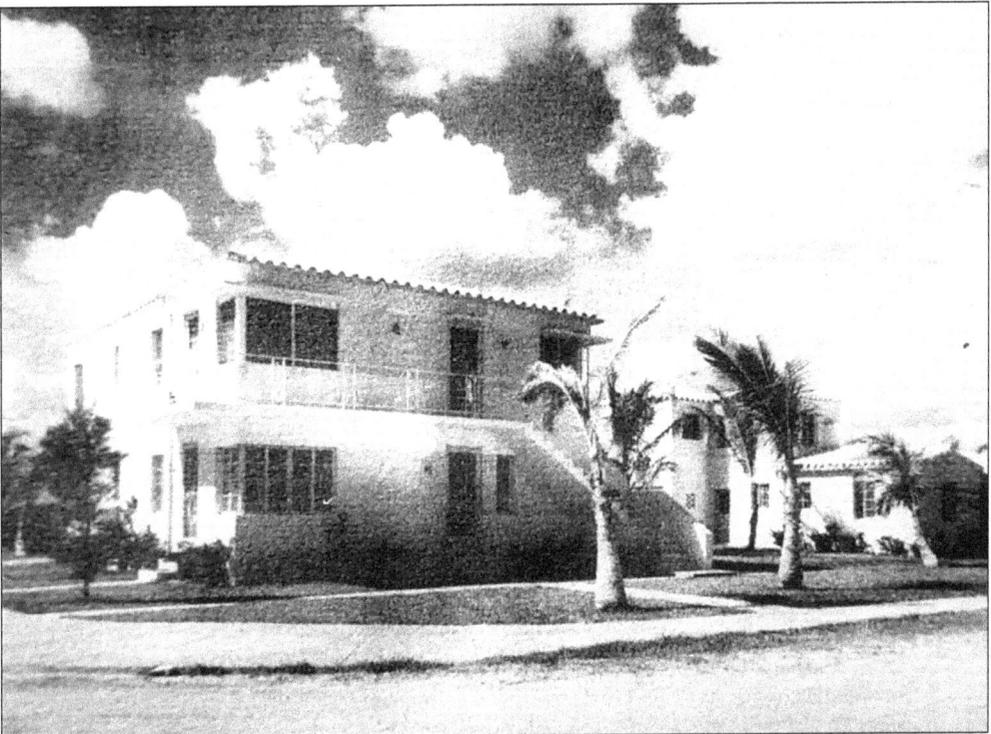

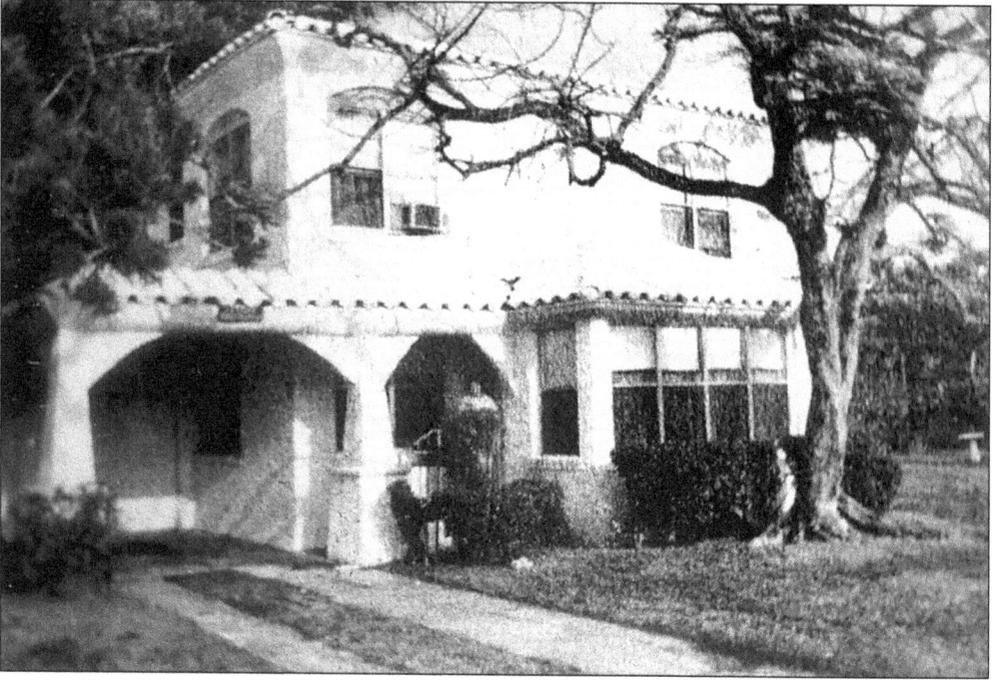

The "Old Homestead," now referred to as the Demko home, was the residence of Melvin and Sarah Anglin and their two sons, Bill and Tom. Built in 1926, it is the only town building on the state's master file of historic structures. It is now the home of the Anglin's oldest daughter, Margaret Anglin Demko.

This is the Demko home, or "Old Homestead," as it appears today on SR A1A. It presents the architectural charm of an earlier period in Florida.

This home, also reminiscent of old Florida architecture, no longer exists. It was the home of George E. Wedekind on 4317 El Mar Drive, and it was here that townspeople met to vote on the re-incorporation of the town on January 30, 1947. Margaret Linardy was elected the first mayor and became the first woman to hold such a position in Lauderdale-By-The-Sea and the state of Florida.

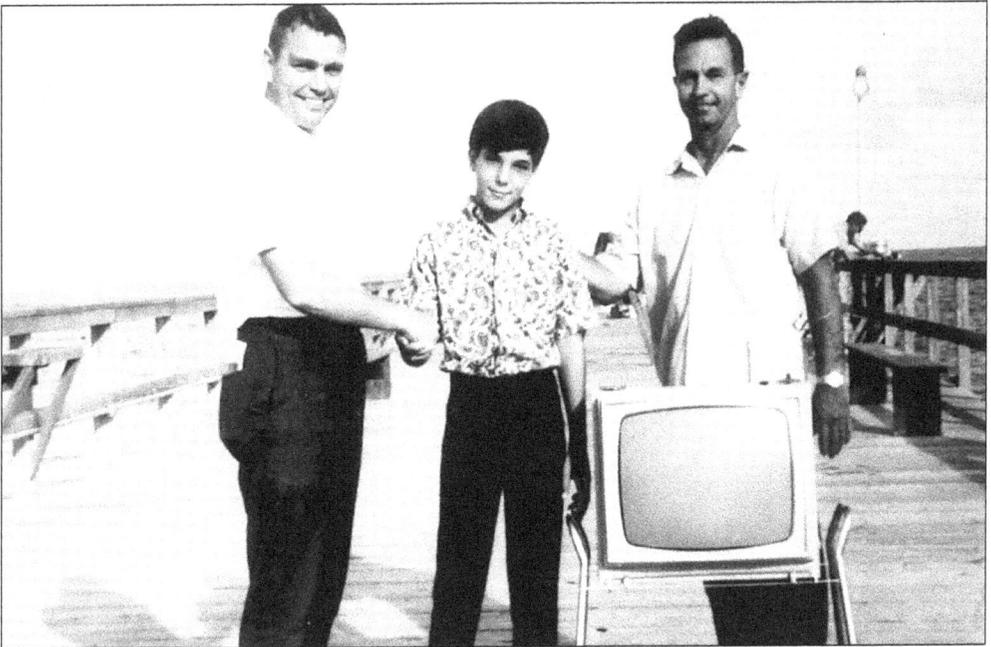

Everett Sorensen, left, and Frank Myatt, right, bought the Anglin Fishing Pier in 1963 and rebuilt it from the bottom up using the latest materials and technology. A television giveaway highlighted the grand opening on November 22, 1963, the fateful day that President John F. Kennedy was assassinated.

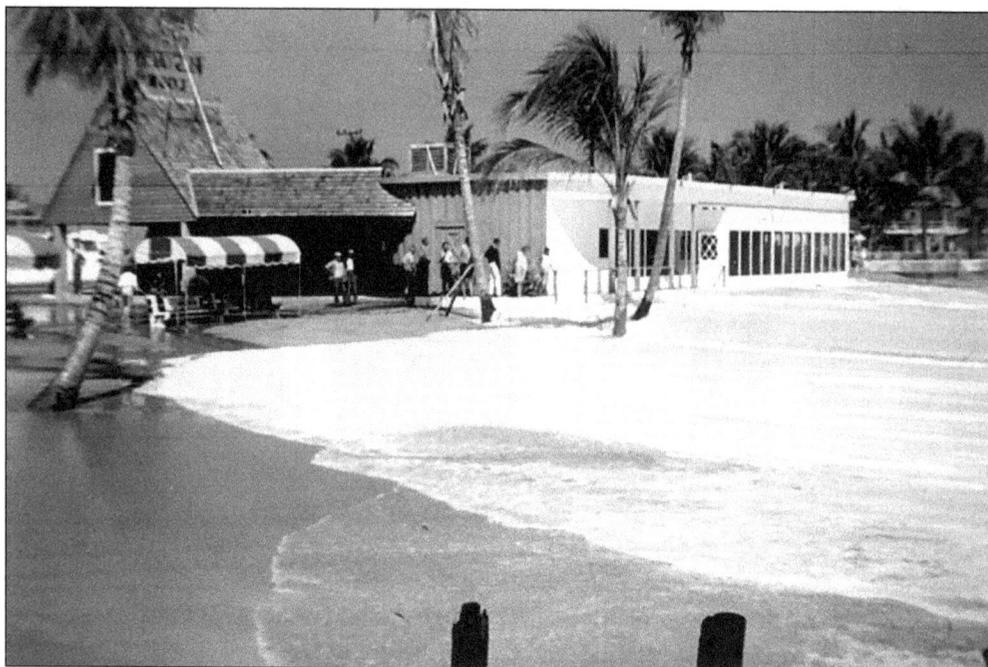

Flooding always presents a danger to oceanfront areas. This 1956 flood occurred at the eastern end of Commercial Boulevard. The Wharf Restaurant, which featured international specialties and was owned by Jim Stefanis, is at the left; it was later replaced by the Aruba Beach Café.

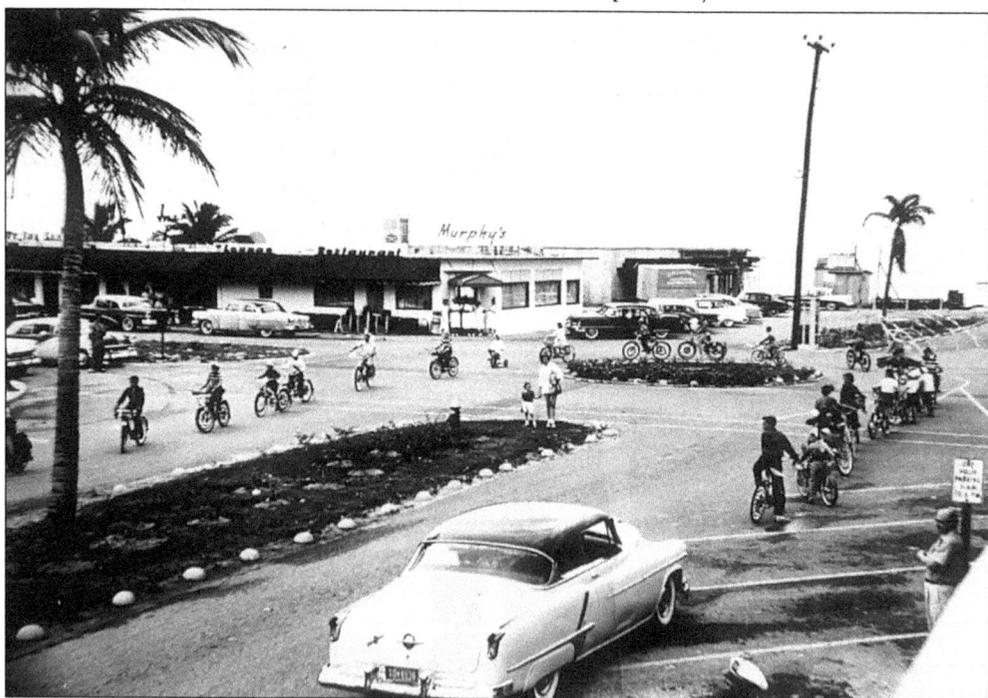

A parade of bikers circles around the intersection of El Mar Drive and Commercial Boulevard in 1956. Today the intersection has become Pelican Square/Anglin Square. Murphy's Restaurant can be seen in the background with the Village Pump Lounge to its left.

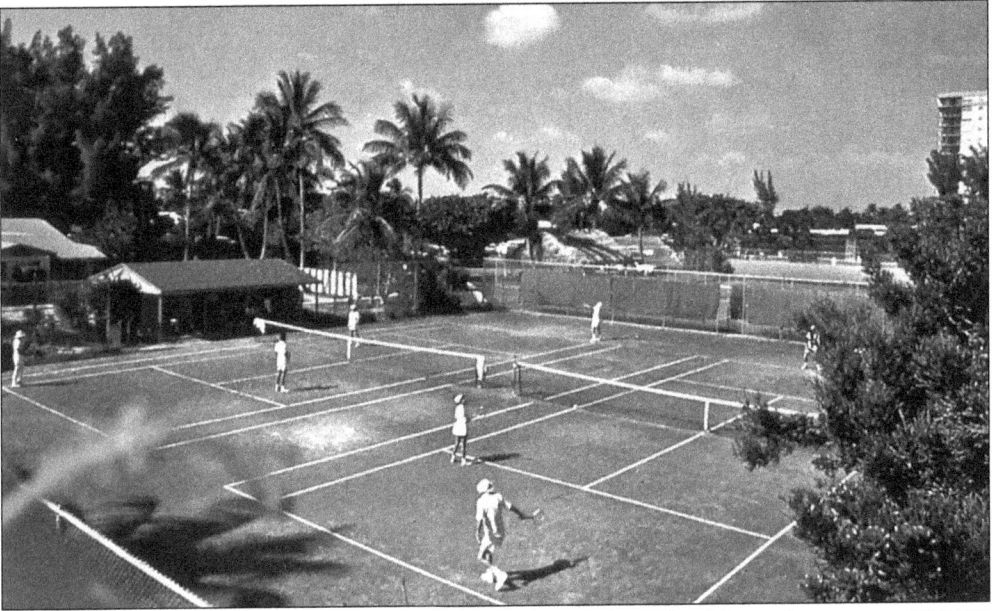

Tennis players enjoy themselves at the Sea Ranch Hotel north of Pine Avenue at 4700 SR A1A, Fort Lauderdale. Built by Robert H. Gore Sr. in 1939, it featured 1,000 feet of oceanfront, 13 tropical acres, 4 clay tennis courts, badminton, shuffleboard, a putting green, lounge, and other amenities. It closed in 1978 and was replaced by the high-rise Sea Ranch Condominiums A, B, and C, which today are part of Lauderdale-By-The-Sea.

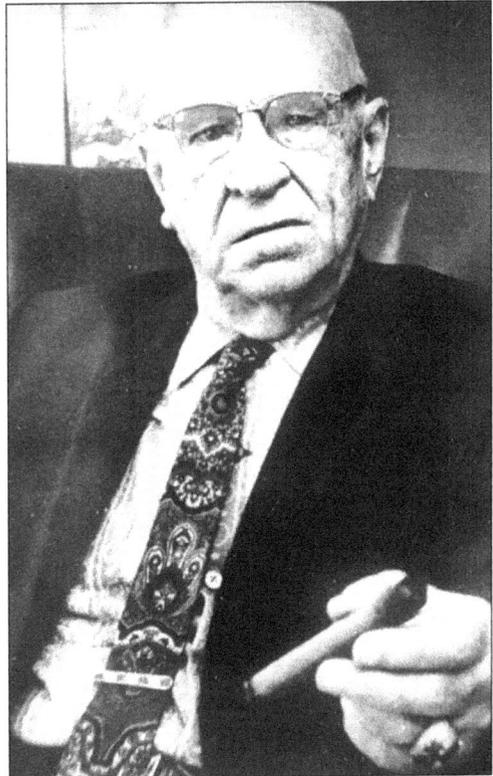

Robert H. Gore Sr. believed in the future of South Florida when he settled in Fort Lauderdale in the 1930s. In addition to owning the Sea Ranch Hotel, he owned a radio station, a newspaper, and the Governors' Club Hotel in downtown Fort Lauderdale. President Franklin D. Roosevelt appointed him to serve as governor of Puerto Rico in 1933. Before his death in 1972, he sold his newspaper, *The Fort Lauderdale Daily News*, to the Chicago Tribune Company and it was renamed *The Sun-Sentinel*.

The Governors' Club Hotel and The Sea Ranch Hotel were prime assets in the Gore real estate empire. Political leaders and famous entertainers were frequent guests at these locations. This advertisement, featuring both properties, appeared in a 1953 brochure.

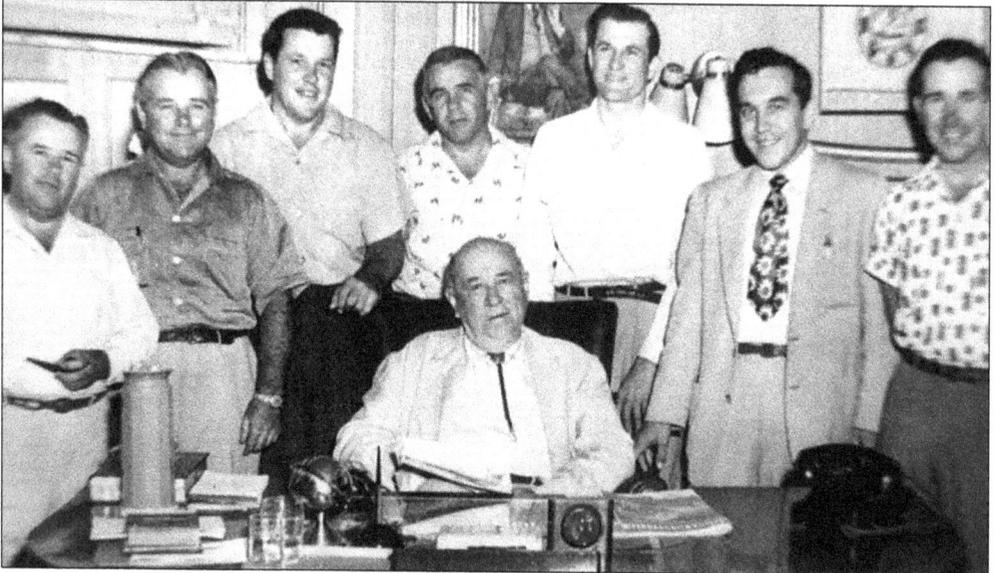

Seven sons assisted Robert H. Gore Sr. in his various enterprises. They are, from left to right, Robert H. Jr., E. Fitzgerald, Theodore, Jack, Frederick, George, and Joseph. Gore also had two daughters, Dorothy and Mary.

Robert H. Gore Sr. gave a boost to downtown Fort Lauderdale when he bought an unfinished building for $20,000 and completed it as the Governors' Club Hotel. It quickly became a landmark that housed prominent citizens such as D.W. Griffith, Jim Farley, Rev. Theodore Hesburgh, Lowell Thomas, Alfred Drake, and governors from the southeast states. This advertisement appeared in 1953.

The
COLONEL'S TABLE
Open 7:00 A.M. to 10 P.M.
SERVING A SNACK
OR
A FULL MEAL

"In the Heart of Lauderdale"

THE ORCHID
DINING ROOM "TIME OUT"
Open Jan. 15th COCKTAIL LOUNGE
to April 1st 11:00 A.M.
Nightly to Midnight
5:30 - 8:30

**The GOVERNORS'
CLUB HOTEL**
DOWNTOWN FORT LAUDERDALE
Phone 2-1441

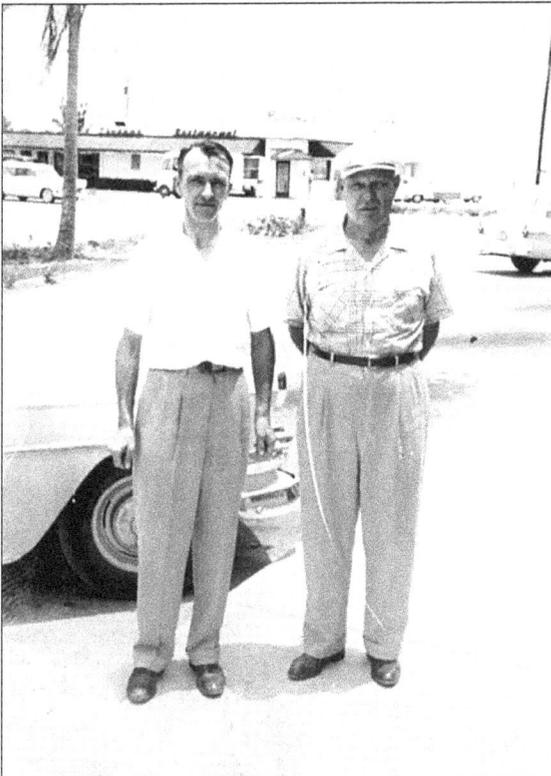

Two leaders who helped to shape Lauderdale-By-The-Sea were Hugh Behan, left, who owned and operated the Market Basket Grocery store, and Jerry Brinkley, a barber turned builder. Brinkley built the Village Pump, which provided a lounge, bar and packaged goods, and Murphy's Restaurant, located next door at 4400 El Mara Drive.

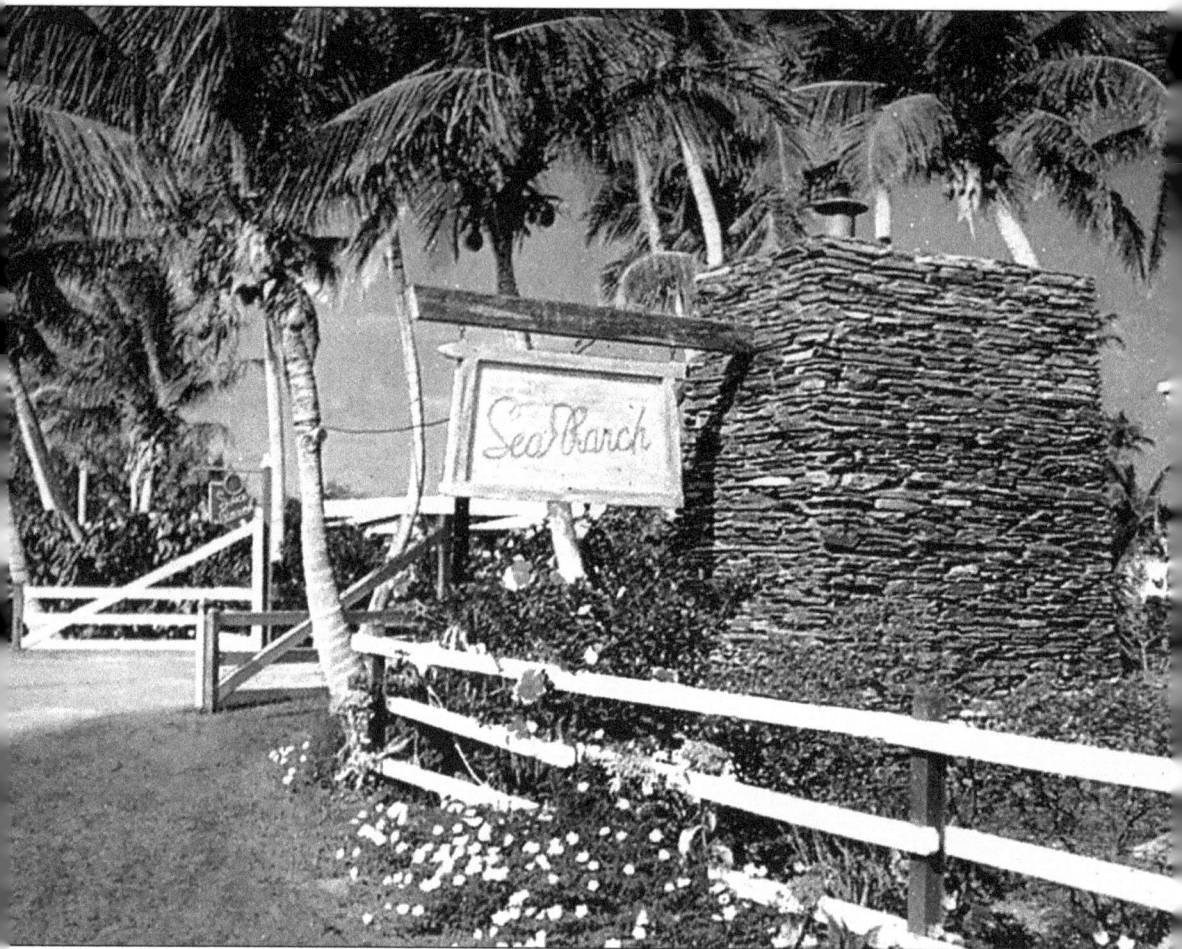

The Sea Ranch Hotel, built by Robert H. Gore Sr., was a prime tourist location on the ocean in what was then Fort Lauderdale, across the way from present the Sea Ranch/Publix Shopping Center. This postcard shows the entrance and gateway to the hotel in 1950.

Two

BUILDING A FOUNDATION

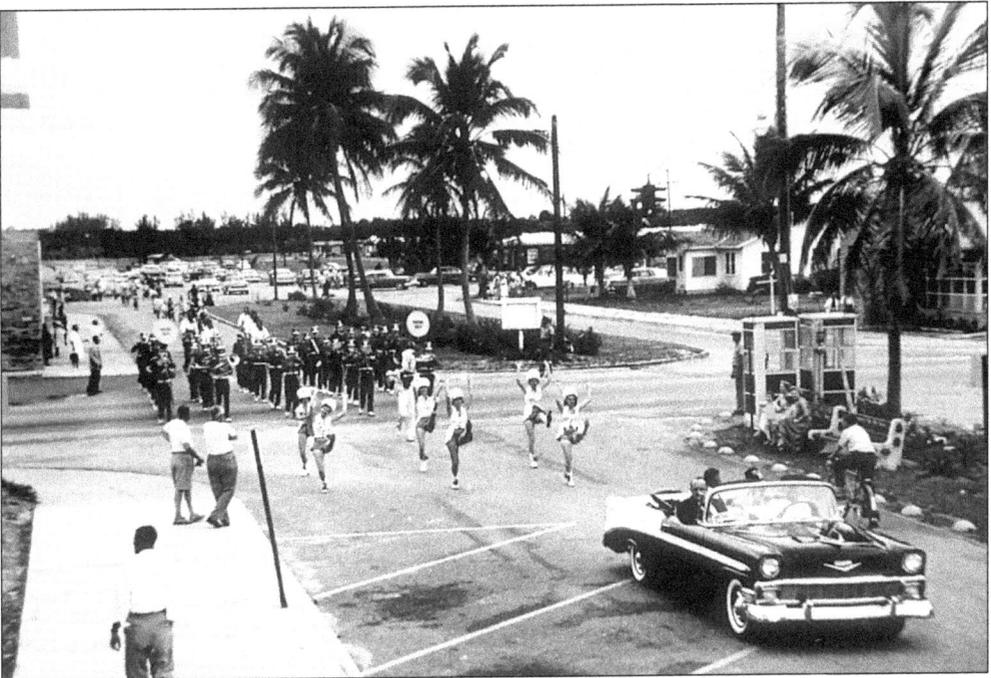

A spirited small-town parade moves eastward on Commercial Boulevard across SR A1A in 1956. In the distance at left there is no bridge over the Intracoastal Waterway. Today, Mack's Groves stands where Al Walthers Real Estate building is at the extreme right center.

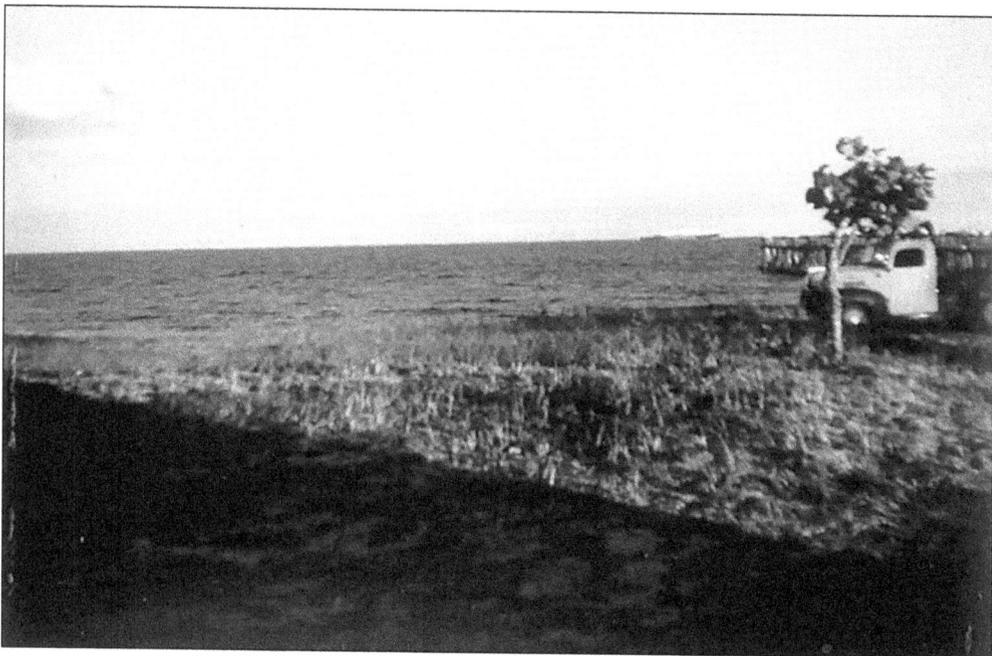

The beach at Lauderdale-By-The-Sea captures nature's splendor in 1953 before development took place. The view is from Murphy's Restaurant, and the pier can be seen at the right.

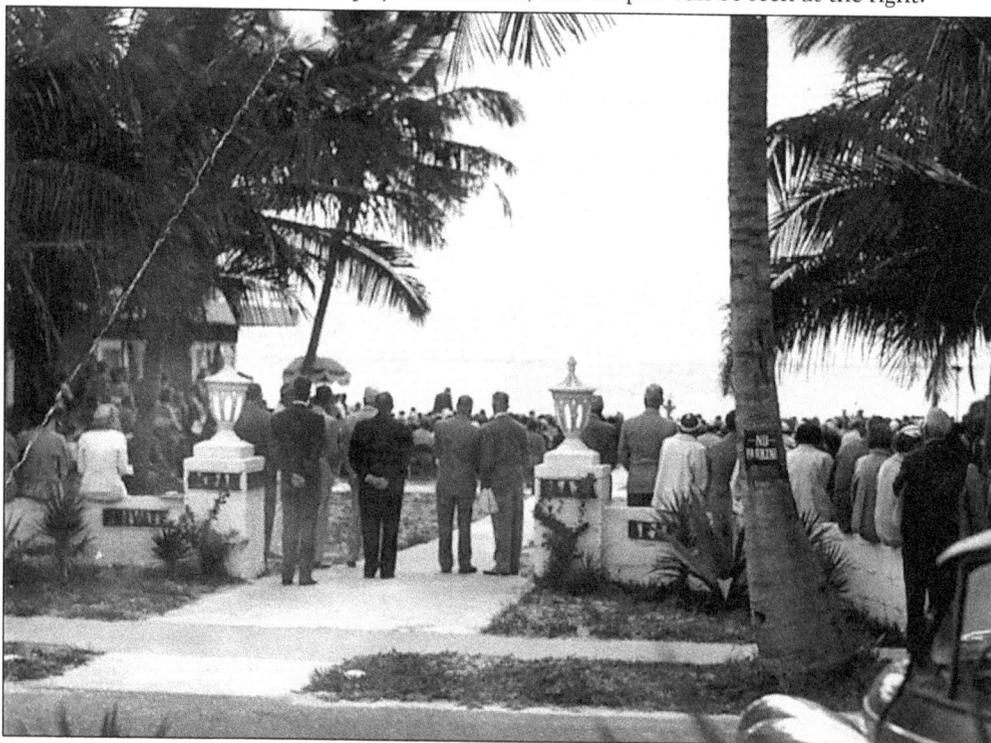

An Easter sunrise service was held in April 1954 at the Ocean Plaza Apartments, 4124 North Ocean Boulevard. Mr. and Mrs. Donald Cook were the resident owners of the property. The motel is now gone. The first sunrise service was held two years earlier.

This rare 1952 image shows the first building that housed the Assumption Catholic Church, which served parishioners until 1994. Immediately to the south was a trailer park and Muriel's Jade House, which attracted a night crowd.

A friendly lunch could be enjoyed by locals at Jim Roetelle's Trott's Corner, 100 Commercial Boulevard (formerly Sullivan's Drug). From left to right are the following: an unidentified man with a hat, Pat Balee (owner of Bale's Fruit Shipping store), and attorney Lee C. Travelstead.

There was strong connection between South Florida and Petosky, Michigan, as this local 1953 advertisement proves. Listed above are local merchants who had shops on La Olas Boulevard in the winter and in Petoskey during the summer. Many moved to Lauderdale-By-The-Sea, including the Hoffman, Murphy, and Behan families.

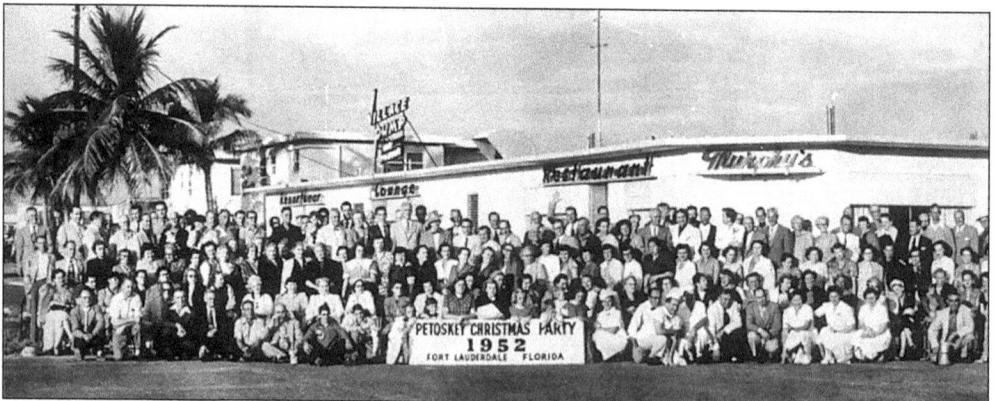

PETOSKEY

The Heart of Northern Michigan's Summer Playground

OFFERS to Fort Lauderdale's winter visitors one of the world's most attractive summer vacation spots. You will enjoy the restful beauty of this little tip-of-Michigan city which has long been known for its warm welcome and gracious hospitality.

A diversified entertainment program of active and spectator sports, sailing, fishing, tennis, riding, golf; all in unspoiled surroundings of jewel-like natural beauty.

The Petoskey Chamber of Commerce will welcome your inquiry.

The following Fort Lauderdale merchants operate shops in Petoskey during the summer. They join in extending welcome to all their local friends to visit them there.

Alice John Rogers Women's Apparel,
 805 East Las Olas
Barney Linens,
 822 East Las Olas
Bob Baker Shoes,
 822 East Las Olas
Ed Behan Tweed Shop,
 716 East Las Olas
Emily Naser Women's Wear,
 709 East Las Olas

Flora Ottimer for Children,
 802 East Las Olas
Gattle's Linens,
 2426 East Las Olas
Maus & Hoffman Men's Clothing
 710 East Las Olas
Punch and Judy Children's Wear,
 822 East Las Olas
Sarah Weinstock Women's Apparel
 820 East Las Olas

A large group of residents from Petoskey, Michigan, gathered for a 1952 Christmas party at the Village Pump and Murphy's Restaurant in Lauderdale-By-The-Sea. Petoskeyites were happy to seek refuge from the frigid north Michigan climate.

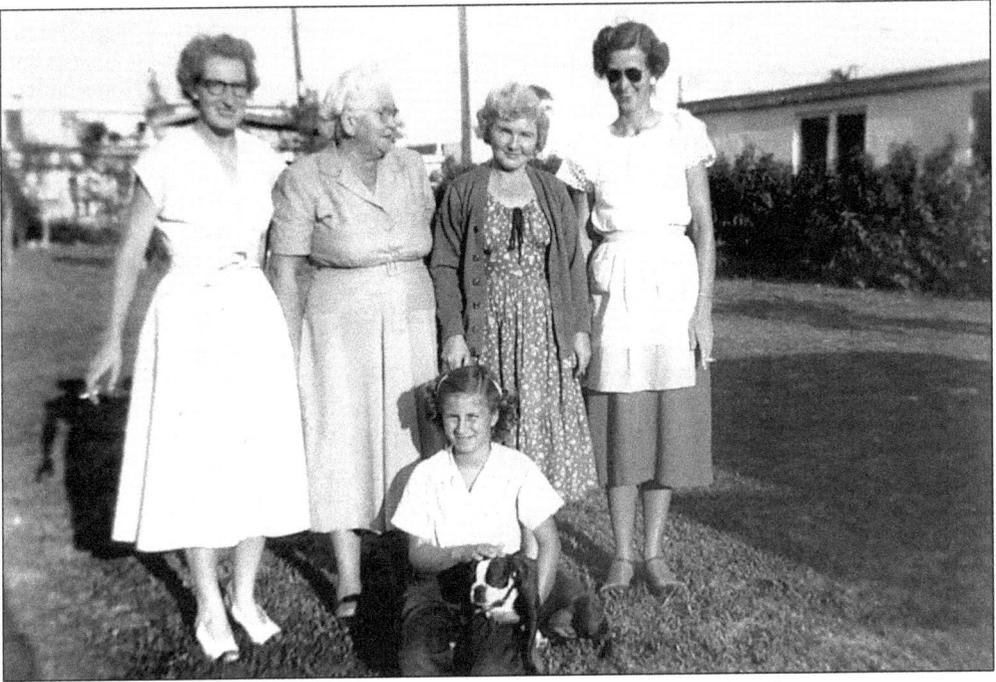

Mrs. Jerry Brinkley, second from right, gathered with friends in 1952. She was an important part of the Brinkley team that believed in Lauderdale-By-The-Sea and contributed to the town's growth.

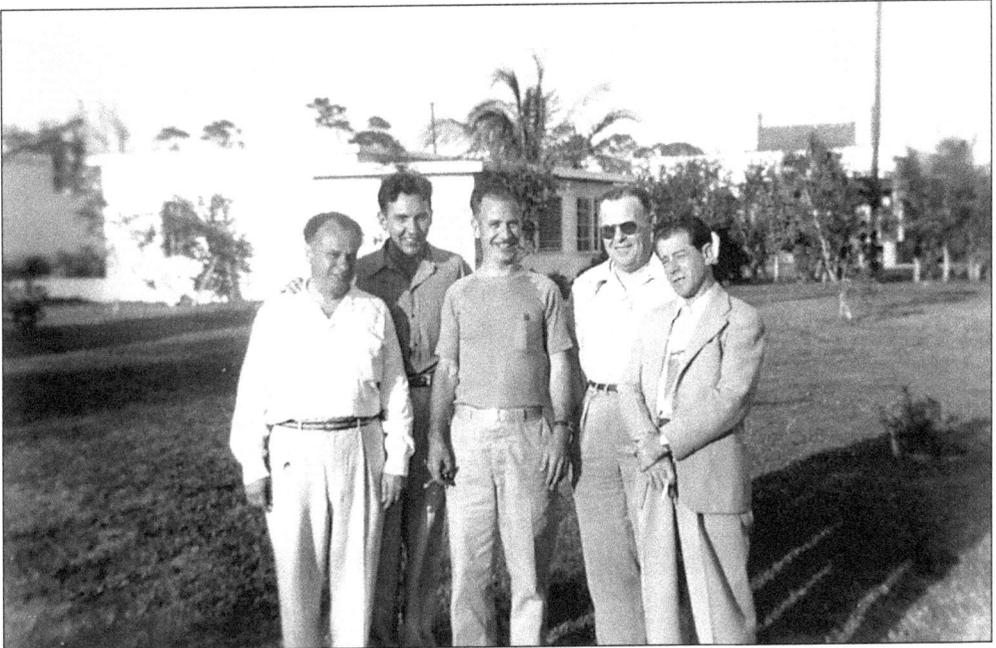

Jerry Brinkley, second from right with glasses, helped build the town. He was a successful barber at the elegant Lauderdale Beach Hotel in Fort Lauderdale. Here he poses with fellow barbers in 1952. He also served as an elected town commissioner.

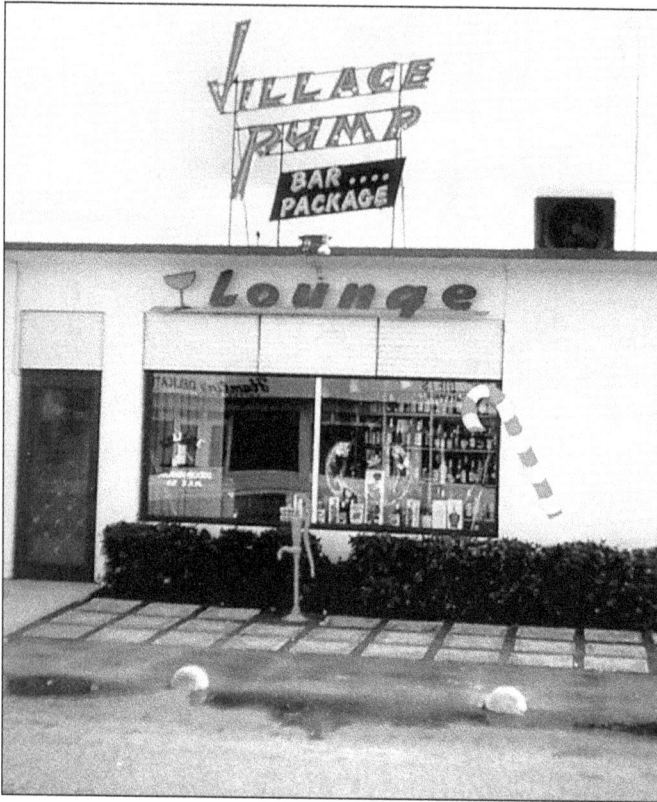

The popular Village Pump, shown here as it appeared in December 1953, was built by Jerry Brinkley. It served as a lounge and package store at 4404 El Mar Drive. The Village Pump remains at the same site to this day. Guests usually had a cocktail there while waiting for a table at Murphy's Restaurant next door.

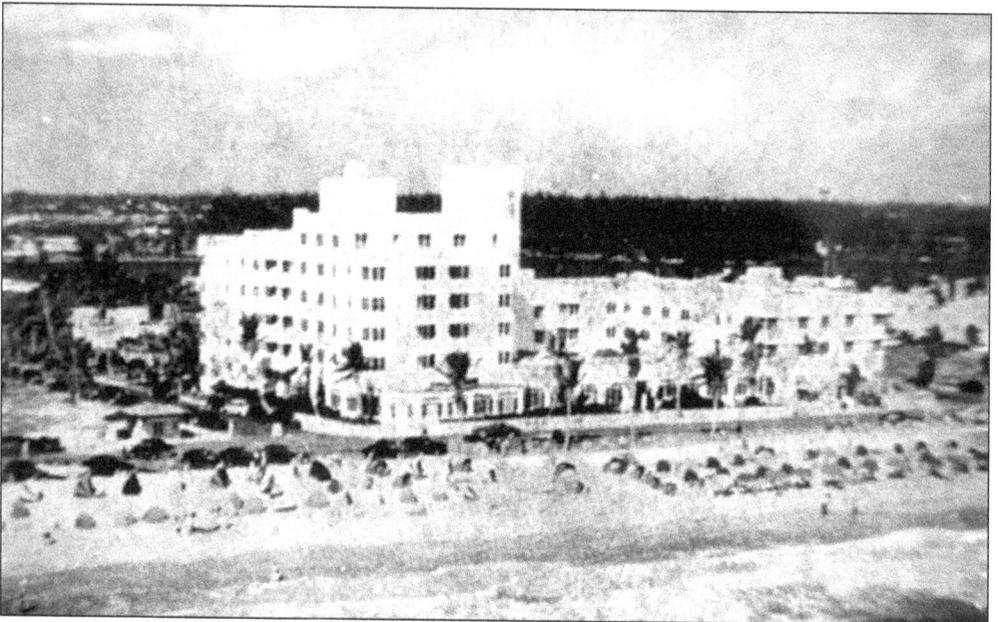

The famous Lauderdale Beach Hotel in Fort Lauderdale offered an all-you-can-eat buffet luncheon for the price of $2.50 in 1952. It was at this hotel that Jerry Brinkley worked as a barber for wealthy clients. President Harry Truman stayed here.

HOME OF THE FLORIDA DERBY

1953 MEETING

MARCH 4 thru APRIL 20

BEAUTIFUL *Gulfstream* PARK

"The Track by the Sea"

NORTH OF MIAMI ON FEDERAL HIGHWAY NO. 1

Horse racing began in Florida in 1925 when Hialeah Park opened. It was followed by Tropical Park, and finally Gulfstream Track, which is located in Hallendale a few miles south of Lauderdale-By-The-Sea. This advertisement announced the 1953 season dates for "The Track by the Sea."

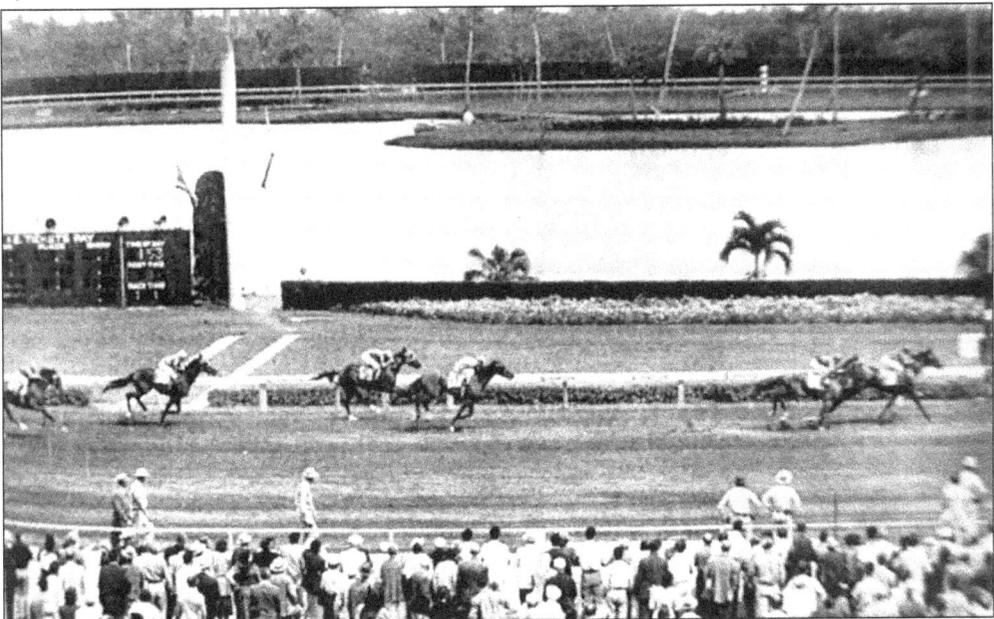

Gulfstream Track attracted leading jockeys and thoroughbred horses, as well as large populations from the North during the racing season. This scene captures a field of horses approaching the finish line 50 years ago.

"Lauderdale by the Sea"
FEATURING OCEANFRONT
PROPERTIES
AL WALTHERS
4401 Ocean Drive
Lauderdale-By The-Sea
2321 Atlantic Boulevard
Pompano Beach

Al Walthers was a prominent real estate broker in Lauderdale-By-The-Sea. His office was at the site where Mack's Groves is located today. Walthers also had a second office on Atlantic Boulevard in Pompano Beach.

Wildlife was a natural phenomenon in Lauderdale-By-The-Sea during the early years. This alligator appeared on Commercial Boulevard opposite Al Walthers' real estate office at 4401 Ocean Drive (SR A1A). Walthers and his wife attended the January 20, 1947, meeting that led to the incorporation of the town.

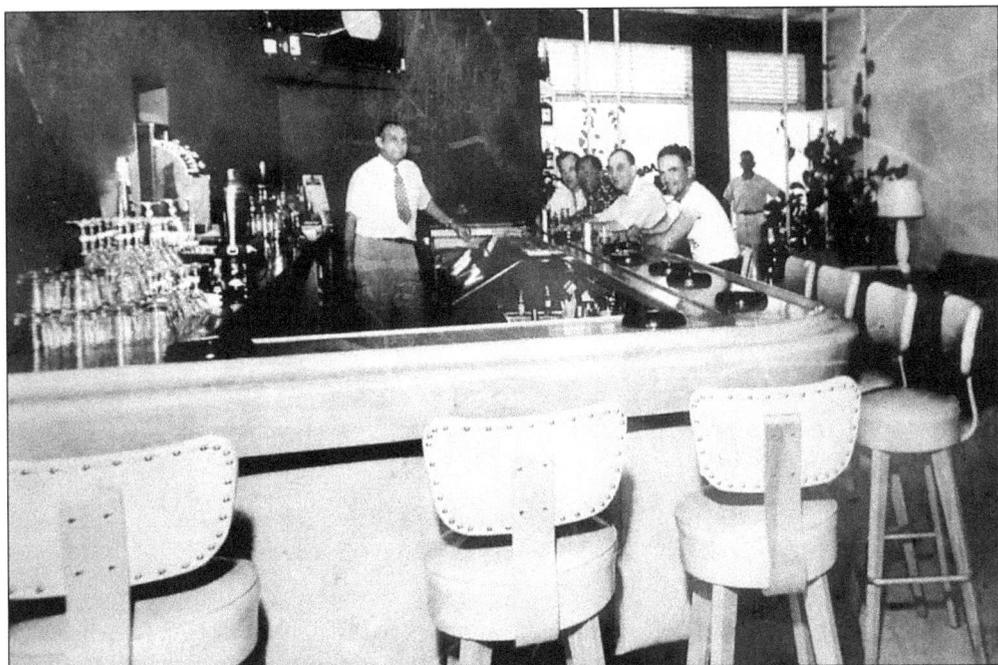

These smiling gentlemen are enjoying a relaxing time and congenial fellowship at the Village Pump bar in 1950. Notice the period television in the background over the bar.

In another scene a few years later (1953), locals gathered for a cocktail and friendly conversation at the Village Pump. Once again the overhead television is turned off.

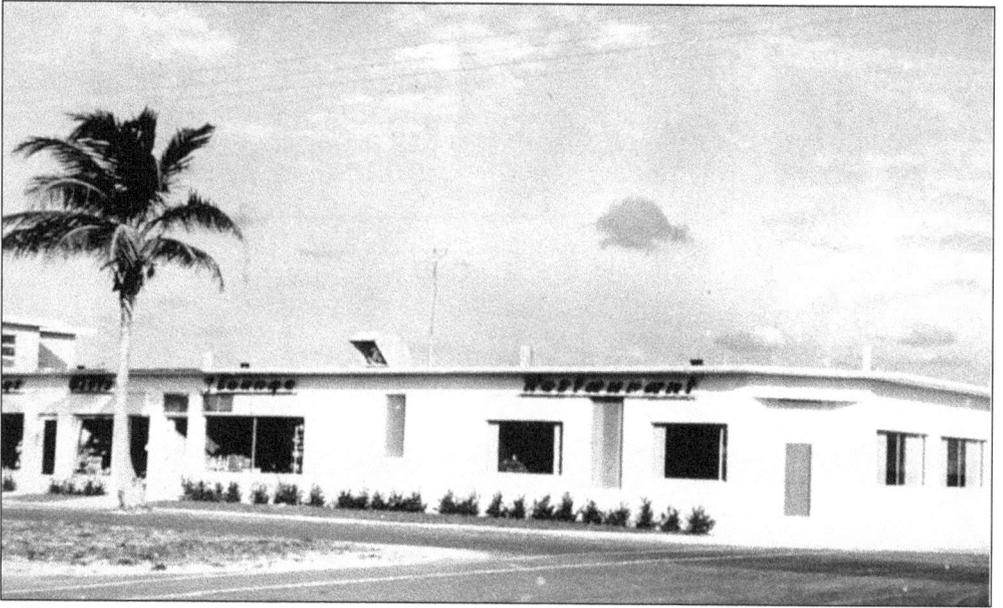

After World War II, a new era of growth had begun for Lauderdale-By-The-Sea. Jerry Brinkley built a block of stores on the east side of El Mar Drive in 1947. They included Murphy's Restaurant, the Village Pump, White's Gifts, and O'Brien's Togs. The town adopted a charter as it reincorporated, and the U.S. Census recorded 234 full-time residents.

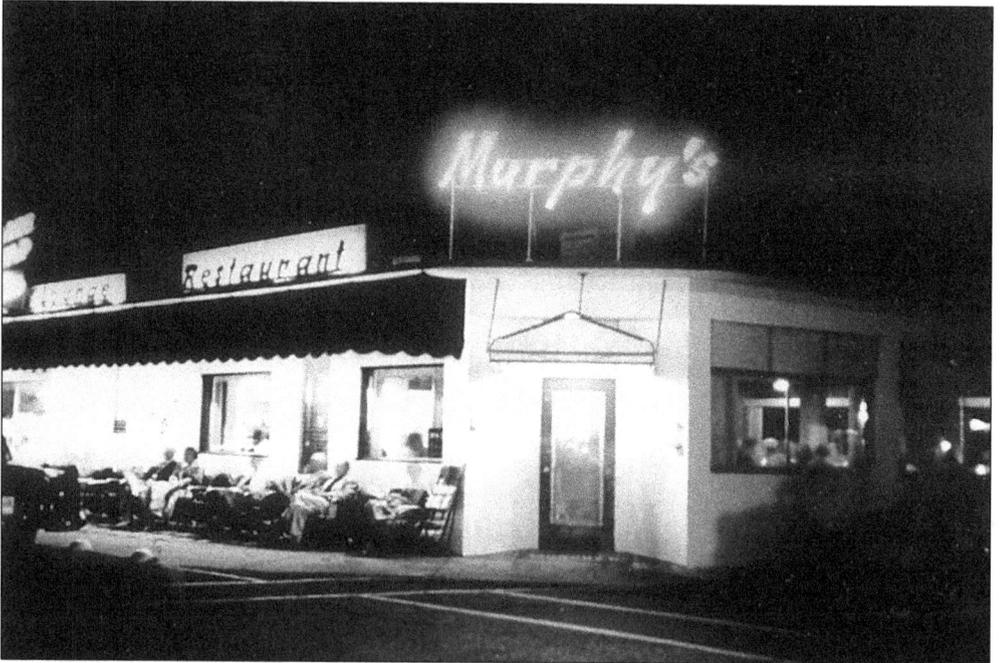

Murphy's Restaurant looked like this during an evening in 1953. The guests in front are waiting for a table outside the restaurant. Murphy's did not serve liquor, so they would have had a cocktail at the Village Pump next door. Notice how well the guests are dressed.

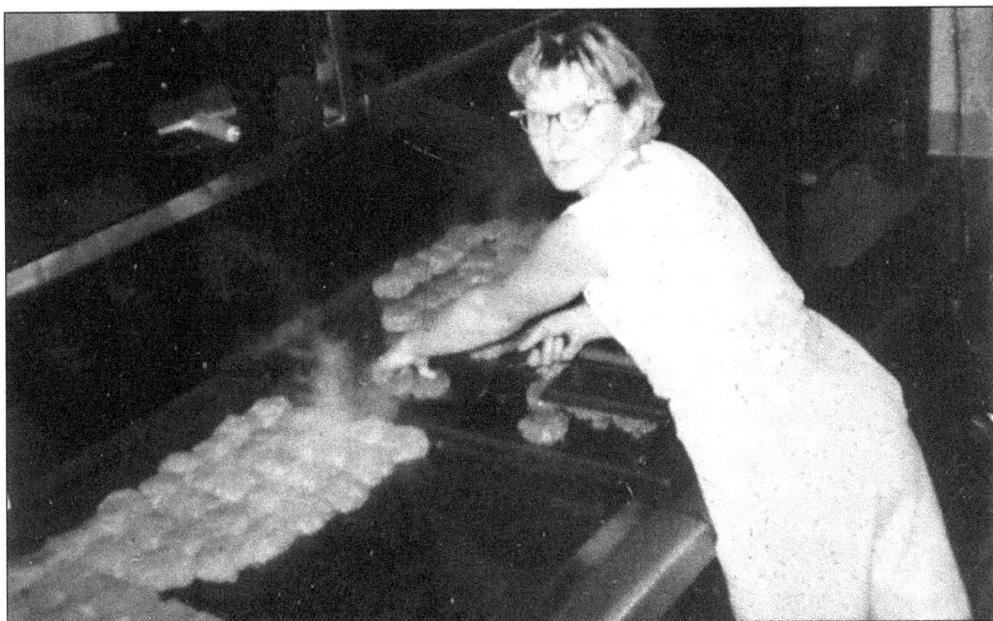

Owner Geraldine Murphy was famous for her "hamburger hour," from noon to one o'clock, when the restaurant was closed during the day. She made prime beef hamburgers for the help while preparing for evening dinner guests, but the public soon learned about this delicacy. Thus, until 1969 she made 350 hamburgers a day for the lunch crowd that gathered at the back kitchen door. Here she is at work.

Here people are lined up to receive their hamburger orders during the lunch hour at Murphy's Restaurant. Old-timers remember how delicious these hamburgers were.

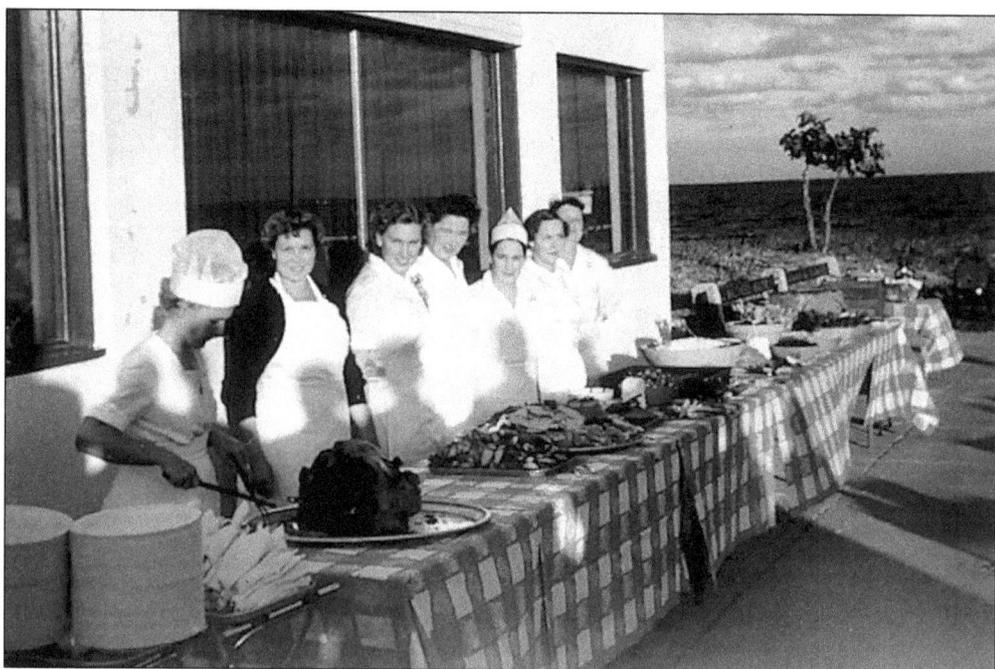

In front of her restaurant in 1953, Geraldine Murphy, left, prepares a Thanksgiving buffet dinner while her smiling staff looks on. The beach can be seen at right, and there are no obstacles blocking the view from the restaurant.

Geraldine Murphy was originally from Petoskey, Michigan. By 1953 she had established herself as a resident of Lauderdale-By-The-Sea. Her restaurant was a huge success and known throughout South Florida. Here she finds time to relax in front of Anglin's Fishing Pier, 1953.

Gwendoline Cook poses in front of the Harbor Drive Apartments at 238 Harbor Drive, which also housed the Steven Construction Company in 1956. The site is now a private residence. Cook, now 92, began vacationing at Petit's Riviera Hotel, sometimes as the only guest. She recalled walking on the beach with no one else on it.

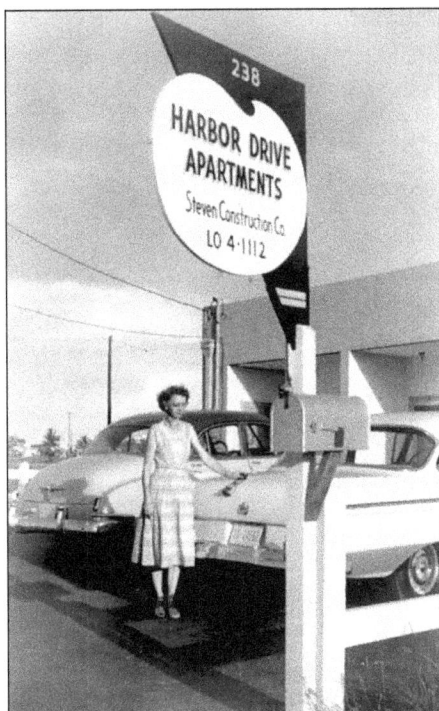

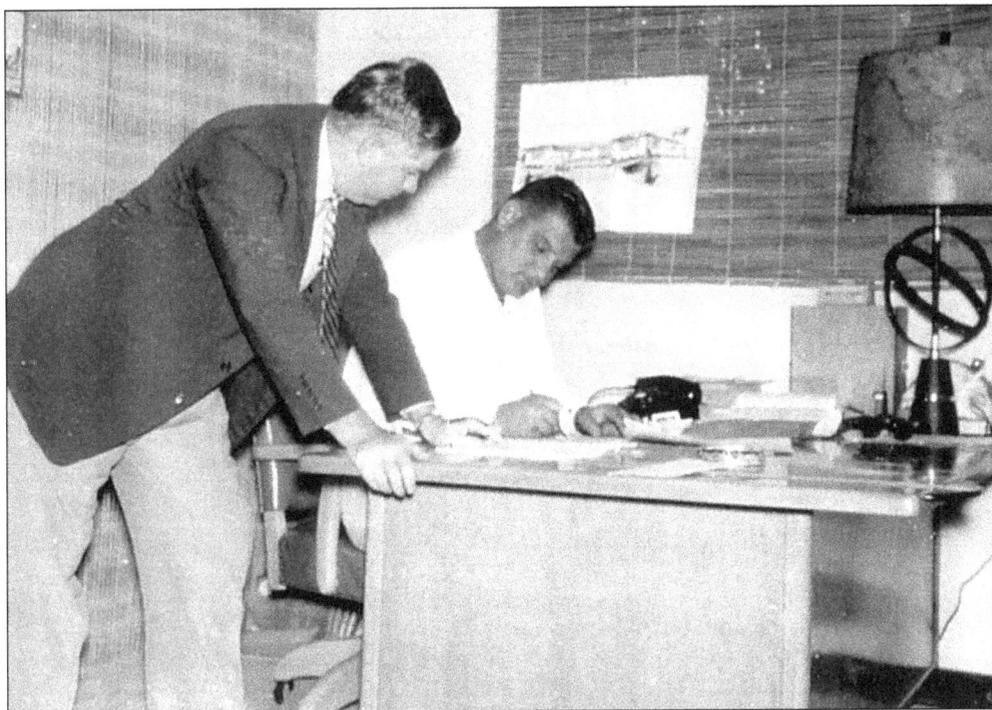

Attorney Lee C. Travelstead, left, and Steven J. Hriczo, right, of Steven Construction Company are pictured here. The company was the owner and builder of the first commercial building in the Silver Shores section of Lauderdale-By-The-Sea on Basin Drive. Hriczo also was the builder of custom homes at Las Olas Isles, apartments in Miami Beach's "motel row," and Vero Beach.

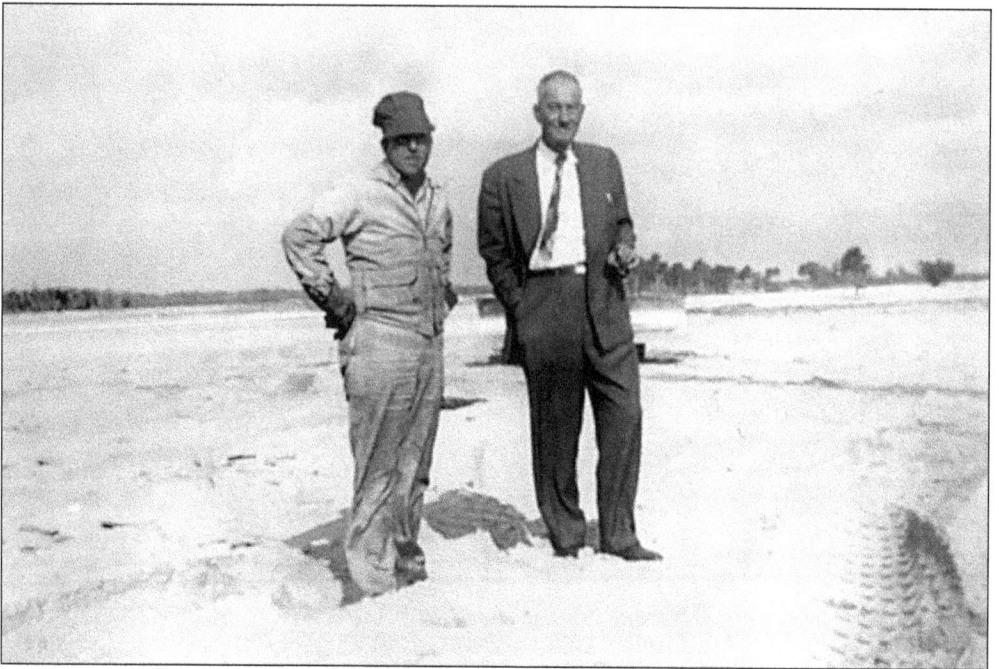

E.K. Bludworth (right) and his assistant survey the Silver Shores construction site, west of the Intracoastal Waterway and south of Commercial Boulevard, in 1952. Bludworth was the grounds superintendent and a partner of William S. Edgemon, a major builder of the period.

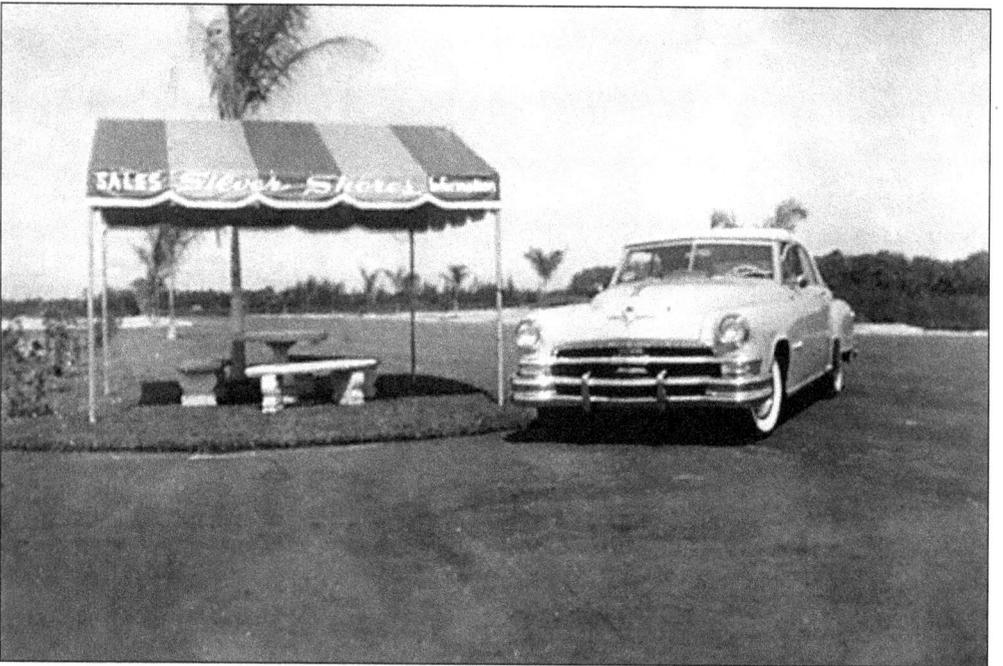

This 1952 scene at the southwest corner of Sea Grape Drive and Commercial Boulevard shows a Chrysler automobile and the sales office, where homes for the Silver Shores development were sold. William S. Edgemon was responsible for over 90 percent of the development of the western part of Lauderdale-By-The-Sea.

The plat of a subdivision of Tract "D" of Silver Shores is reproduced here. It was executed by builder William S. Edgemon on April 8, 1952. The Silver Shores Waterway opened an outlet to the Intracoastal Waterway.

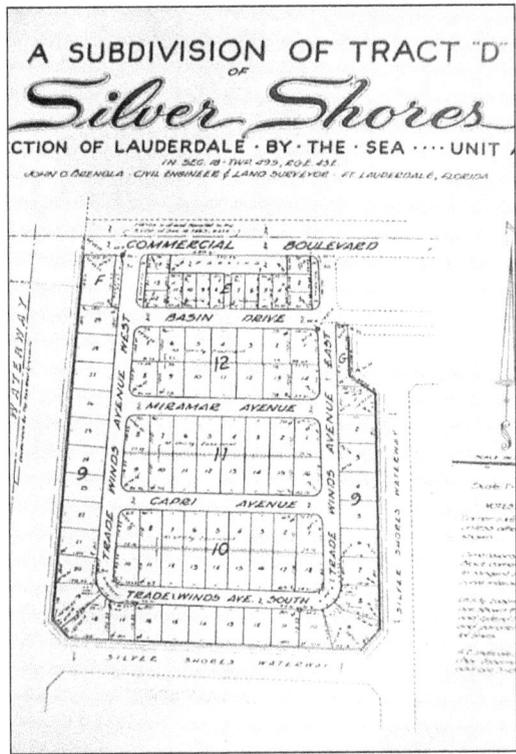

A SUBDIVISION OF TRACT "D"
OF
Silver Shores
CTION OF LAUDERDALE · BY · THE · SEA ···· UNIT
IN SEC. 18 · TWP. 49S. RGE. 43E.
JOHN O. BRENGLA · CIVIL ENGINEER & LAND SURVEYOR · FT. LAUDERDALE, FLORIDA

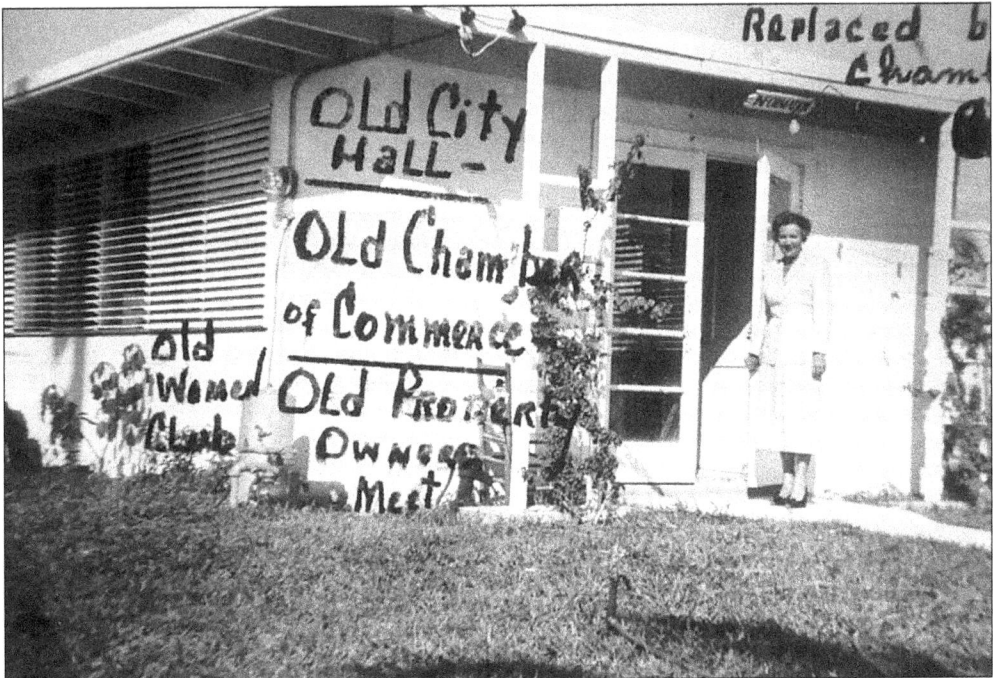

The building above was constructed in 1949 and located at SR A1A and Bougainvilla Drive. It provided meeting facilities for the City Hall, Women's Club, Property Owners Association, and Chamber of Commerce. It was eventually replaced by a new Chamber of Commerce building.

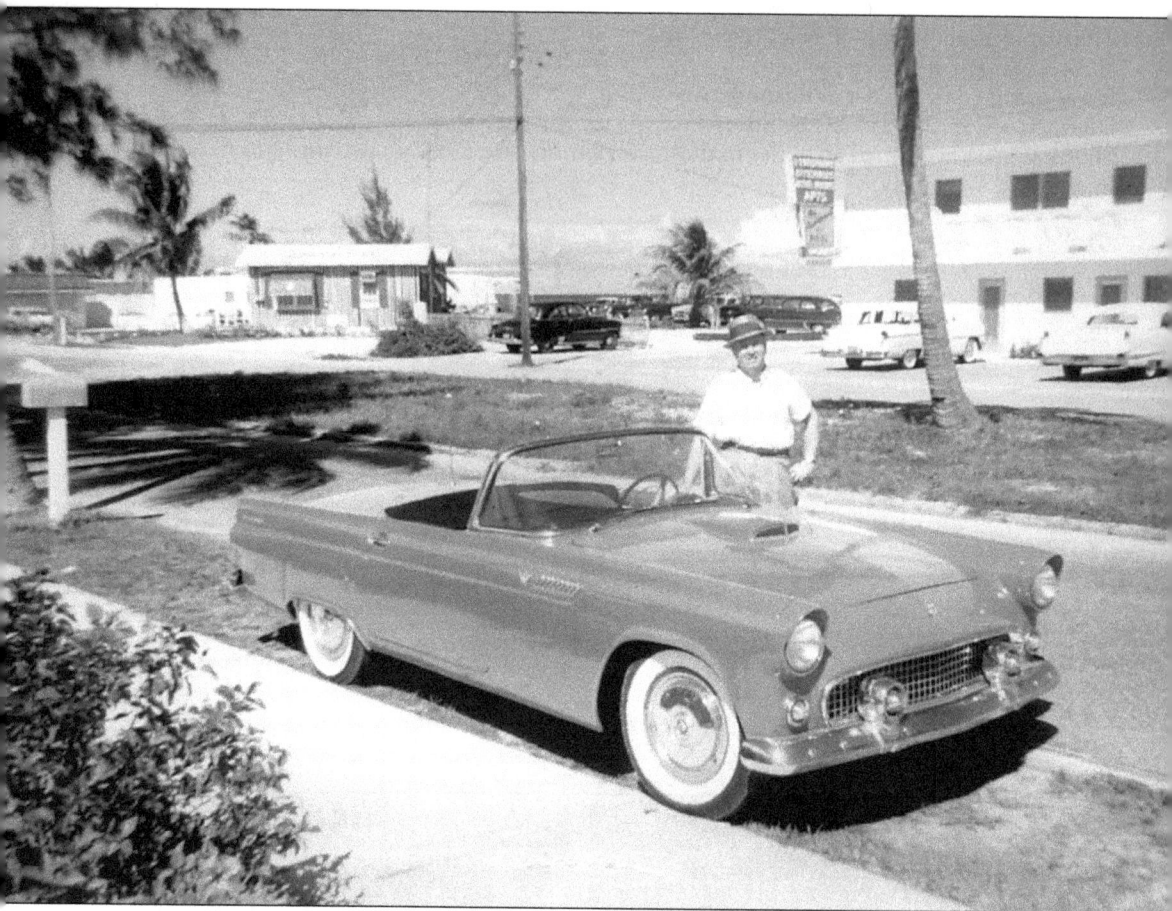

Town attorney and later judge Lee C. Travelstead stands by his 1955 Thunderbird at El Mar Drive in October of 1956. Pettit's Riviera Apartments (now the 105-room All Suite Pier Point Resort) is in the background at right on the beach. Lord's Real Estate office building is at left; it was later moved to a new location on SR A1A. Travelstead graduated from Harvard and received a law degree from the University of Miami. He made Lauderdale-By-The-Sea his permanent home in 1953.

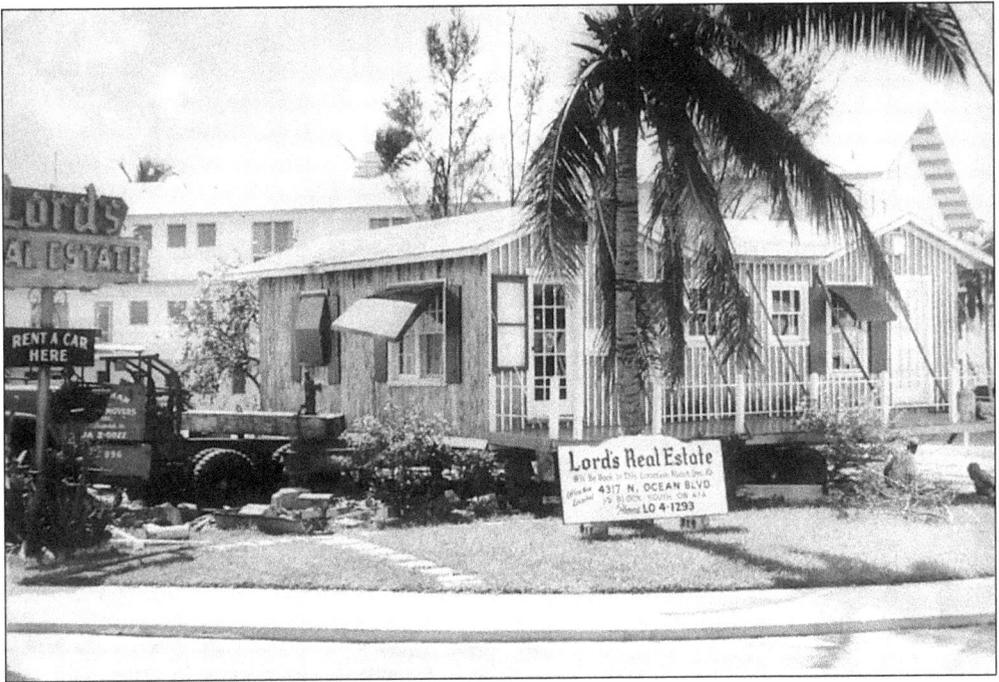

Alice Lord's real estate office, as it appeared in the 1950s, was a fishing shack in front of the pier. It was relocated south of the "Old Anglin Homestead" (now the Demko home) on SR A1A when Commercial Boulevard was developed.

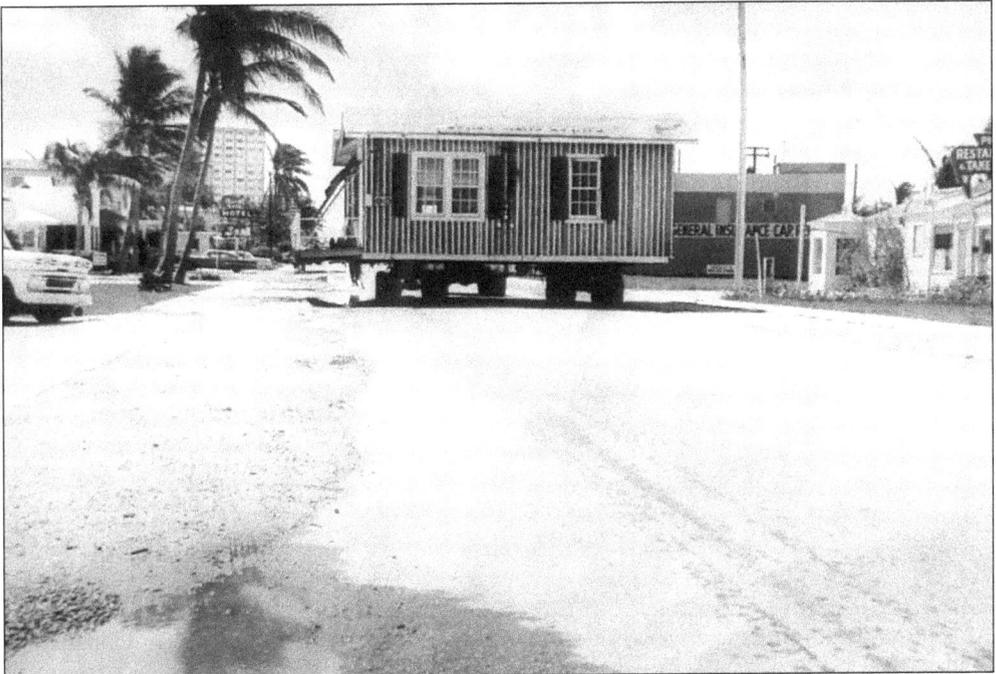

The fishing shack/Lord's Real Estate office was moved when Frank Myatt and Everett Sorensen bought the land on which it stood. Margaret Anglin Demko, one of Melvin and Sarah Anglin's daughters, asked that it be relocated. Here it is being moved in the 1960s.

The fishing shack/Lord's Real Estate office is shown here at its current location south of Commercial Boulevard and on the east side of SR A1A (Ocean Drive). It provides a rustic setting within a more modern and urbanized Lauderdale-By-The-Sea.

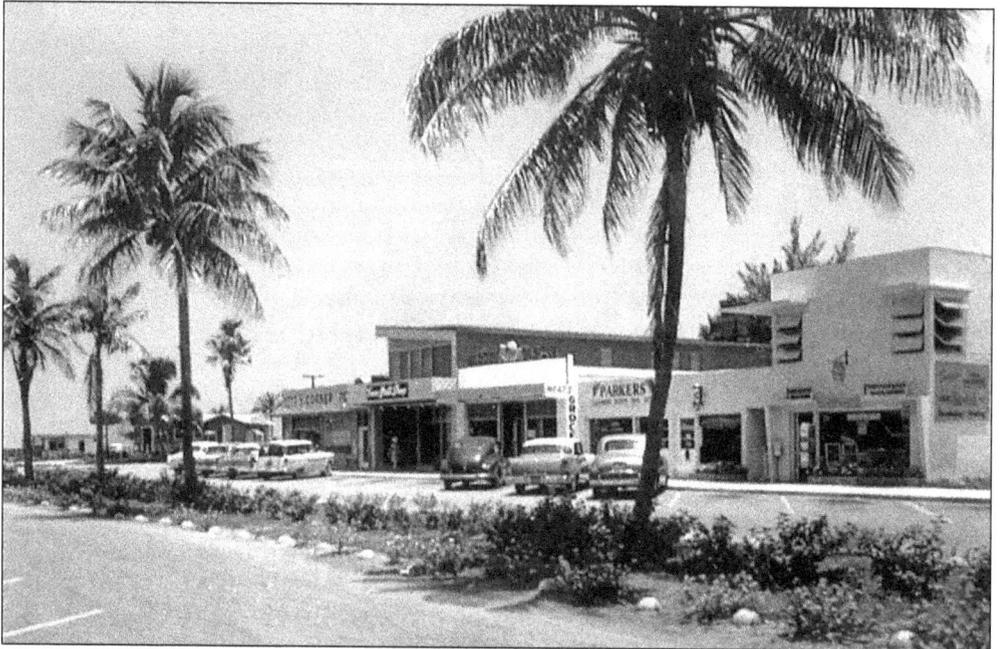

A 1950s postcard presents a view of the "shopping center" on the south side of Commercial Boulevard before it was modernized. The Lord's Real Estate building is at left next to Trott's Corner, which stood at 100 Commercial Boulevard. The ocean is in the distance. The meats and grocery store, center, was owned by Hugh Behan. Brinkley's barbershop is to the right of Parker's; at that time it was operated by Robert F. Clark.

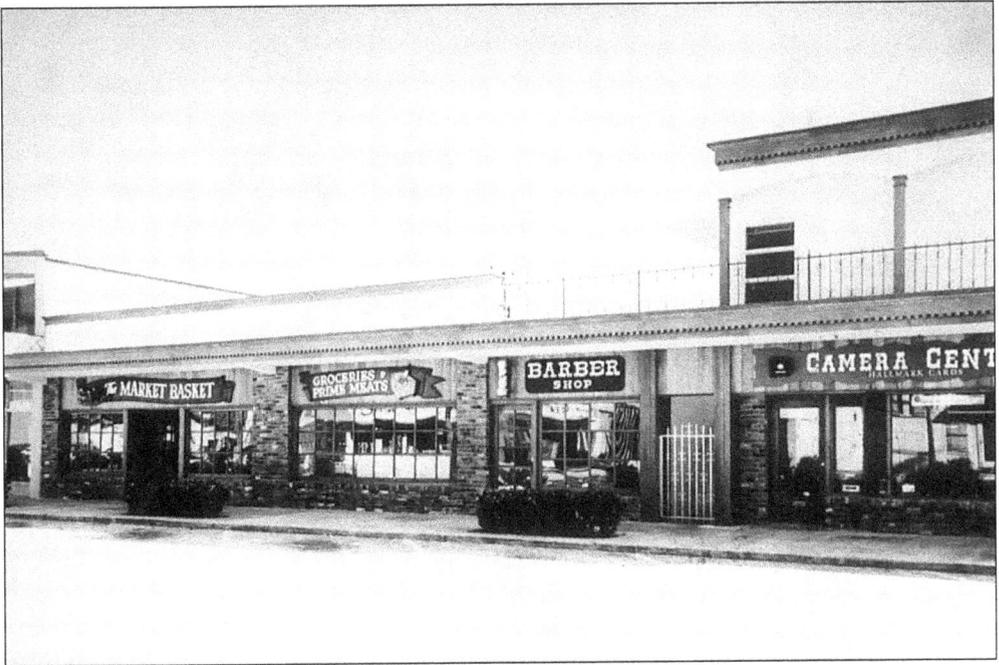

The Business Men's Association was able to have Commercial Boulevard refurbished in the 1960s, and this is the result on the south side. It presented a more attractive and cohesive appearance with carved wooden signs, gold lettering, and brick storefronts.

Hugh Behan, above, relaxes for a moment at the Market Basket, the meat and grocery store he established in 1949. For the next 32 years the Market Basket served as the town center for shopping and news. Behan satisfied requests for the high-quality food demanded by residents and tourists. He led the Business Men's Association for a while; Behan died in 1976.

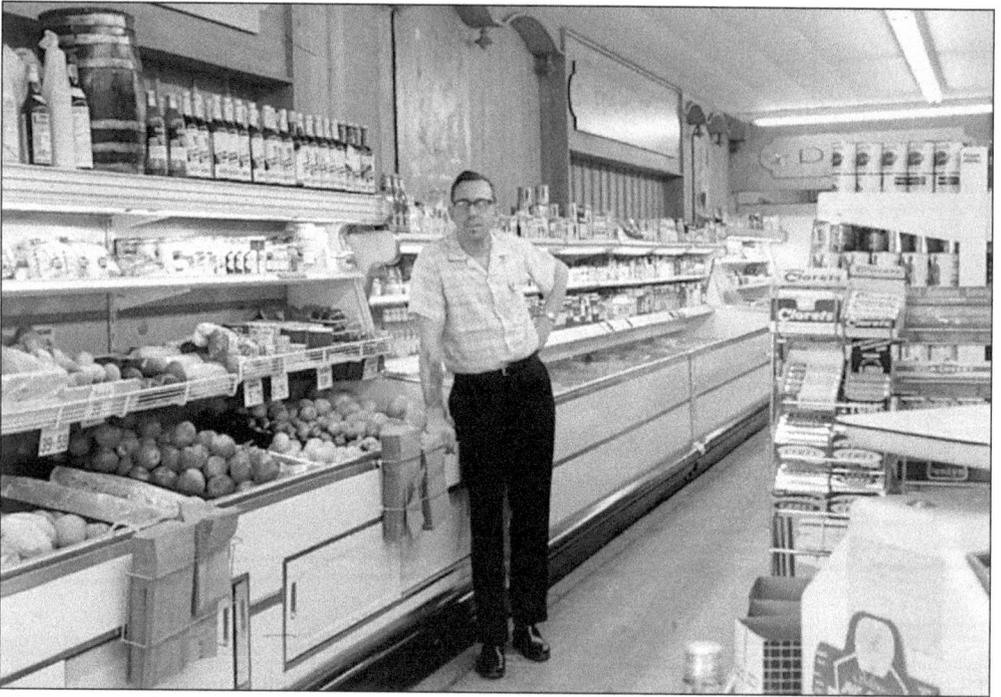

The interior of Hugh Behan's Market Basket provided a neat and clean atmosphere conducive to shopping. Pictured here is Lou Sparks, a town volunteer fireman, in 1961.

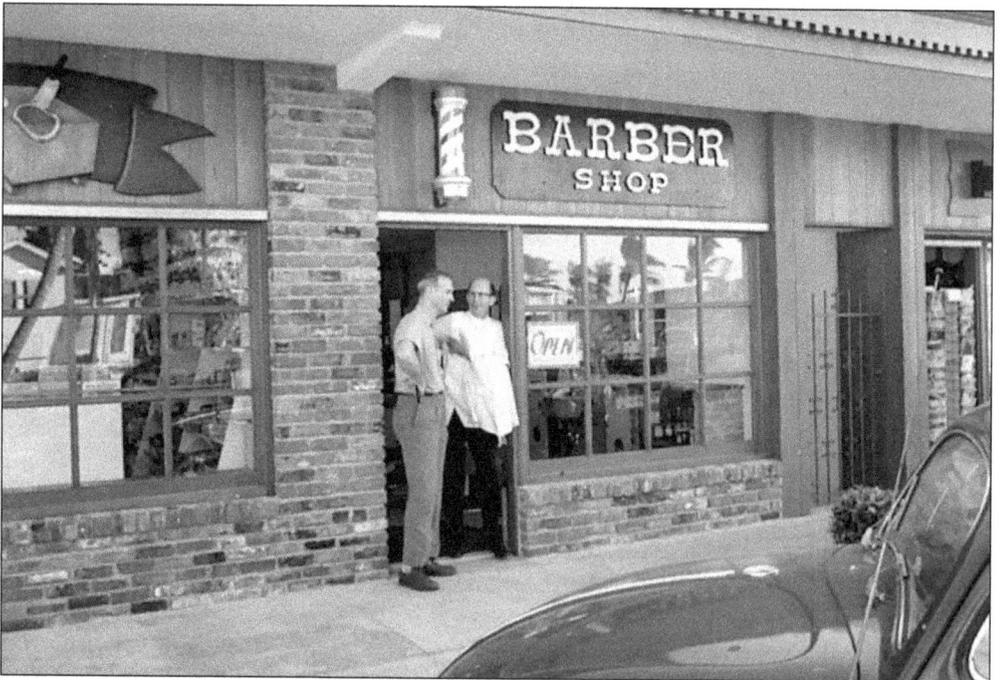

A customer, left, chats with Robert F. Clark in front of his barbershop at 108 Commercial Boulevard. Clark bought the shop from Jerry Brinkley in 1952 and ran it successfully for the next 30 years.

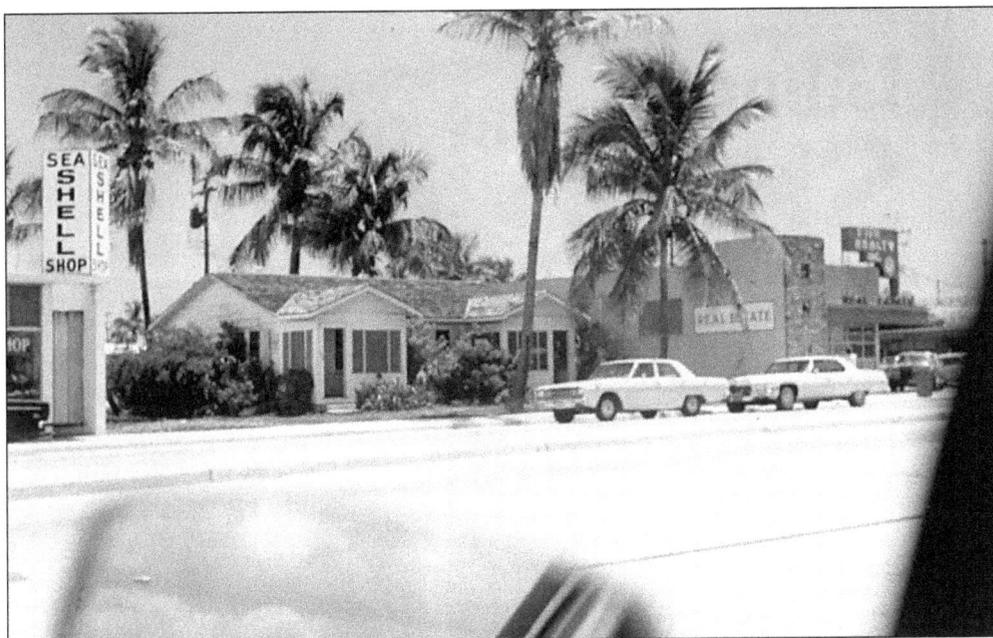

The east end of Commercial Boulevard at SR A1A (Ocean Drive) has changed in the past four decades. At the extreme right is Al Walthers Real Estate office, which has been replaced by Mack's Groves. The building in the center no longer exists and has been replaced by low-rise commercial buildings.

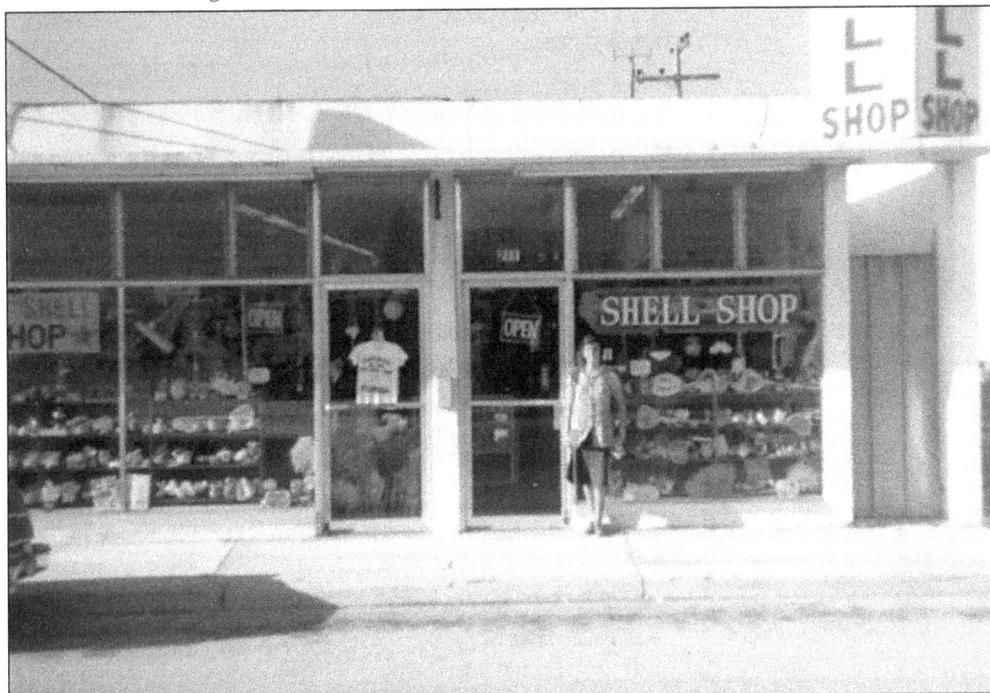

The Sea Shell Shop in 1970 was located on the north side of Commercial Boulevard around the corner from Mack's Groves. The stores that occupy this space today are the Cigar Store, Incaware, and A Craft of Art. Louie's Diner is nearby.

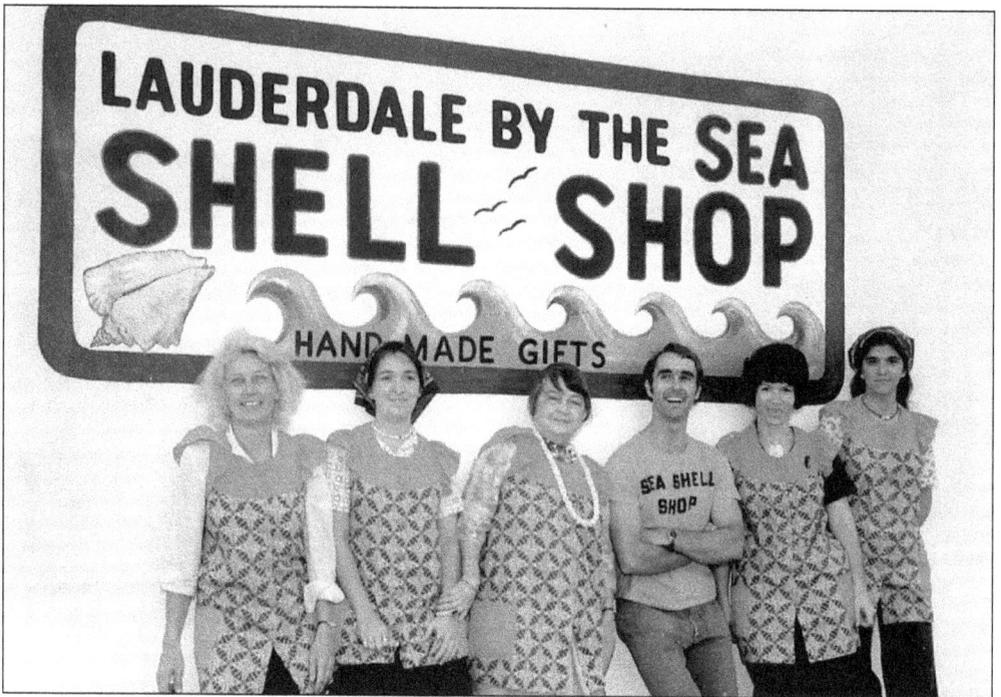

These people are standing in front of the Sea Shell Shop in 1970, a popular place for tourists to purchase gifts. From left to right are Virginia Klobe (owner), and employees Debra Wirth, Hilda Volk, Mike Wilson, Ramona Davis, and Cathy Wirth.

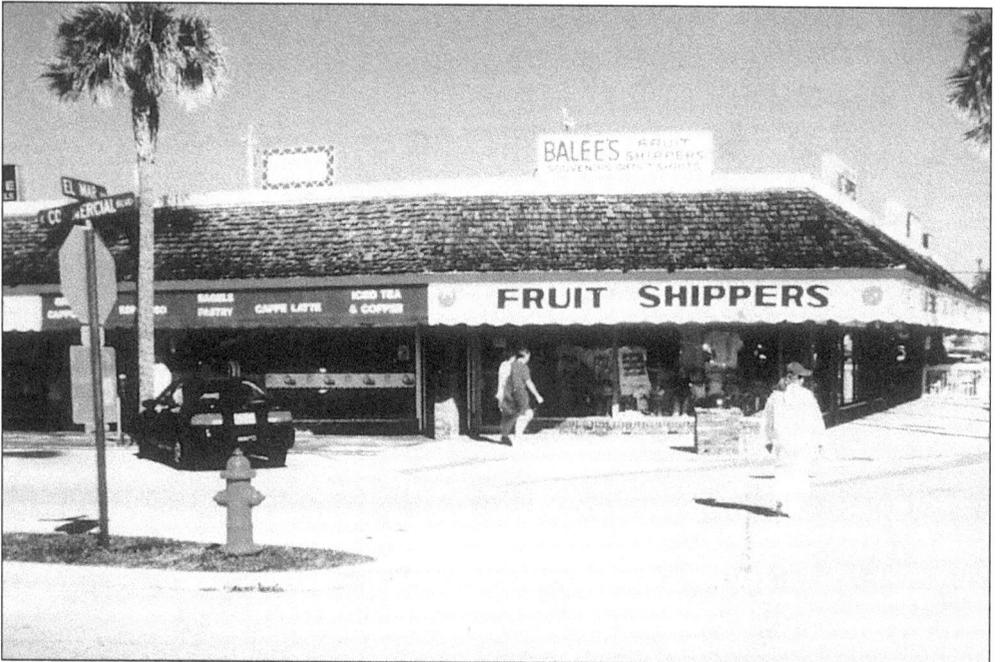

Balee's Fruit Shippers, owned by Pat and Lorraine Balee, was still doing business up until 1997. The store dominated the corner of Commercial Boulevard and El Mar Drive, as the street sign at left indicates. Bond Hardware-Plumbing was located next door.

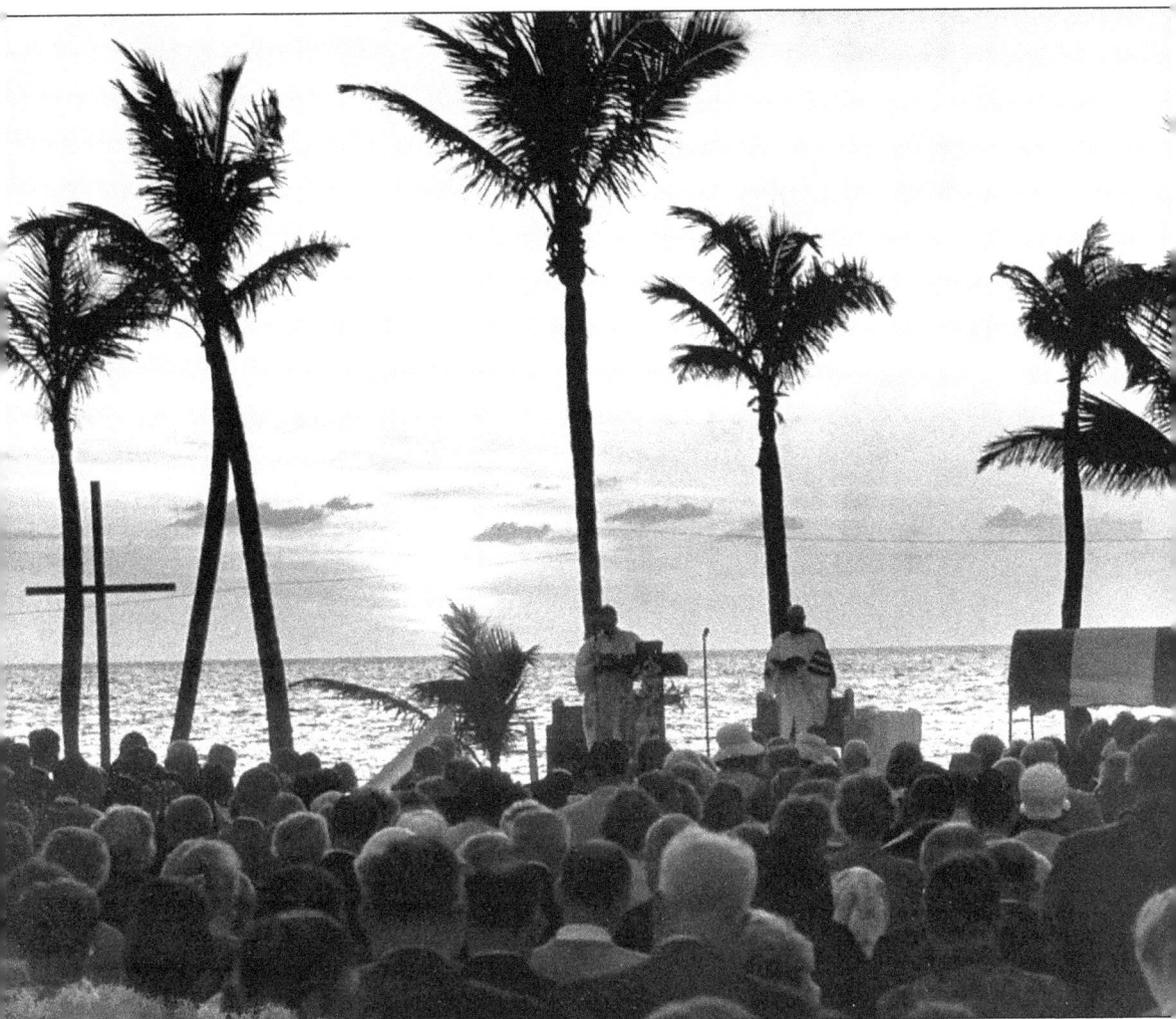

An Easter sunrise service was held on the beach by the Lauderdale-By-The-Sea Community Church at 5:45 a.m. in 1956, amid palm trees and a spectacular natural setting. Microphones were placed in the palm trees for auditory enhancement, and congregants were attentive as the ministers lead the service. Note the cross at left.

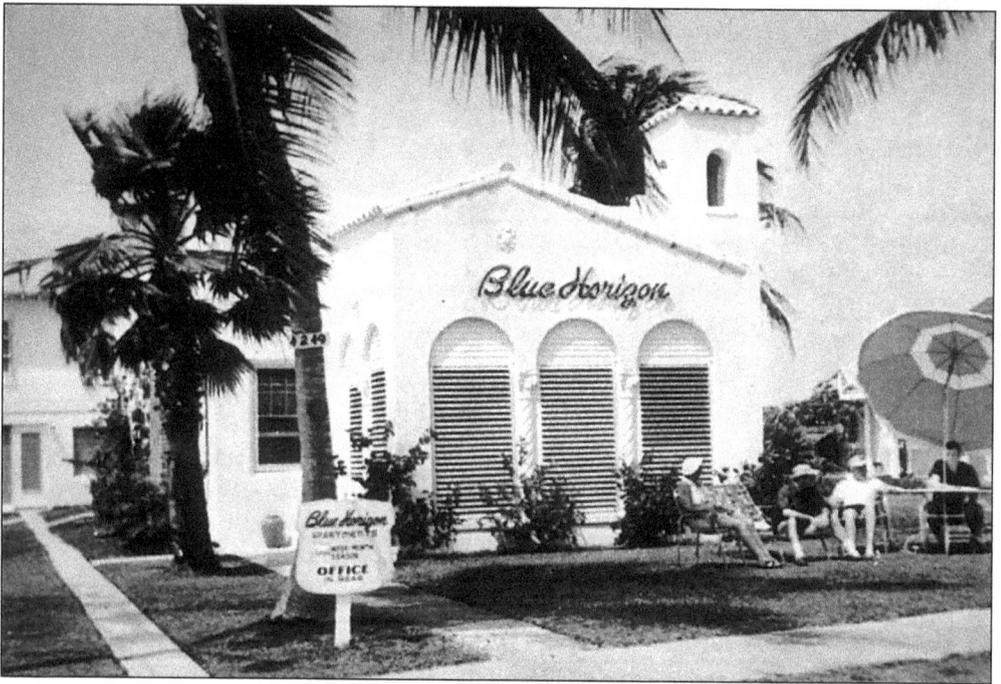

By the 1950s, tourism had become, and would remain, the town's biggest industry. The charming Blue Horizon Apartments (above) at 4249 Bougainvilla Drive were an important part of the local tourism business. The fact that there were no huge hotels in town allowed the owners of small motels to offer personalized service to guests. Usually the owners were a husband and wife who lived in the community.

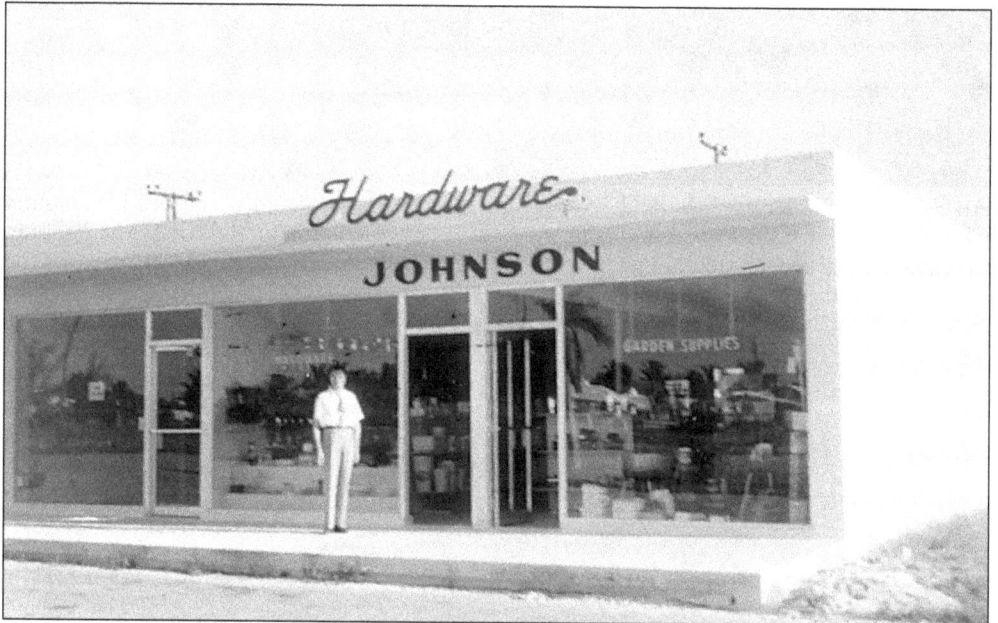

Lester Johnson stands in front of his hardware store, which had just opened in 1957 at 232 Commercial Boulevard. Today, Beach Ace Hardware occupies the site. Larry Wirth built the complex of stores.

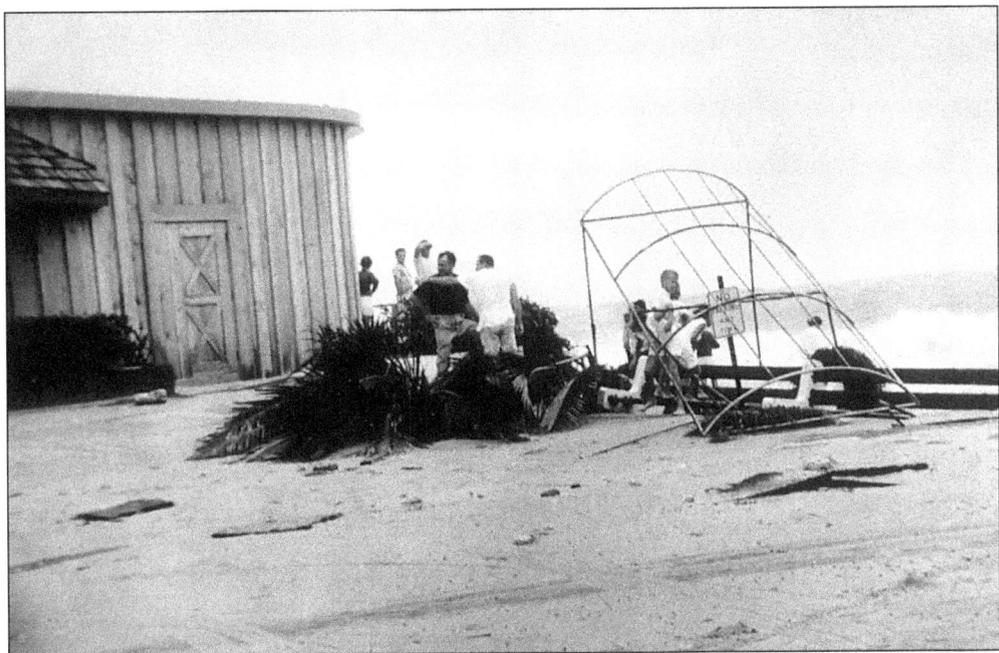

A tropical storm in 1956 caused flooding at the beach, knocking down the steel frame that held a canvas cover and uprooting palm trees. At left the Wharf Restaurant, owned by Jim Stefanis, remained standing. Curious sightseers look over the damage.

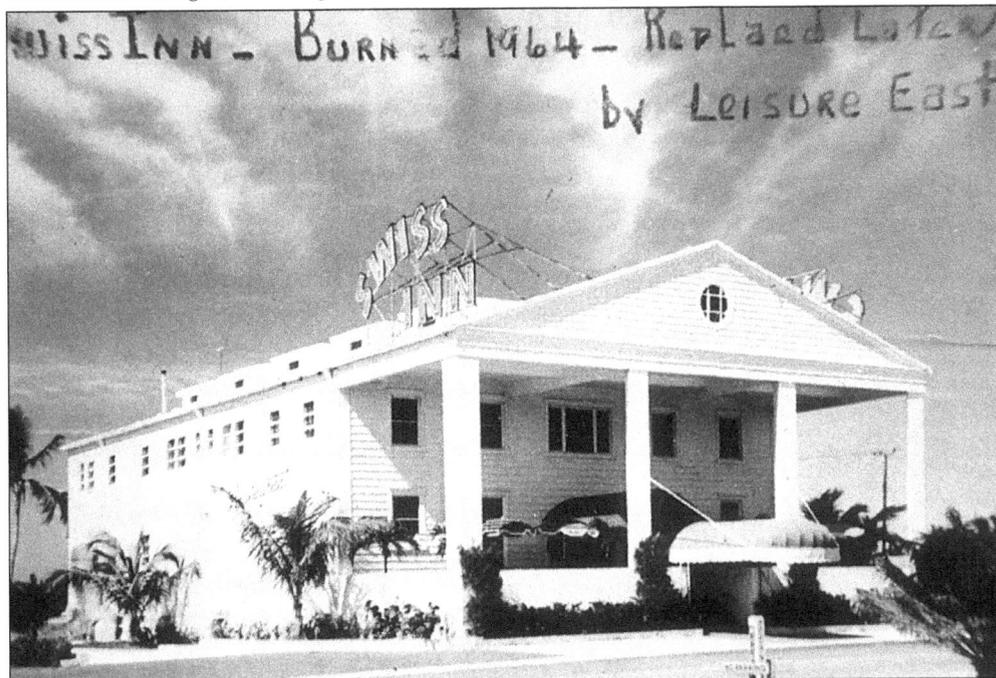

The Swiss Inn Restaurant, later called Grandma's, was built by Steve Calder, a land developer and banker. It was located where Bougainvilla Drive meets SR A1A (Ocean Drive). Community Church services were held here, as well as elections and Women's Club meetings. It burned to the ground in 1964.

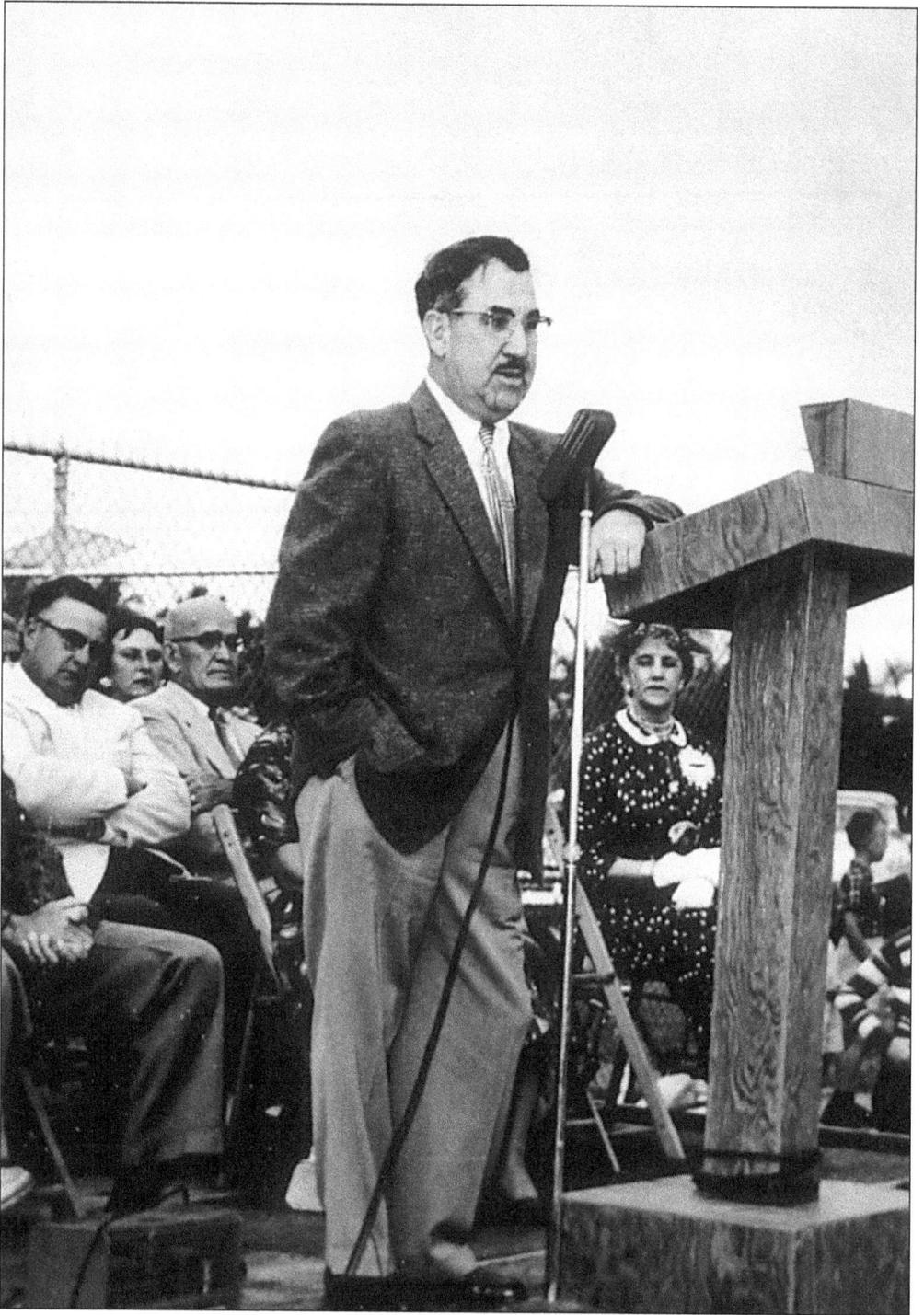

Town leader and benefactor Glen Friedt Sr. addresses the audience during the Friedt Park dedication ceremony in 1956. Lucy Friedt is at right. The Friedts donated money for the park amenities. The Melvin I. Anglin family had donated the land west of Poinciana Street to the town.

Three

MAYOR COLNOT TAKES CHARGE

Gilbert H. Colnot, above, guided Lauderdale-By-The-Sea as mayor and town manager from 1958 to 1978. He was a hands-on leader who practiced fiscal conservatism. In 1973 the town voted to set height limits of 33 feet (or three stories), a rare move as developers attempted to build high-rise structures and politicians sought to increase revenue and tourism. Colnot said he did not want his town to become like Miami.

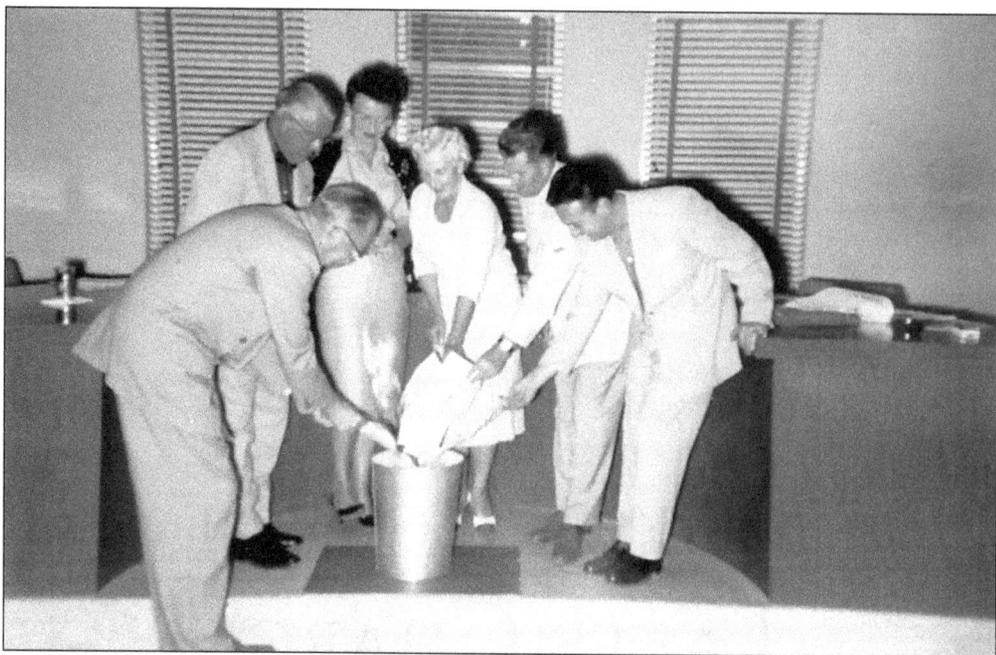

From left to right, Mayor Colnot, commissioner William B. Parsons, town clerk Juanita Pendlebury, vice mayor Lorna Perks, commissioner Jack Forrest, and town attorney Richard J. Cory burn the paid-up Town Hall mortgage in 1960. When Colnot left office in 1978, the town was debt-free.

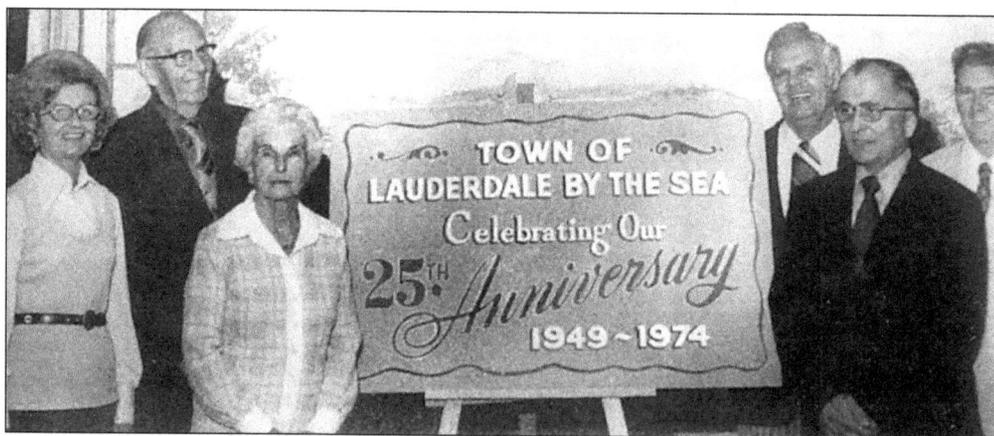

The 25th anniversary of the town's second incorporation was celebrated in 1974. Enjoying the event are, from left to right, town clerk Juanita Pendlebury, Mayor Gilbert H. Colnot, Lorna Perks, William Karley, Howard Hall, and Jack Forrest, who later became mayor and town manager.

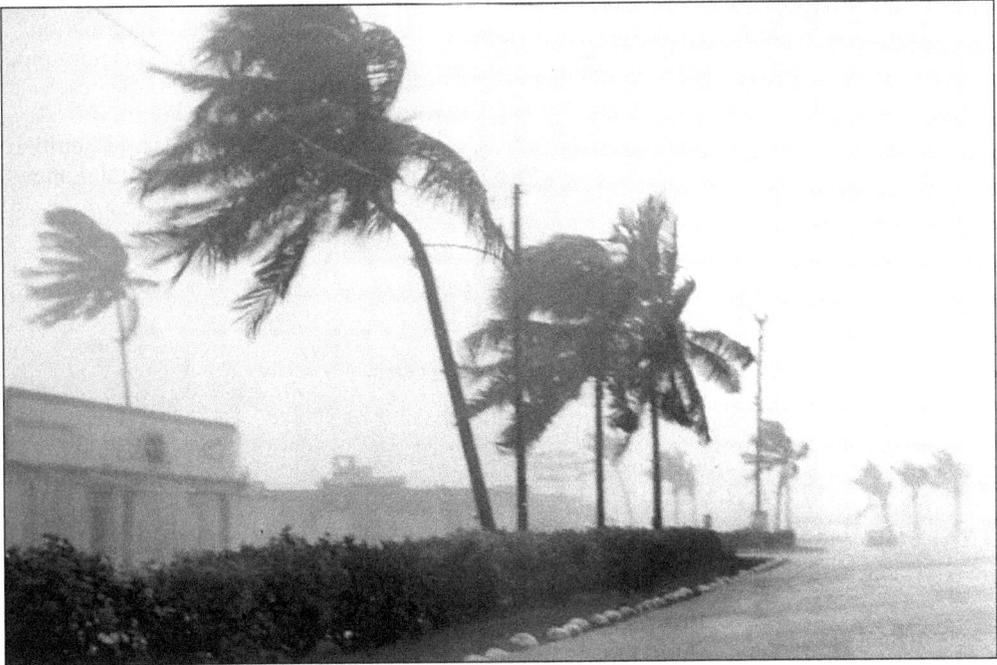

Hurricane Donna pounded the beach at Commercial Boulevard in 1960 with winds gusting up to 175 miles per hour. Looking east towards the Atlantic Ocean, Anglin's Fishing Pier cannot be seen. El Mar Drive, running north and south, is barely visible in the distance.

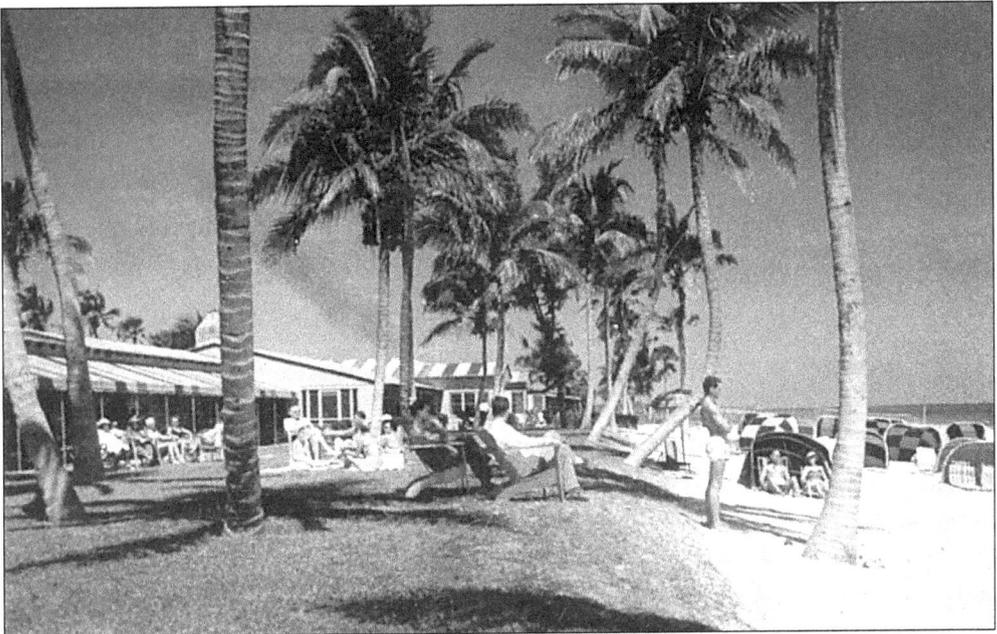

A view of the Sea Ranch Hotel and the beach (then with a Fort Lauderdale address in 1950) highlights the luxurious tourist destination, which was located north of the city's downtown center where Robert H. Gore Sr. owned the Governors' Hotel. The Sea Ranch hotel closed in 1978 with a Gore family reunion as its final function. The site is now occupied by the Sea Ranch Condominiums A, B, and C, in Lauderdale-By-The-Sea.

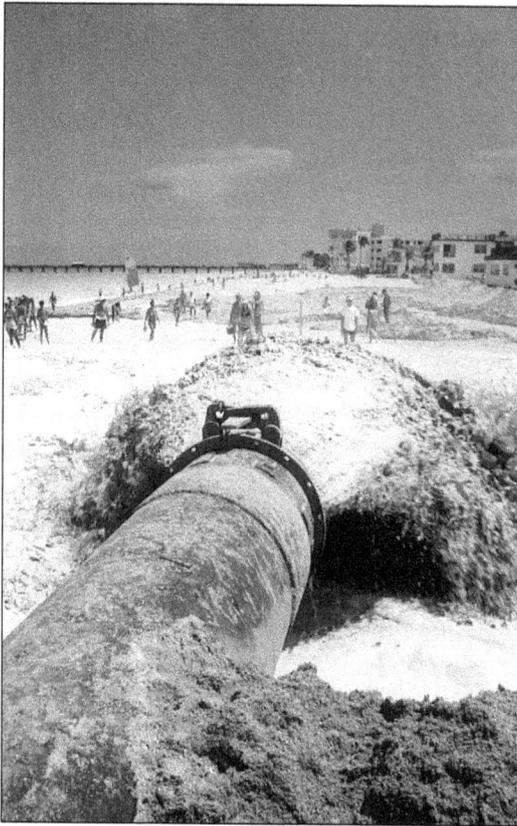

This is a picture of a beach reclamation project underway in 1969. This huge pipe is shooting ocean sand onto the beach, with the Anglin Fishing Pier in the background. The project cost $12 million dollars of federal, state, and local money.

Here the project continues. Reclamation equipment can be seen at left. Bathers and sightseers are enjoying themselves while others are gathering seashells.

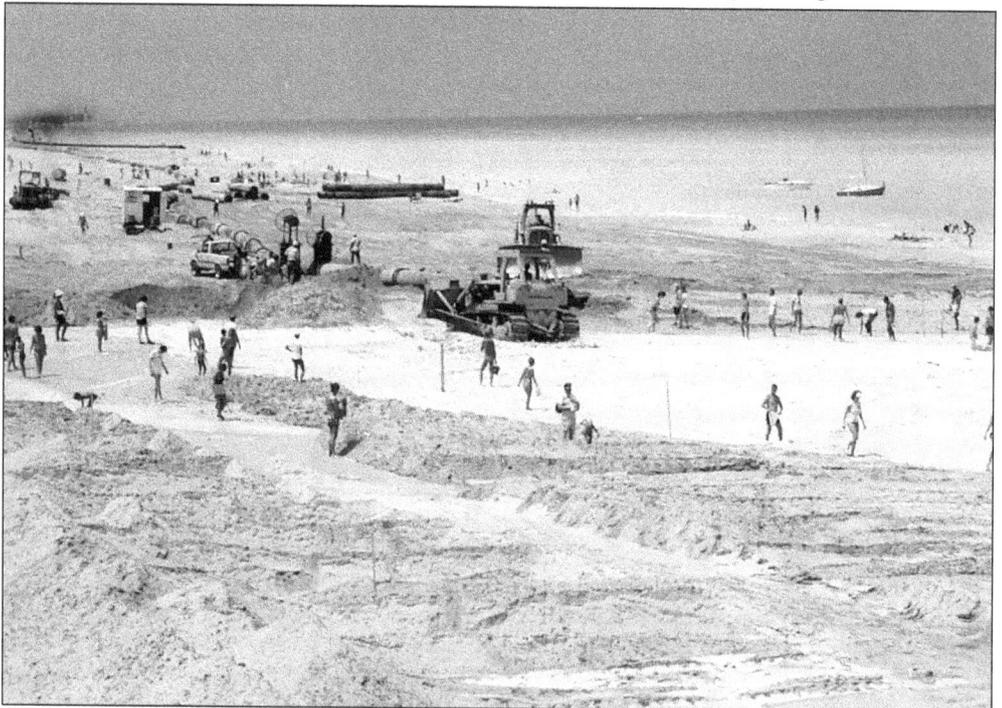

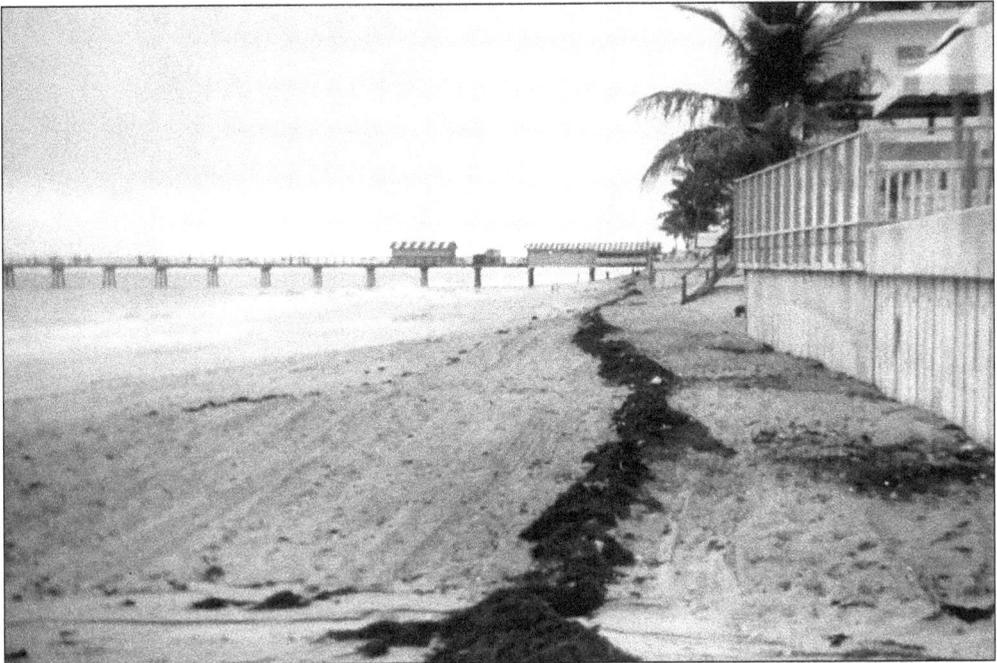

With the pier in the distance, looking south, the effect of severe beach erosion is evident. The seawall of the Tides Inn Motel, 4624 El Mar Drive, is at the right. There are no palm trees at the location.

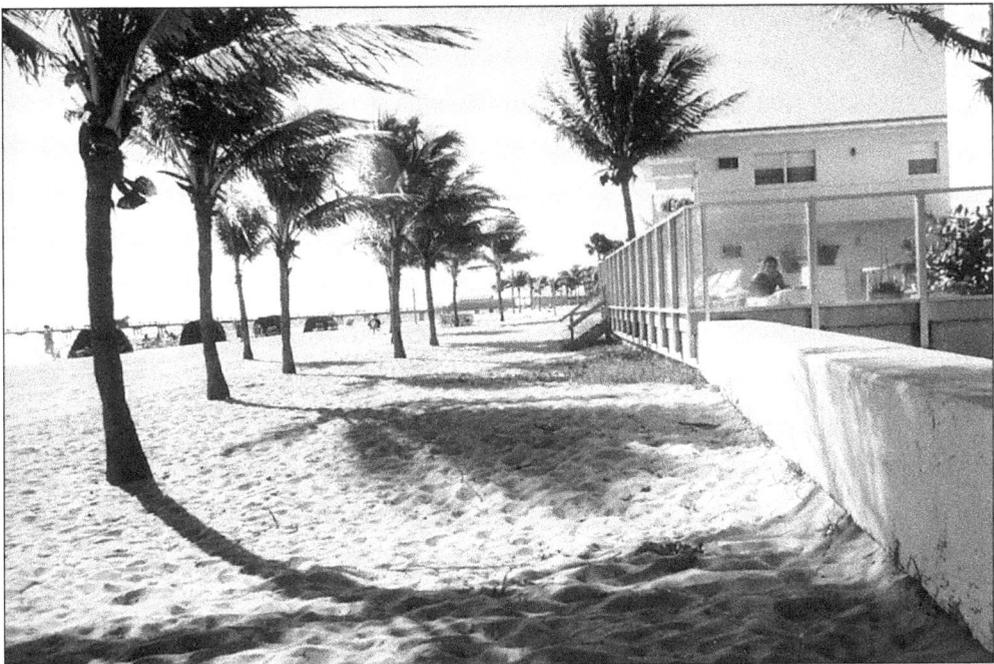

This is the appearance of the beach after millions of dollars of federal, state, and local money was used to pump sand from the ocean bottom. The sea wall of the Tides Inn Motel can be seen at the right looking south to the fishing pier. The addition of palm trees created a more attractive scene.

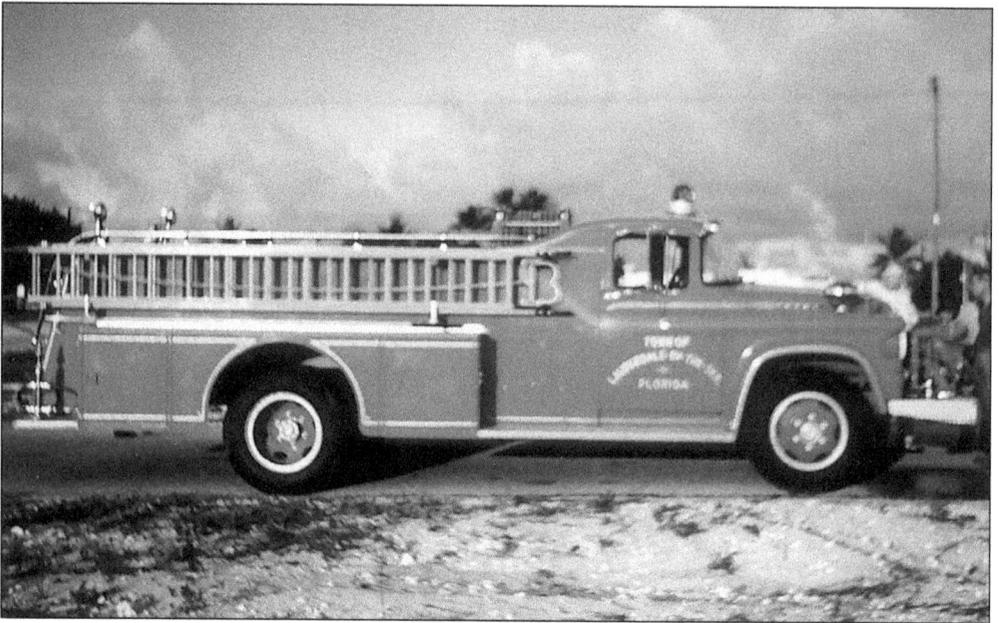

The volunteer fire department received its charter in 1961, and Ray Summers was its first chief. This new fire truck and related equipment cost $25,000. The town paid for it in cash, a transaction that exemplified Mayor Colnot's fiscal conservatism of not wanting to take on debt.

In 1961, Lauderdale-By-The-Sea made it illegal to display and gut fish in public, as well as to catch shark and barracuda. This young man (above) was arrested for displaying a shark. As a result, Mayor Colnot and commissioners became the butt of numerous jokes locally and nationally, but they refused to yield. Written on the shark are the words, "Displayed and Arrested."

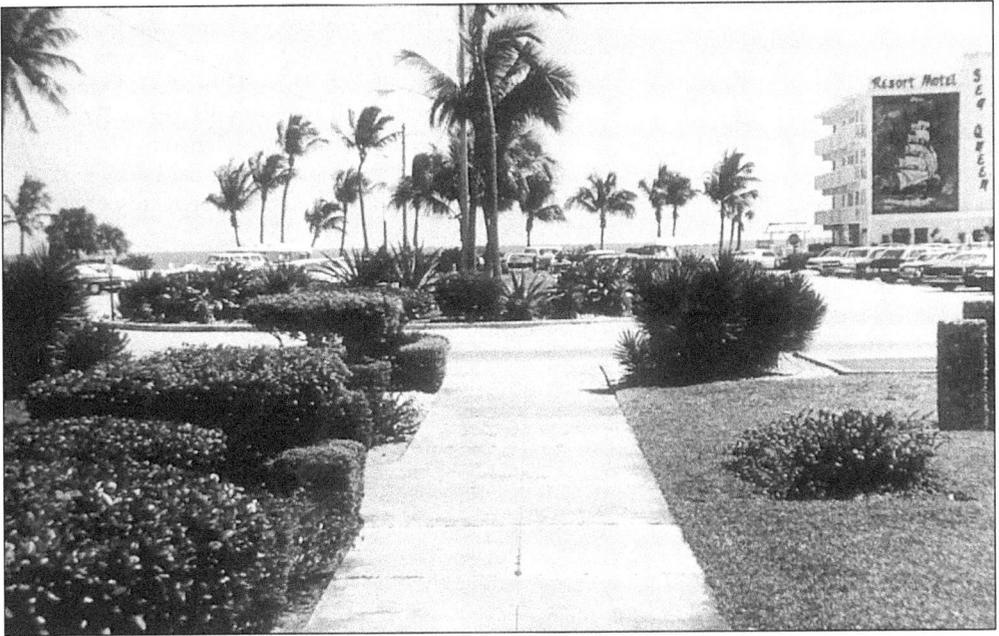

Looking east at El Prado, the beautifully landscaped parking area leads to the beach before parking meters were installed. At right, in the background, is the Sea Queen Resort Motel with a ship mosaic on its wall. The motel is part of the Villas-By-The-Sea group.

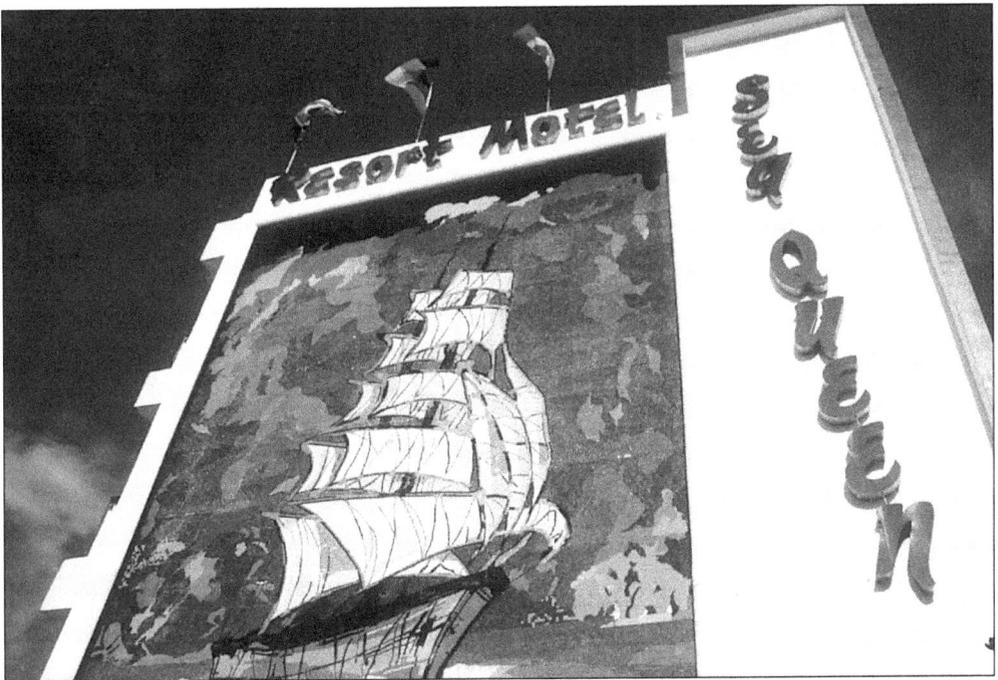

A closer view emphasizes the striking beauty of the ship that adorned the Sea Queen Resort Motel. It is located at the southeast corner of El Prado and El Mar. The mosaic has since been painted over.

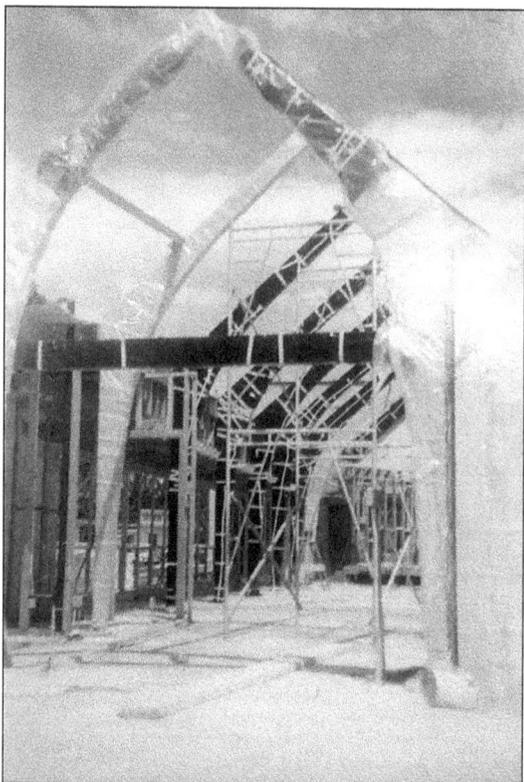

The Community Church was built in 1959 on a long triangular section of land (400 feet by 50 feet) between Poinciana Street and Bougainvilla Drive. Architect George Waddley designed the building so that it was basically three-sided. Builder William Weed constructed the church at a cost of $79,000.

This is the Community Church as it appeared immediately after it was completed. Glen and Lucy Friedt donated a Hammond organ and $100,000 to establish a trust fund, with the annual income to be used for church expenses.

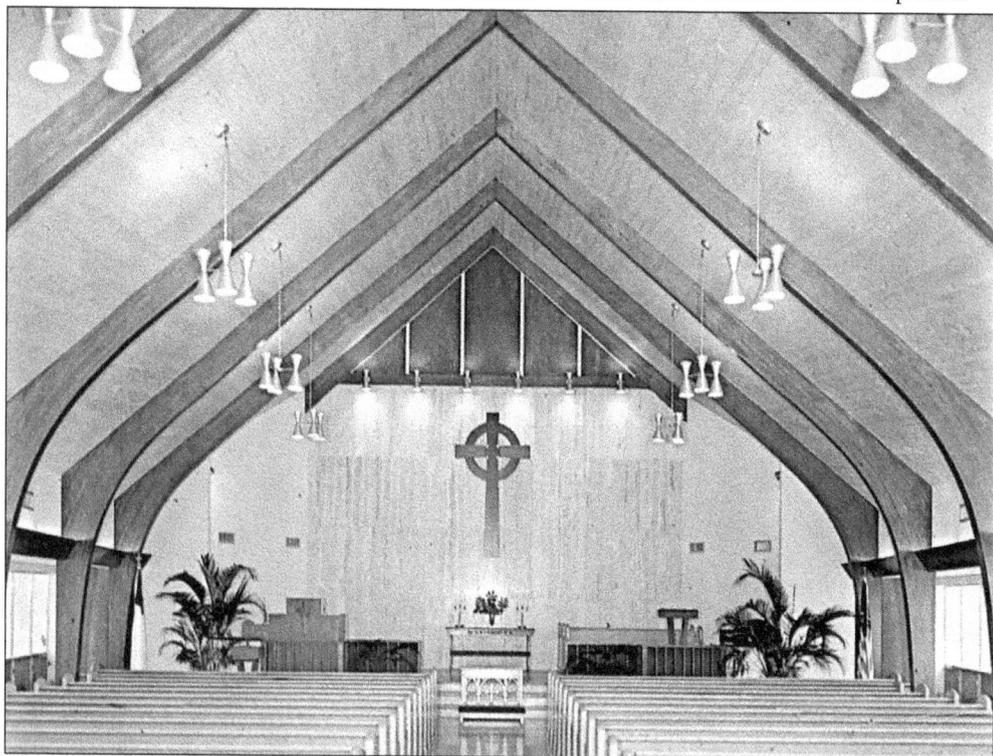

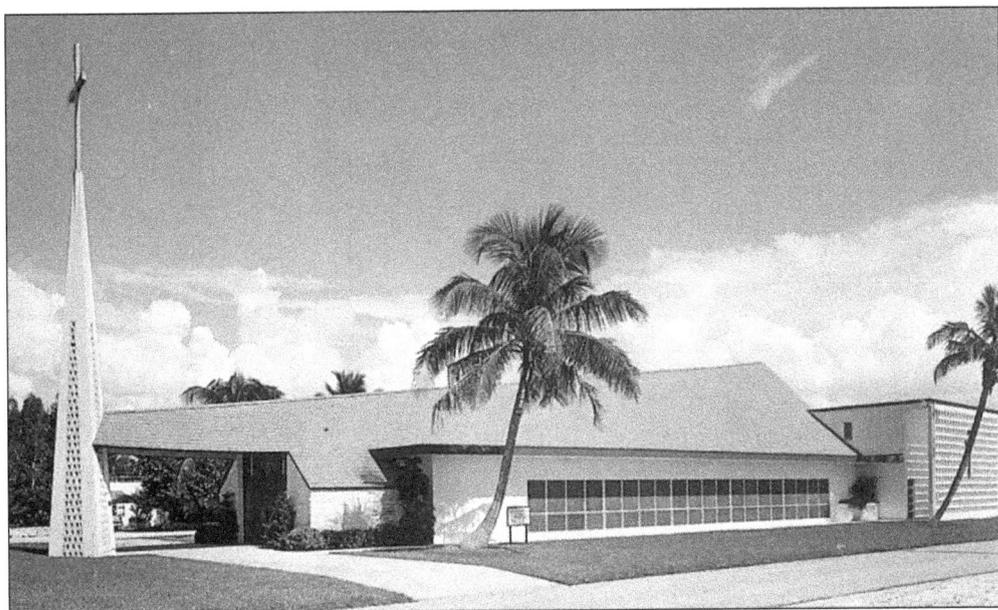

The Community Church of Lauderdale-By-The-Sea is seen upon completion in this postcard image from 1960. The Presbytery of Southern Florida was organized in 1954 and the first formal worship service was held on the second floor of the Swiss Inn Restaurant on Sunday, December 5, 1954. The Rev. Edward A. Finn conducted the service. A stainless steel cross topped the campanile at 50 feet at the new church.

The Rev. J. Curtis Hodgens, second from right, joins a group of congregants after a Sunday service in front of the Presbyterian Community Church in 1961. In the spirit of ecumenism, the church's altar cross was donated by Mrs. Robert D. King, a Catholic, and Henry Weiss, a Jew. In the early years services were held at the Swiss Inn Restaurant, which no longer exists.

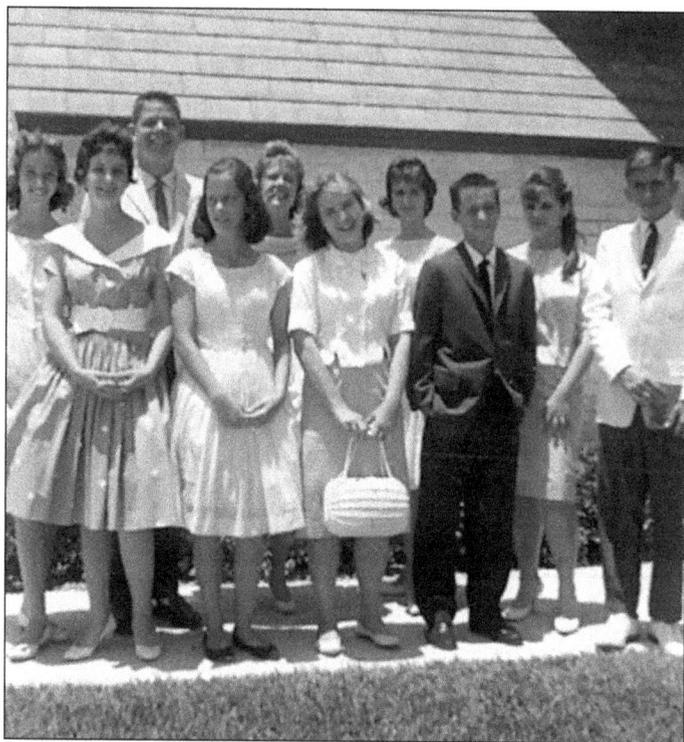

These 10 smiling communicants of the Community Church of Lauderdale-By-The-Sea (of the United Presbyterian Church of the U.S.A.) are preparing for an outing in 1961. The church has always organized spiritual and social youth activities.

The Rev. J. Curtis Hodgens delivers a sermon to a well-attended Sunday church service. Reverend Hodgens served as pastor from 1959 to 1969. The church has been a stabilizing institution within the community for five decades.

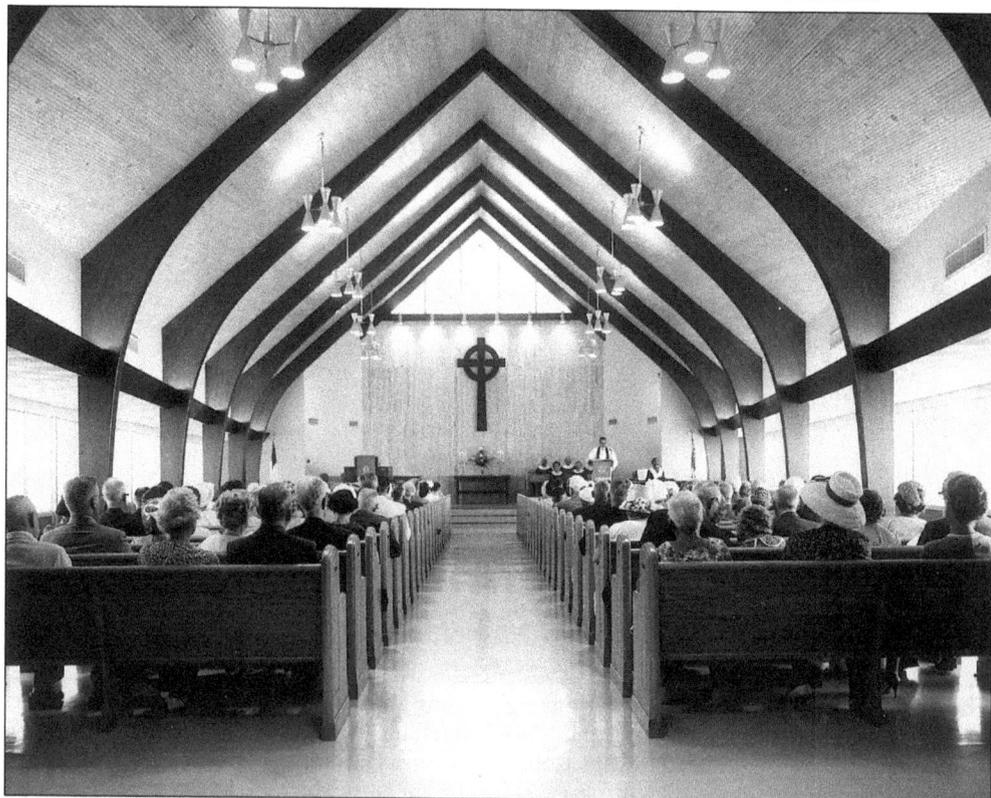

The Villa Serena Resort, left, announces its "private beach" at the northeast corner of El Mar Drive and El Prado in the early 1970s. The image is from a postcard. Notice that parking meters were not installed at the time.

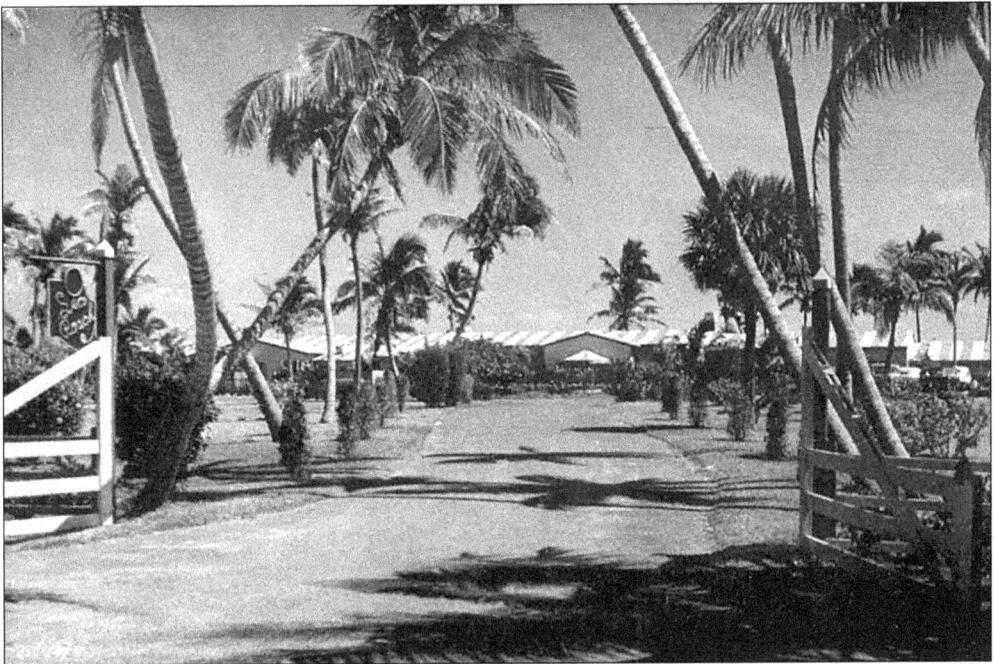

This 1950 postcard caption described the rustic entrance to the elegant Sea Ranch Hotel as being "on the Atlantic Sea Shore, Fort Lauderdale, Florida." The hotel no longer exists and has been replaced by the Sea Ranch Condominiums A, B, and C, now within the borders of Lauderdale-By-The-Sea.

Marie A. Tiffany, president of the Assumption Catholic Church Women's Guild (1969–1970), prepares to attend the breakfast installation of incoming president Lillian E. Gallagher on May 11, 1970, at the Sea Ranch Hotel. The old church, rear left, was torn down and replaced with the present church in 1994.

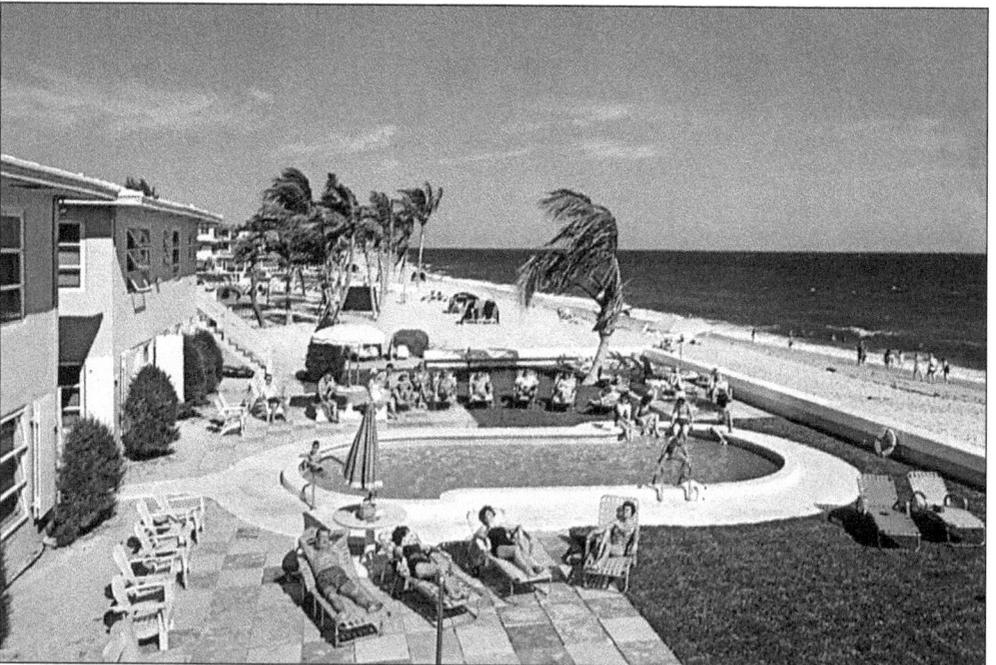

The Silver Sands Apartments, 4448 El Mar Drive, date back to the 1950s and are pictured here on a postcard. Karl and Sarah Fife owned the resort motel. Karl Fife later took over Al Walthers's real estate office and also served as town commissioner.

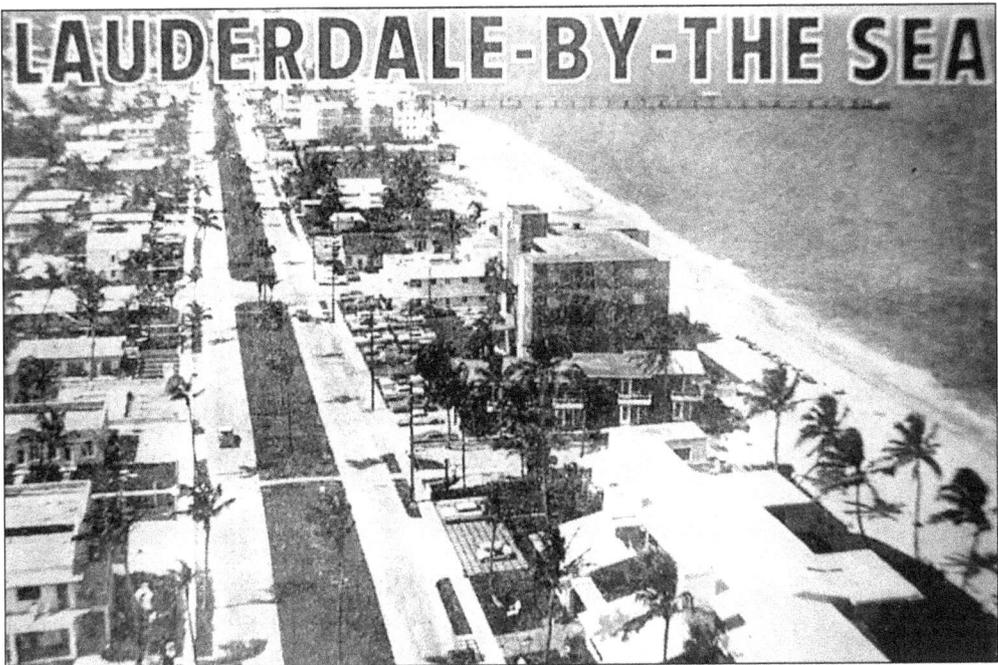

LAUDERDALE-BY-THE SEA

A 1964 aerial photograph shows the Anglin Fishing Pier jutting out to the Atlantic Ocean in the background. El Mar Drive runs north and south with the median in the center. The beach area was well established as a tourist mecca at this time. The tall building at the right is Lord's Apartments. The 1960 U.S. Census recorded 1,327 residents in Lauderdale-By-The-Sea.

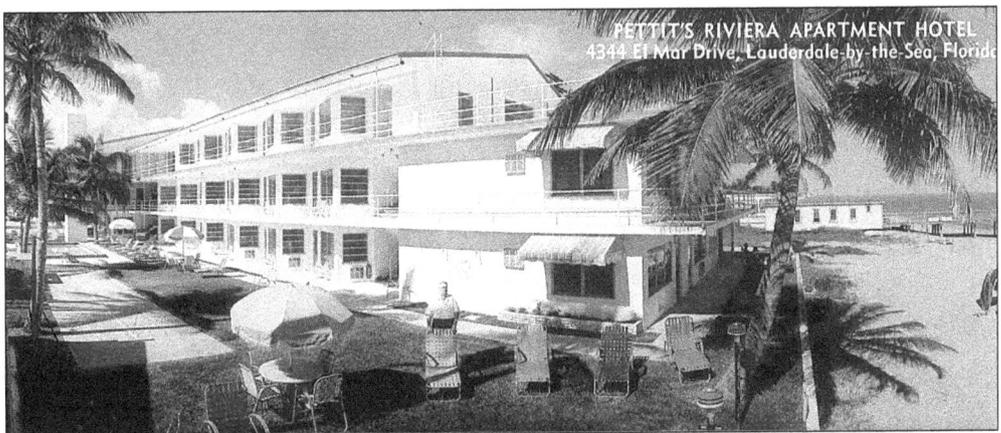

Pettit's Riviera Apartment Hotel was ideally located just south of Commercial Boulevard and on the beach close to the Anglin Fishing Pier, as it appeared in this 1960 postcard. Charles Pettit, standing at center, was a candy manufacturer from New York. The hotel is today known as the Pier Point.

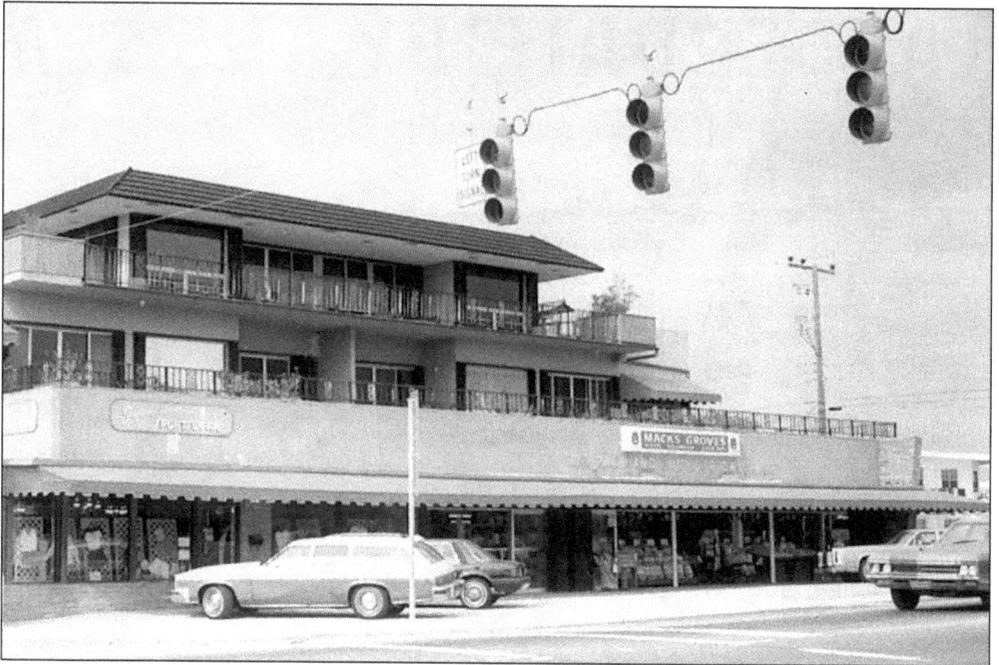

Mack's Groves, shown here as it appeared around 1980, has always been a popular gift shop where tourists could get a light lunch. At the time, Joanne's Sportswear was located to the left. Note the neatly designed apartments above the stores.

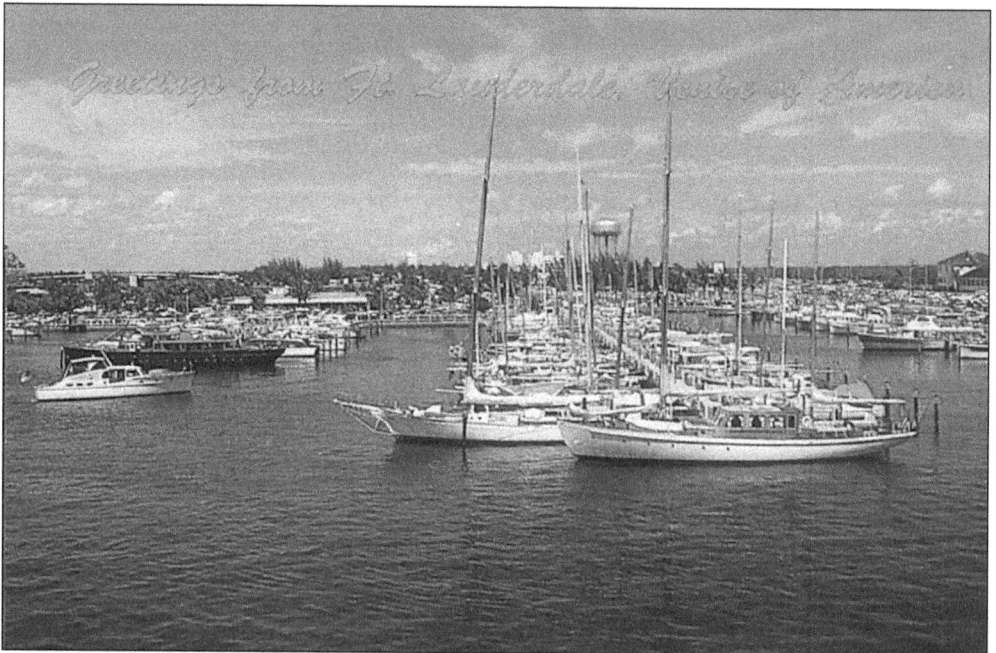

Nearby Fort Lauderdale received more notoriety than its tiny neighbor, Lauderdale-By-The-Sea. The above postcard featured Bahia Mar as the "World's Largest Yacht Basin" in the "Venice of America."

Don Shawver relocated his Village Pharmacy from the north side of Commercial Boulevard to the southeast corner of Sea Grape Drive and Commercial Boulevard in 1964. Much of the town's development had been located east of SR A1A before this time because the bridge had not yet been built.

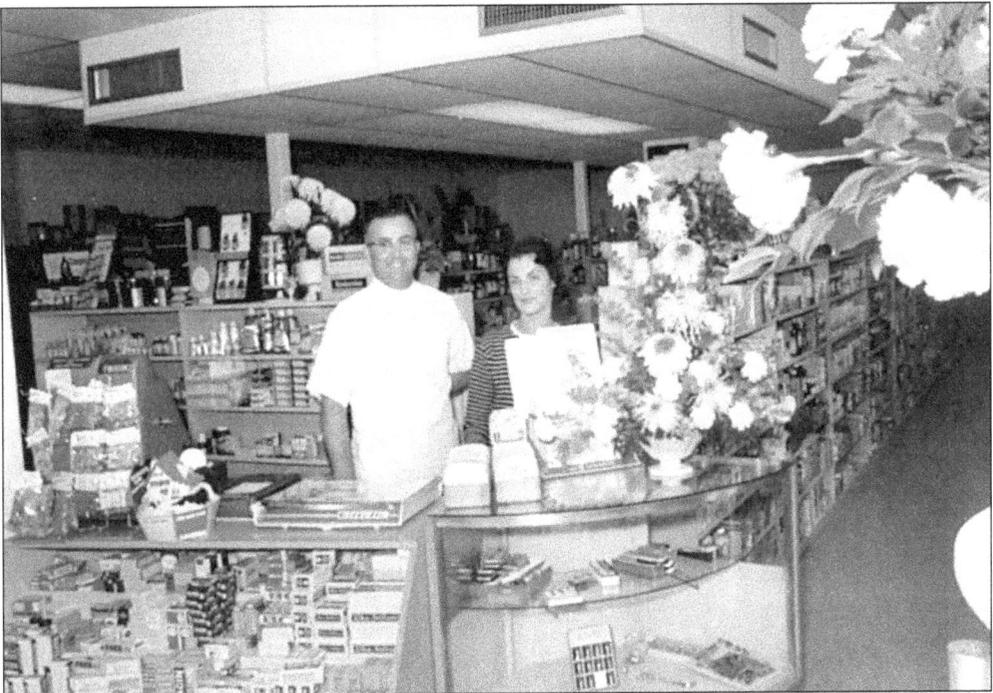

Don and Norma Shawver stand ready to serve in Don's Village Pharmacy. The Shawvers were longtime residents of Lauderdale-By-The-Sea. Today this complex is known as Commercial Plaza and the Kwik Pic Food Store has replaced the Village Pharmacy.

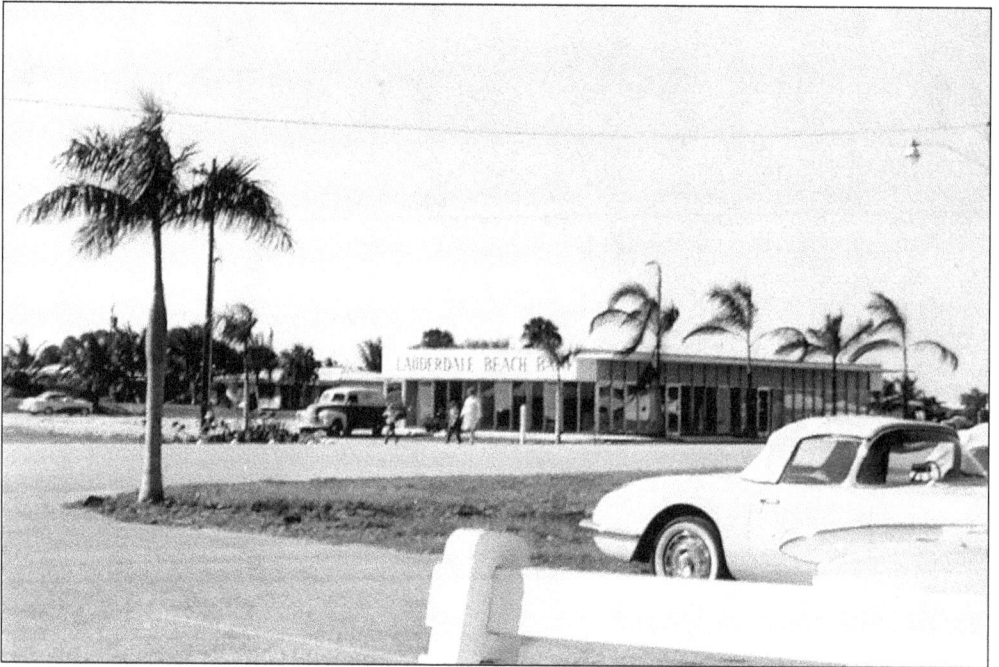

The Lauderdale Beach Bank was the first bank to arrive in town. It was established in 1961, as shown above, originally at the southwest corner of East Tradewinds and Commercial Boulevard. Renovation and expansion occurred later. Today it is the Sun Trust Bank.

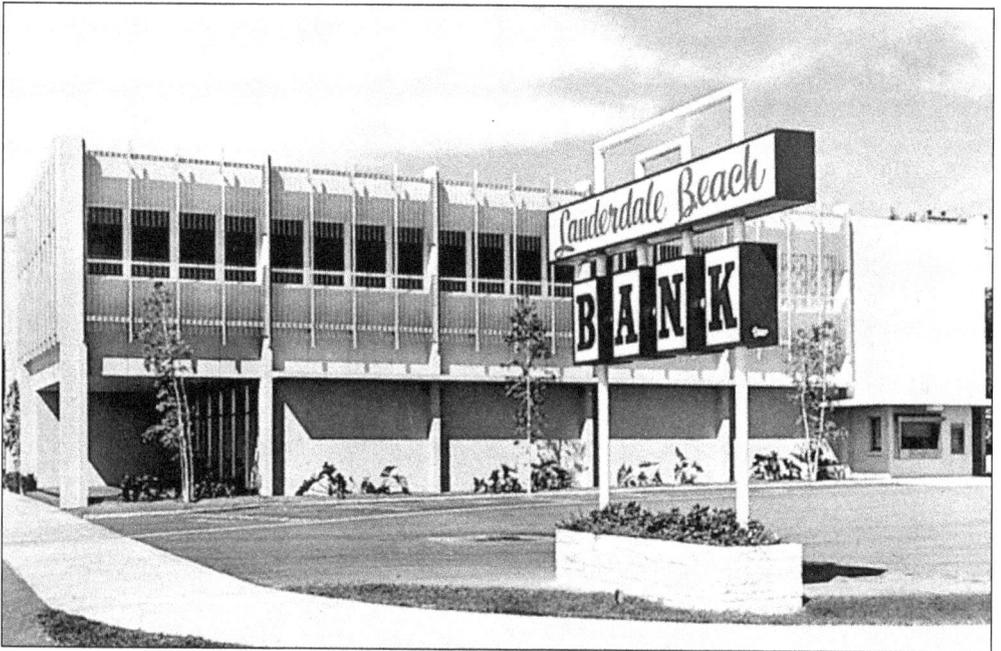

This postcard depicts the Lauderdale Beach Bank after it was enlarged. Its caption stated: "Serving the East Coast with complete banking services." It became the Sun Bank in 1976 and, after a merger in 1981, became the Sun Trust Bank. Some cosmetic changes were added soon thereafter.

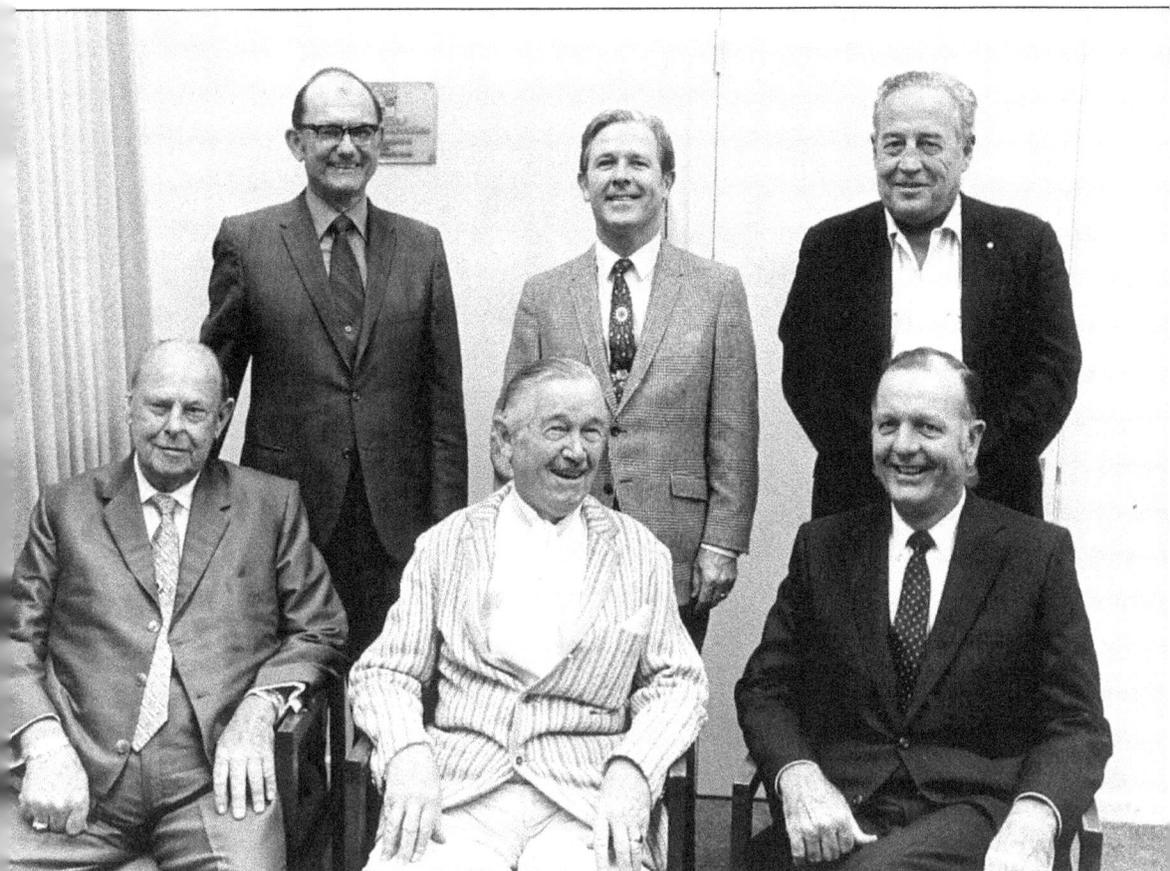

The board of directors of the Lauderdale Beach Bank in 1971, pictured from left to right, are the following: (front row) Stephen A. Calder (real estate broker and developer), George S. McFadden (real estate broker), and Dwight L. Rogers Jr. (chairman of the board); (back row) Charles C. Burton Jr. (president), John Morris Jr. (attorney), and Clay D. Dyal (president of Wilton Manors National Bank).

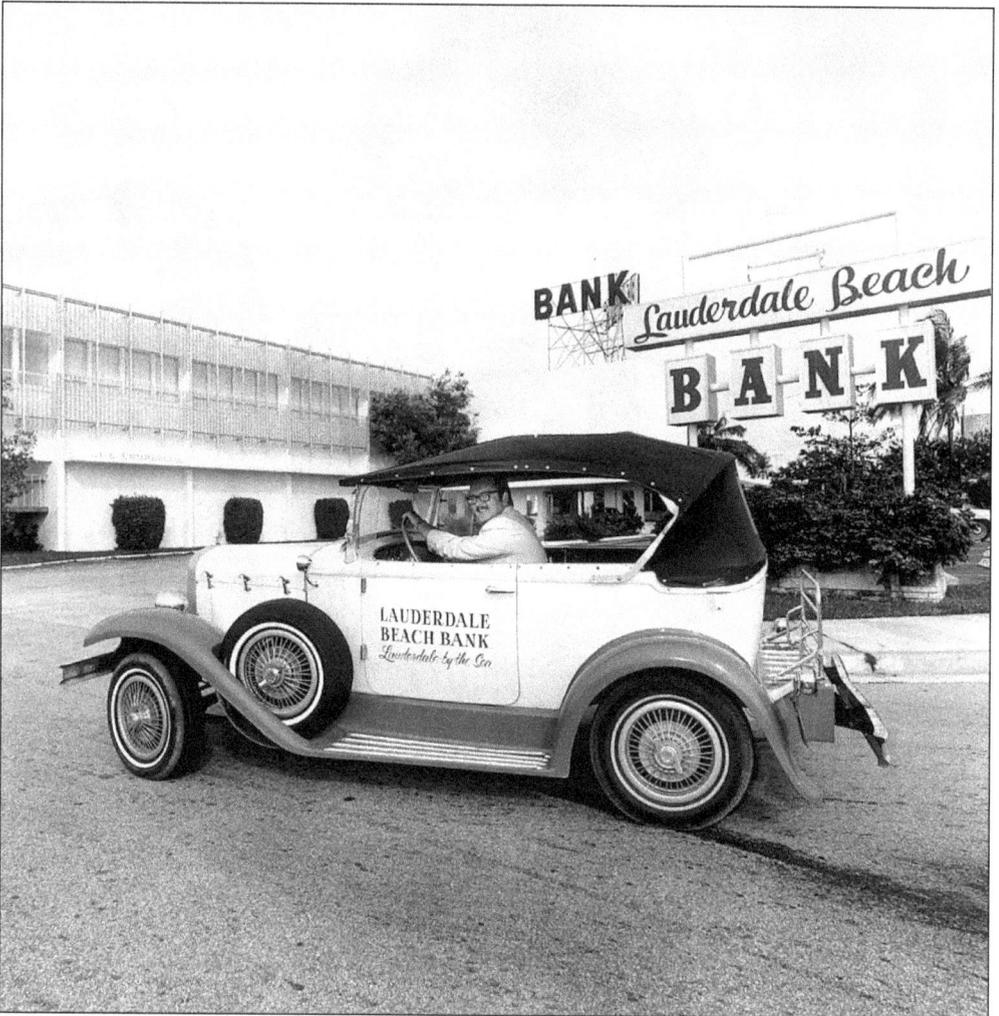

Marc Hodgeman, marketing director of the Lauderdale Beach Bank, drives a vintage automobile to celebrate the bank's tenth anniversary in 1971. The Sun Trust Bank occupies the site today at 221 Commercial Boulevard. The banking business expanded dramatically after the bridge opened in 1965.

The Commercial Boulevard Bridge nears completion at the beginning of 1965 in this view from the east side of the Intracoastal Waterway. The bridge opened Lauderdale-By-The-Sea to the west, increasing traffic and commerce. Along with the construction of the Anglin Fishing Pier in 1941, it had a great impact on the town.

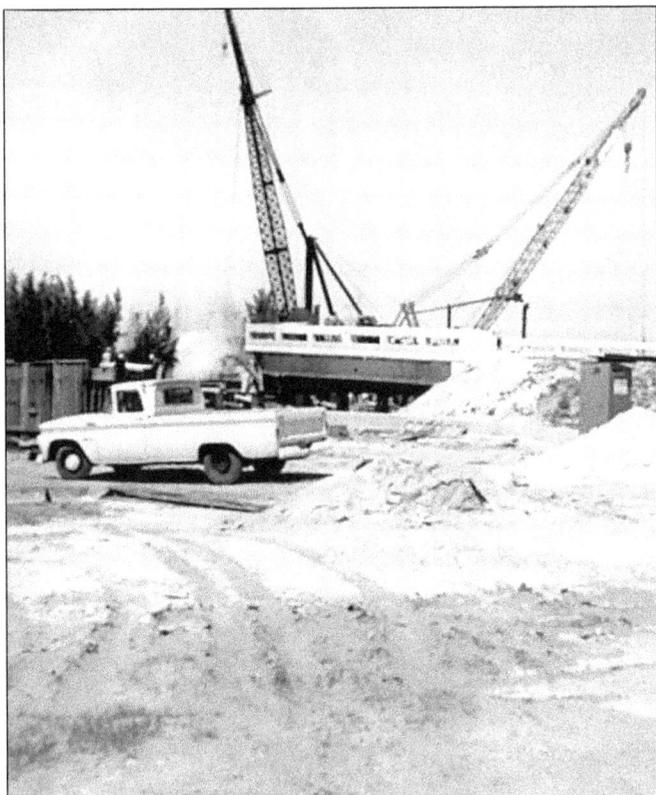

Robbie Shawver Jr. (left), son of Don and Norma Shawver, stands next to Forrest Rockett Jr., Lauderdale Beach Bank cashier, with a logo as they prepare to participate in the opening ceremonies of the Commercial Boulevard Bridge, October 1965. The event signaled a major transition in the town's history.

73

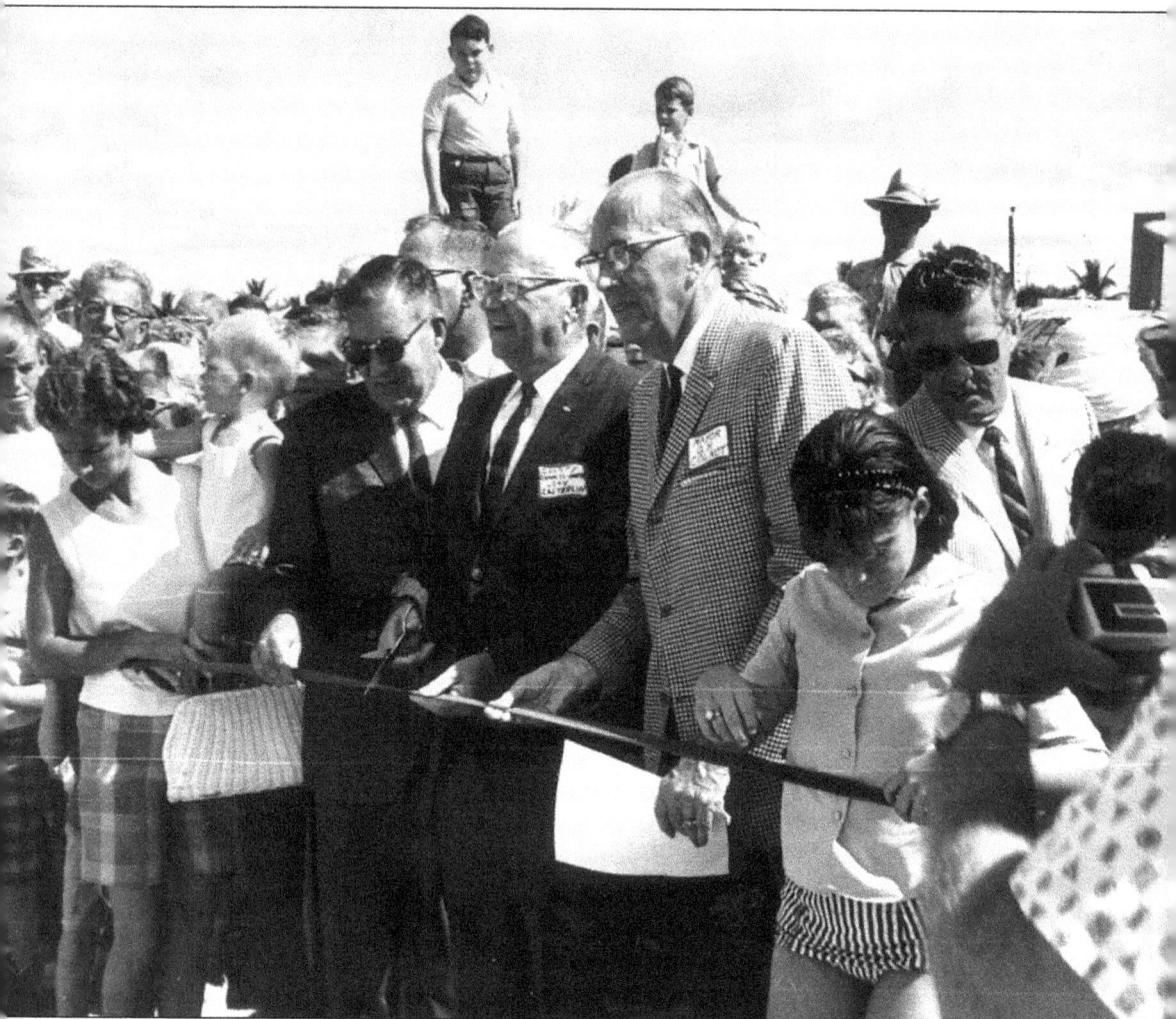

A huge crowd gathers for the ribbon-cutting ceremony of the opening of the Commercial Boulevard Bridge, October 16, 1965. Mayor Gilbert H. Colnot (in checked jacket) stands to the left of county commissioner John Esterlin, who is about to cut the ribbon. Though he opposed the construction of the bridge, Mayor Colnot was unable to stop progress.

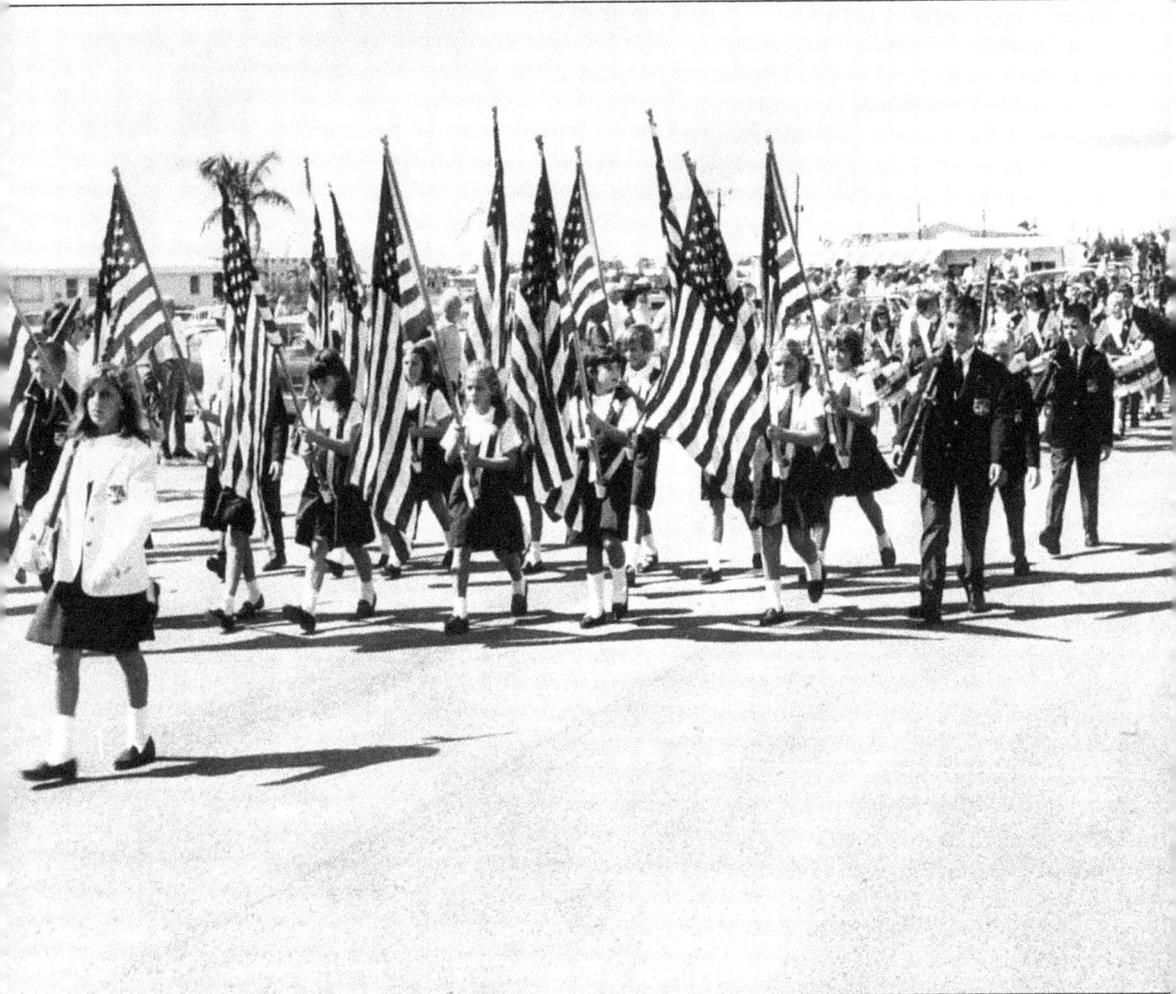

The Pine Crest School band put on a patriotic display during the opening ceremonies of the Commercial Boulevard Bridge. The bridge provided an east-west access to the beach from Federal Highway (U.S. 1) and points west. Other school bands and dignitaries participated in the parade as they crossed over the Intracoastal Waterway from the west.

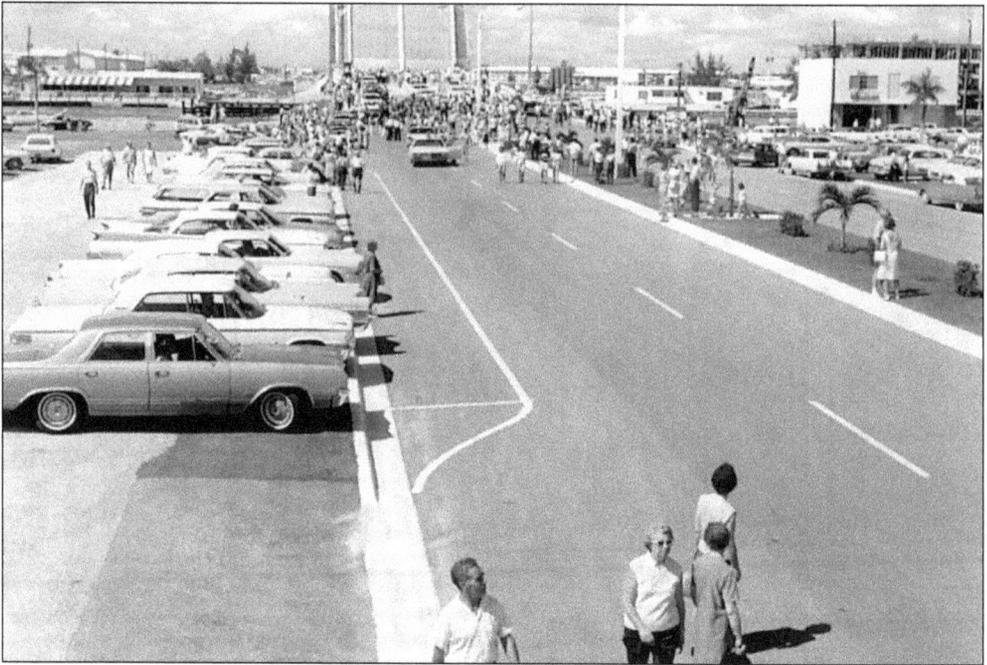

Town residents came out to view the inauguration of the bridge, October 16, 1965. Town organizations participated in the event, and an invitation-only lunch was held at the Wharf Restaurant for prominent leaders.

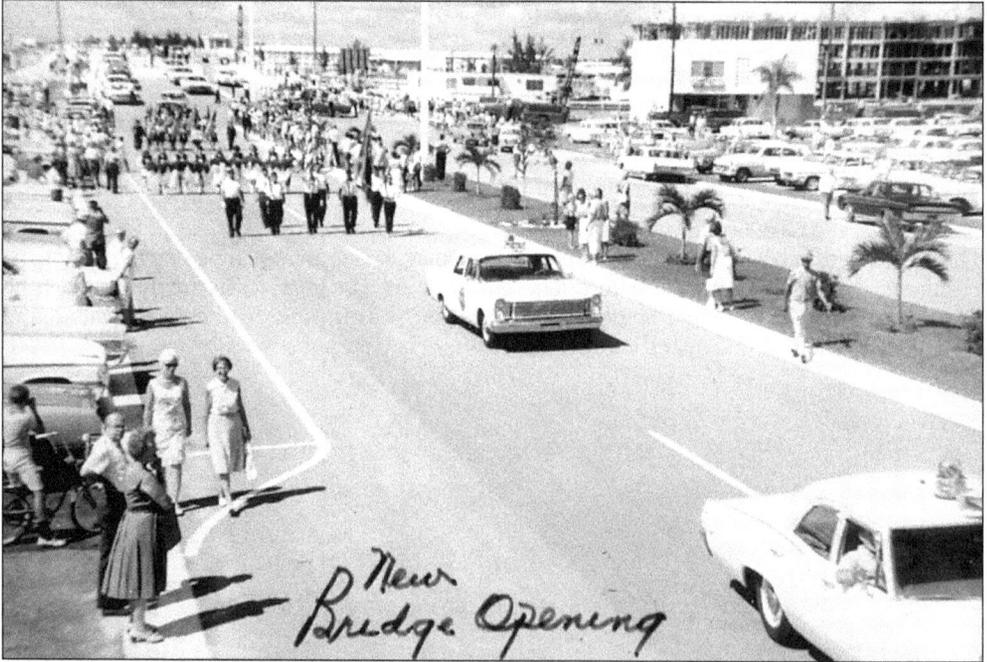

New Bridge Opening

Looking west to the Commercial Boulevard Bridge, the ceremonial parade lengthens eastward. Old-time residents speak of Lauderdale-By-The-Sea's history in terms of "pre-bridge" and "post-bridge." Traffic problems arose and the town then found a source of income through the issuance of increased traffic fines.

Lauderdale Beach Bank employees join the parade celebrating the opening of the bridge in 1965. The bank provided refreshments in its parking lot. Speeches were delivered, and children were given balloons and other presents.

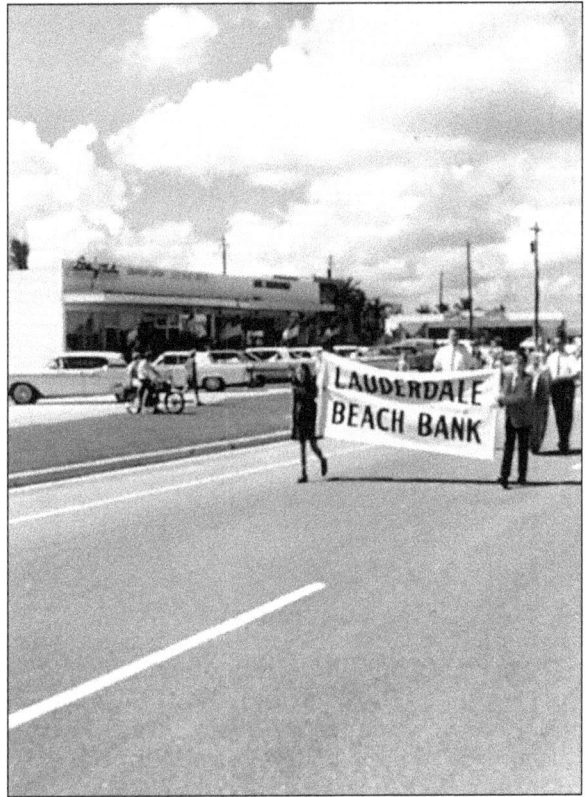

The Lauderdale-By-The-Sea police department consisted of five officers in 1966. At left is chief of police John Hovey. At the time, the department faced "impossible traffic problems" resulting from the opening of the bridge. Celebrity Johnny Carson received a ticket for speeding in town and joked about it to a national audience on the *Tonight Show*.

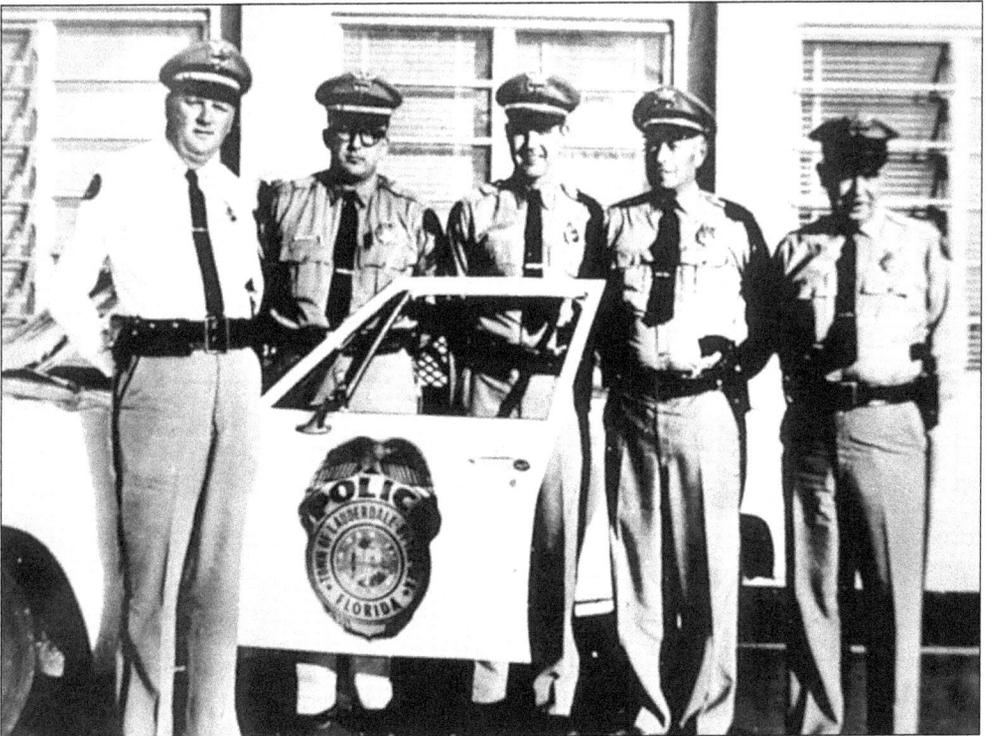

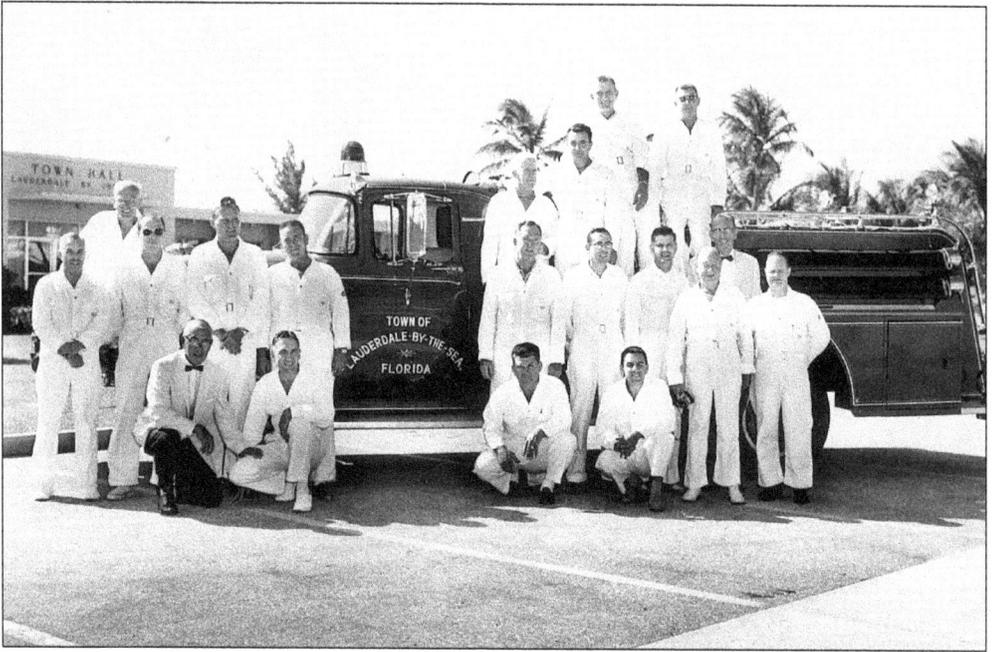

The volunteer fire department was organized in 1960, at which time a new pumper truck was purchased. This is the first group of volunteer firemen. The department has traditionally organized and conducted the town's annual Fourth of July celebration. Kneeling at left is commissioner William B. Parsons; kneeling third from left is Ray Summers (later fire chief and commissioner). Mayor Colnot is at the right wearing a bow tie.

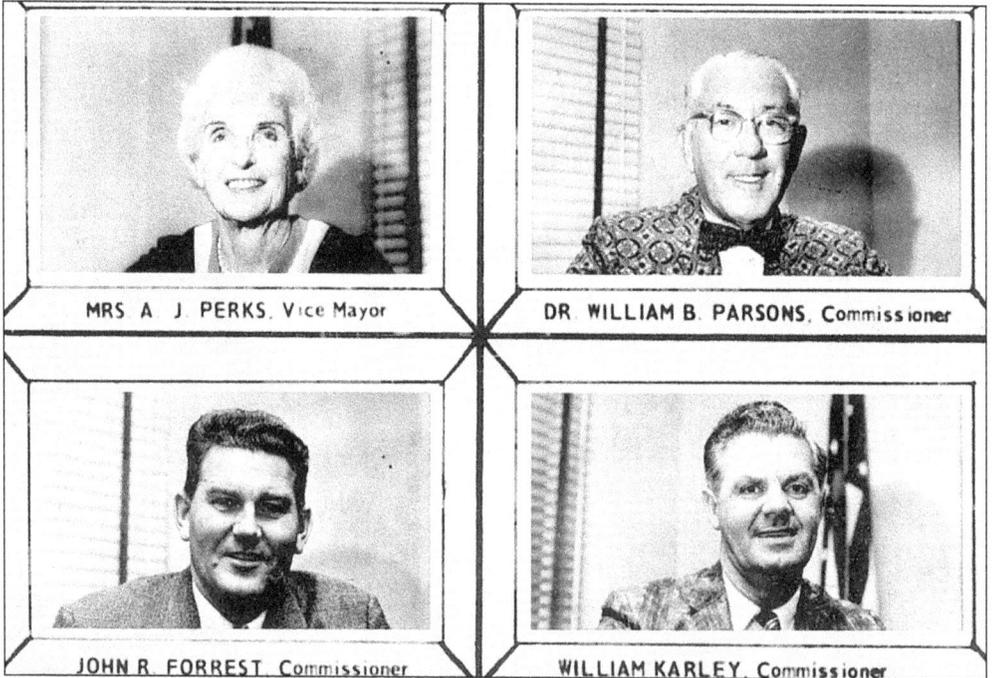

MRS. A. J. PERKS, Vice Mayor

DR. WILLIAM B. PARSONS, Commissioner

JOHN R. FORREST, Commissioner

WILLIAM KARLEY, Commissioner

Four of the five town commissioners in 1966 are, from left to right, (front row) John B. Forrest and William Karley; and (back row) vice mayor A.J. Perks and William B. Parsons.

78

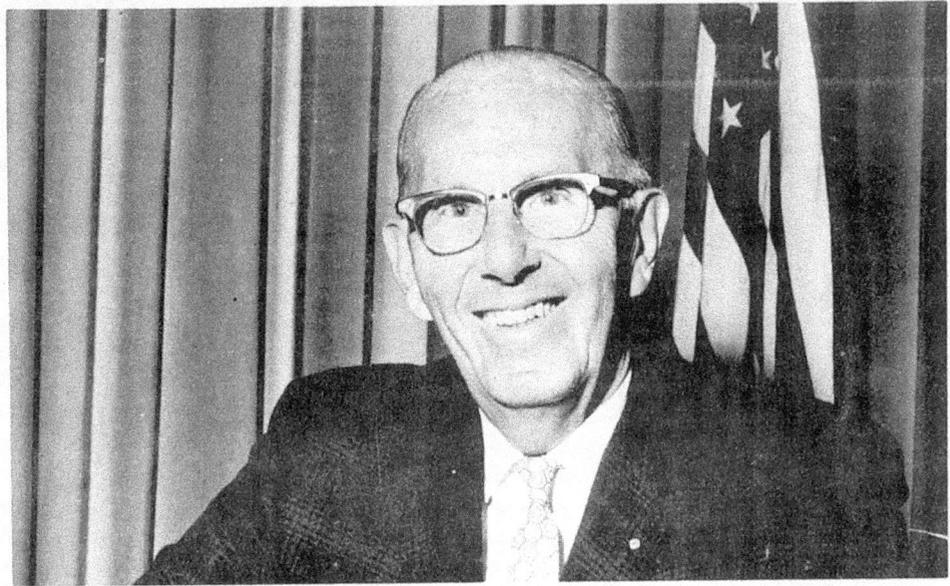

G. H. COLNOT, Mayor

MRS. "WALLY" PENDLEBURY, Town Clerk

MRS. "DEE" SCHNEIDER, Deputy Clerk

A dedicated Gilbert H. Colnot served as mayor from 1958 to 1978, a period of rapid growth. He was a fiscal conservative who closely monitored taxes and spending and sought to maintain a small-town atmosphere for the community. His general success was achieved with the help of two capable administrators, Mrs. Wally Pendlebury, town clerk, and Mrs. Dee Schneider, deputy clerk.

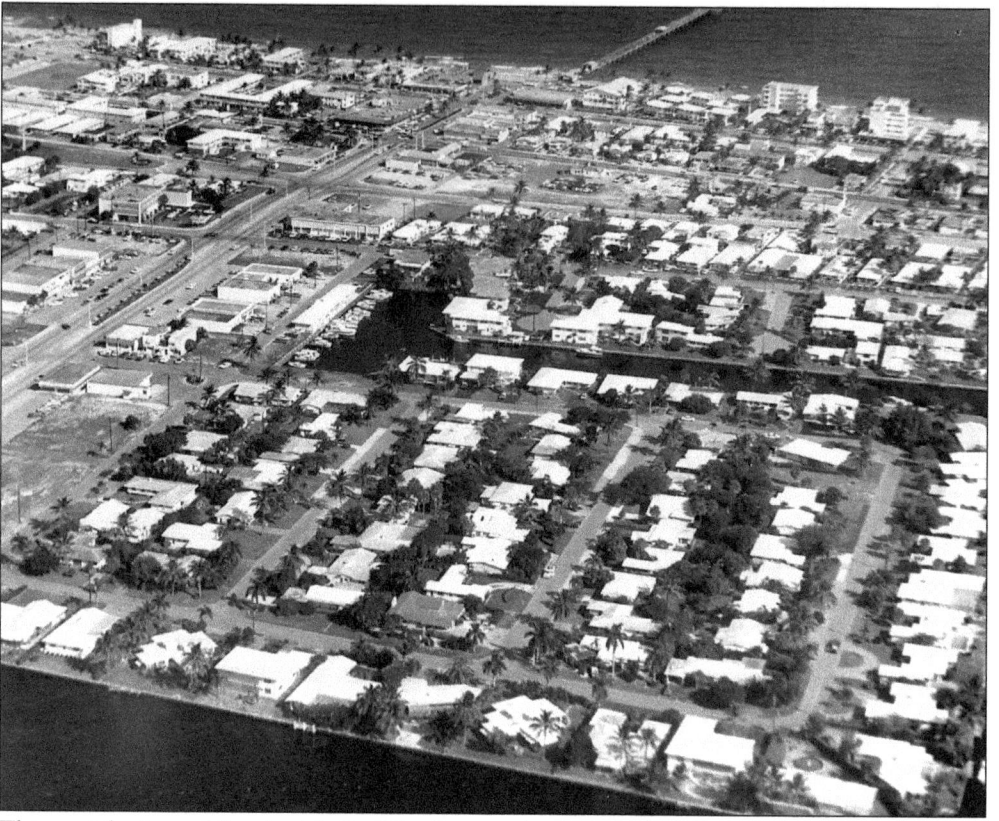

This aerial view of Lauderdale-By-The-Sea in the 1980s depicts a compact town. While South Florida cities were constructing high-rise buildings, Lauderdale-By-The-Sea retained its small- town character by limiting growth. The pier can be seen in the background leading to Commercial Boulevard. At center, the Silver Shores Center, with boats docked, leads to Silver Shores Waterway and eventually to the Intracoastal Waterway at bottom.

Four

HISTORICAL MARKERS
AND MORE

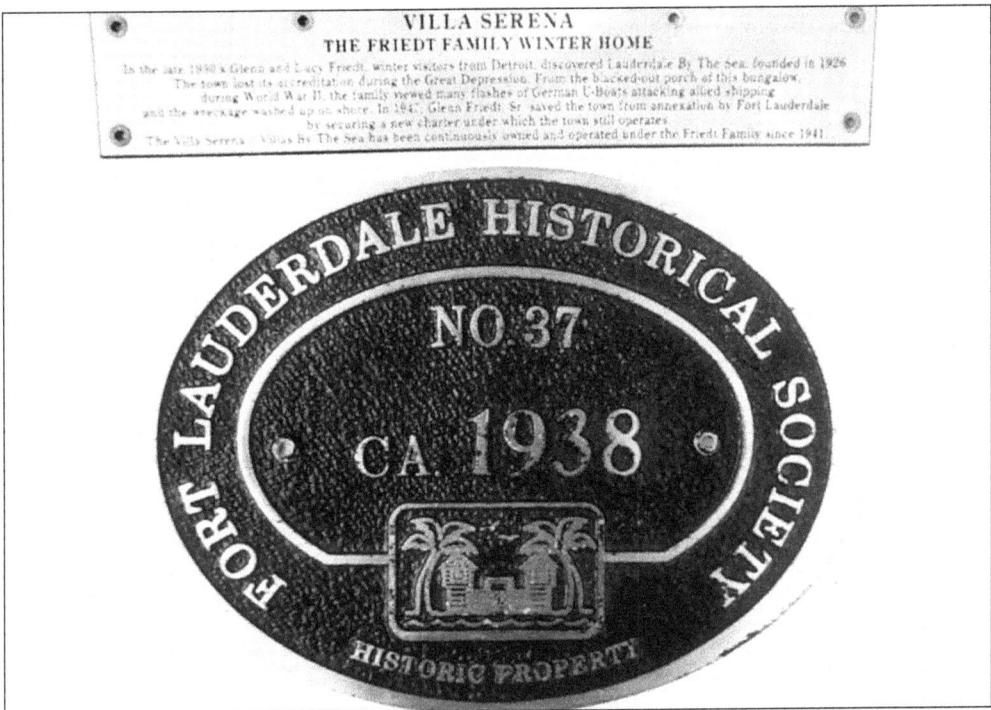

The Fort Lauderdale Historical Society designated the original Friedt house as a "historic property." It served as a winter home in the late 1930s when Glen and Lucy Friedt wintered in Lauderdale-By-The-Sea. The Villa Serena apartments have been run by the Friedt family since 1941. Glen Friedt Sr. died in 1991 at the age of 97, and Lucy died in 1996. They had two children, Glen Jr. and Ted.

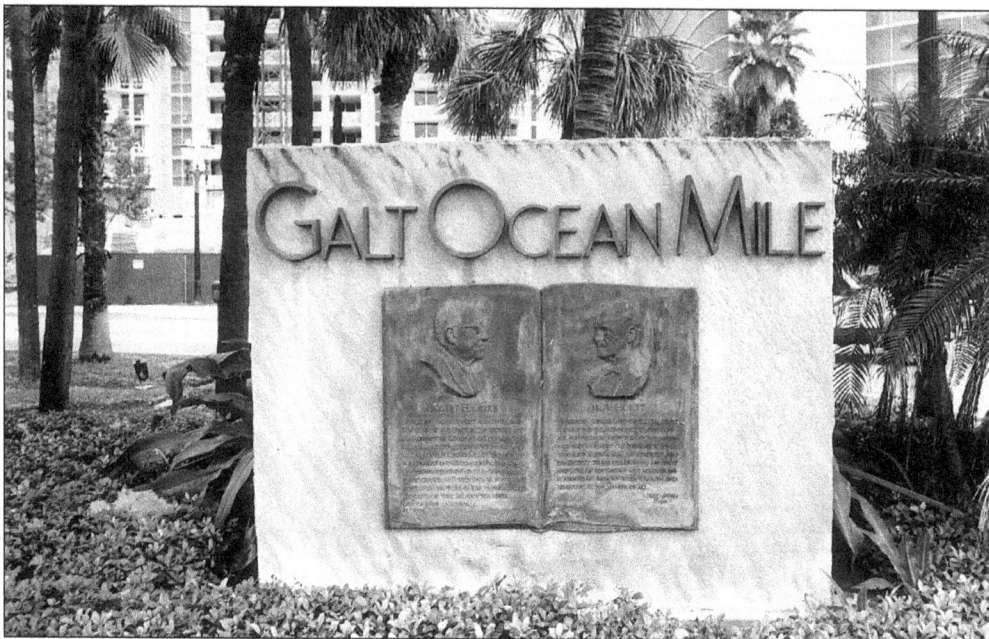

The Robert H. Gore Sr. and M.A. Hortt Monument is located at Northeast 41st Street, State Road A1A, Galt Ocean Mile. Gore was an industrialist, statesman, and philanthropist. M.A. Hortt was a land developer and public servant.

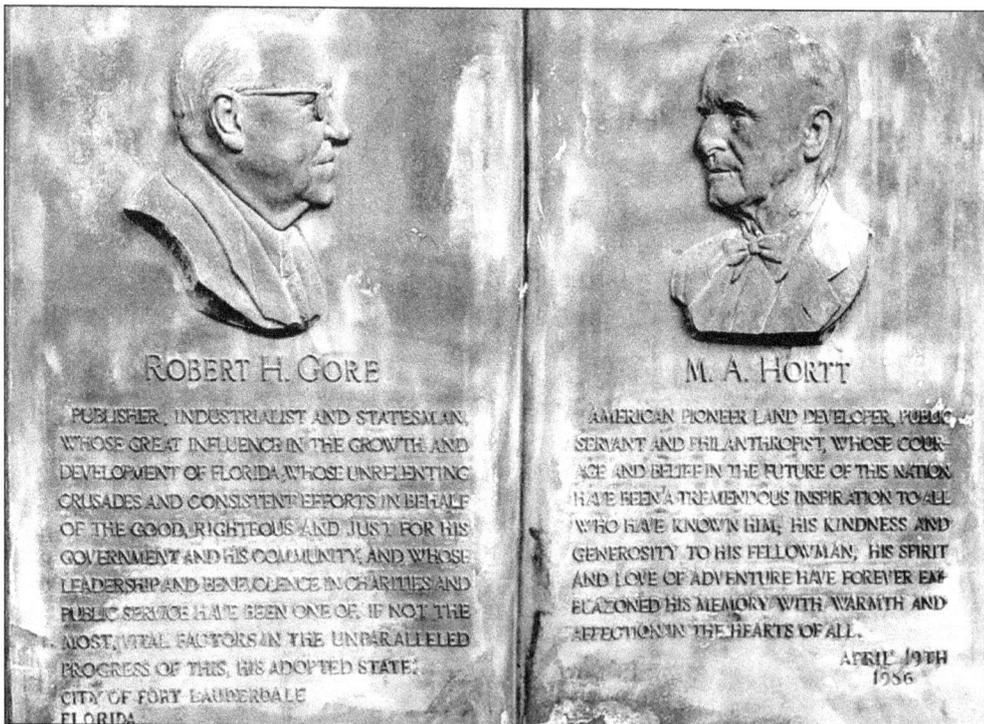

The Gore/Hortt historical marker was dedicated on April 19, 1956, at the Galt Ocean Mile, just south of Lauderdale-By-The-Sea. They were honored for their contributions to the growth and development of the South Florida region.

A composite view taken from SR A1A (Ocean Drive) captures the beautifully landscaped El Prado, with the beach in the distance. In the center foreground is the monument honoring the town's founder and first mayor Melvin I. Anglin (1872–1949). Parking meters are evident as part of the town landscape.

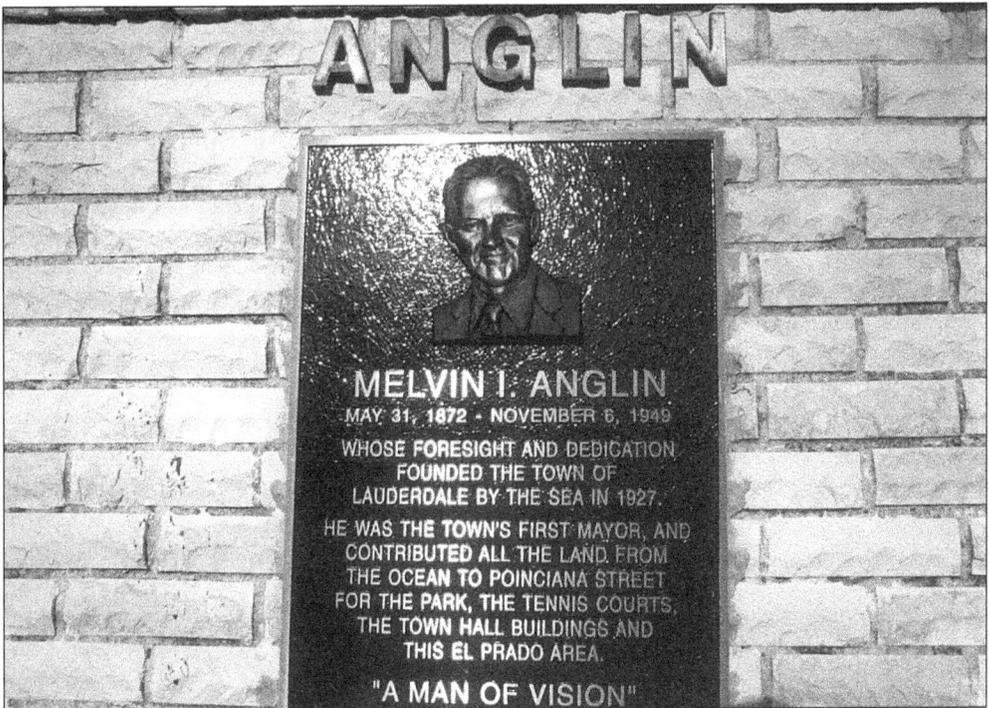

This close-up image of the Melvin I. Anglin monument designates Mr. Anglin as "A Man Of Vision" for his many contributions. In addition to his public service, he donated all the land from the ocean to Poinciana Street, which included the park, tennis courts, town hall, and El Prado area.

IN MEMORY OF
MELVIN AND SARAH ANGLIN,
PIONEER DEVELOPERS OF
LAUDERDALE-BY-THE-SEA,
THE TOWN COMMISSION, ON
MARCH 3, 1998, NAMED THIS AREA:
MELVIN ANGLIN
COURTYARD
MR. & MRS. ANGLIN FOUNDED THE
TOWN IN 1924, AND DONATED
THE STREETS AND THE LAND
FOR THE TOWN HALL
BUILDINGS AND FRIEDT PARK.
THE COMMISSION EXPRESSES ITS
APPRECIATION FOR MARGARET
ANGLIN DEMKO'S GENEROUS
CONTRIBUTION TOWARD THE
BEAUTIFICATION OF THIS COURTYARD
THOMAS D. McKANE III, MAYOR
OLIVER PARKER, VICE MAYOR
COMMISSIONERS
JAMES POLLOCK
ERNEST FONTAINE
JOHN YANNI

Another historical marker at the Melvin I. and Sarah Anglin courtyard was dedicated March 3, 1998, by the town commission, which expressed its gratitude to Margaret Anglin Demko for contributing to the courtyard's beautification. This marker is located north of the Community Church.

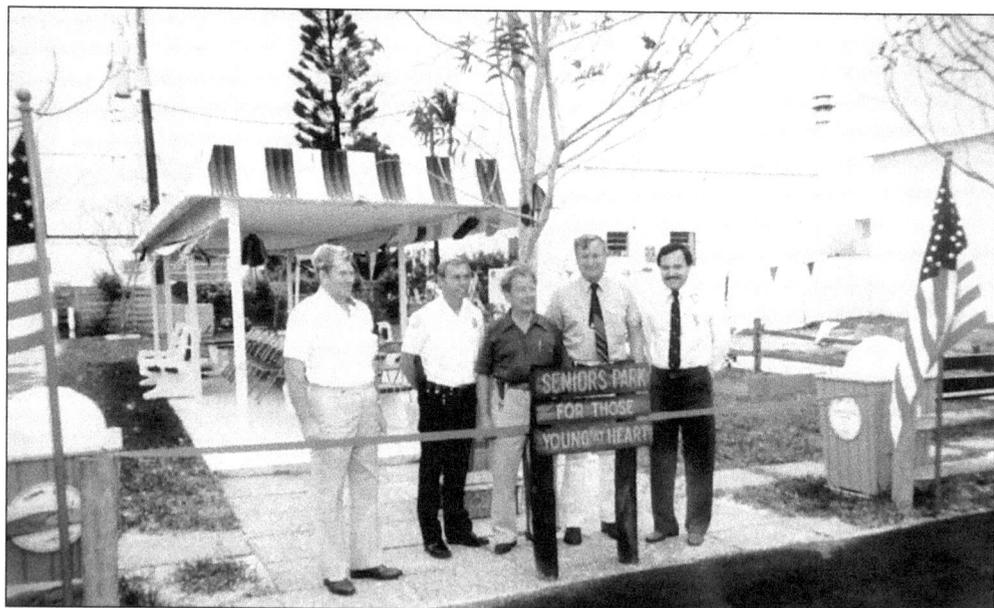

The town responded to senior citizens' needs by building a park that offered a place to relax and play bocci, shuffleboard, and chess. The ribbon-cutting ceremony took place in 1983. From left to right are mayor Jack Forrest, police chief Joe Fitzgerald, and commission members Michael Spicola, Wally Kilday, and Tom McKane. The park, which is on Bougainvilla Drive by the firehouse, was named for Michael Spicola, who died two years later.

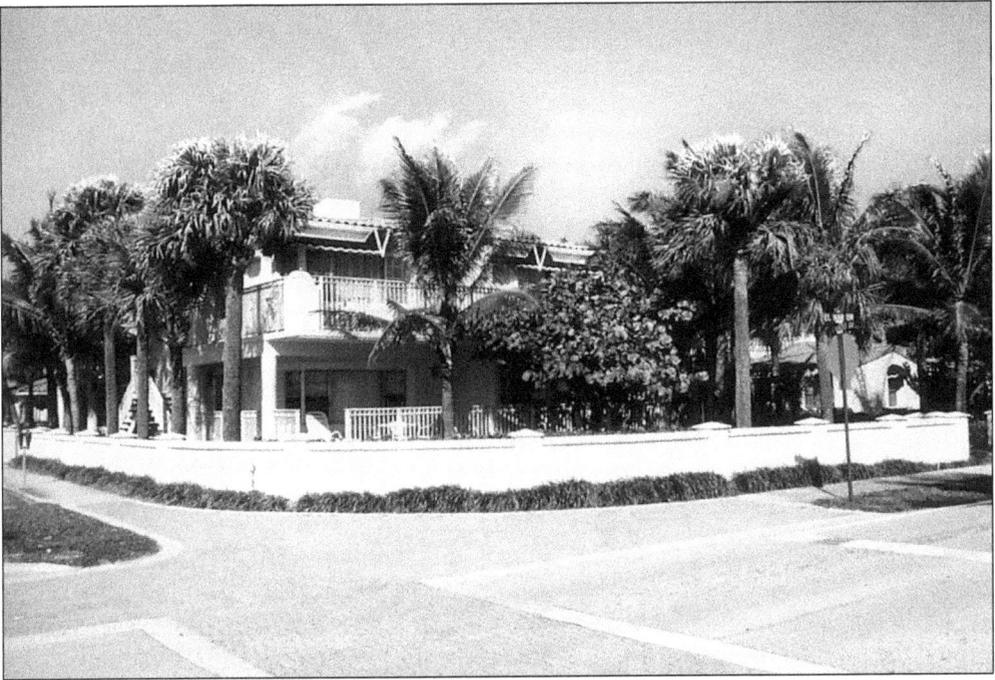

Glen and Lucy Friedt made their mark on Lauderdale-By-The-Sea by believing in real estate and the town's future. For more than half a century, they developed the Villa Serena guesthouse at El Mar and El Prado, which is seen today in prime condition.

This image is taken from a 1961 Assumption Catholic Church Bulletin when Rev. Patrick D. O'Brien was pastor. The rectory is to the left. The old parish church/auditorium was razed to make room for the new church in 1994.

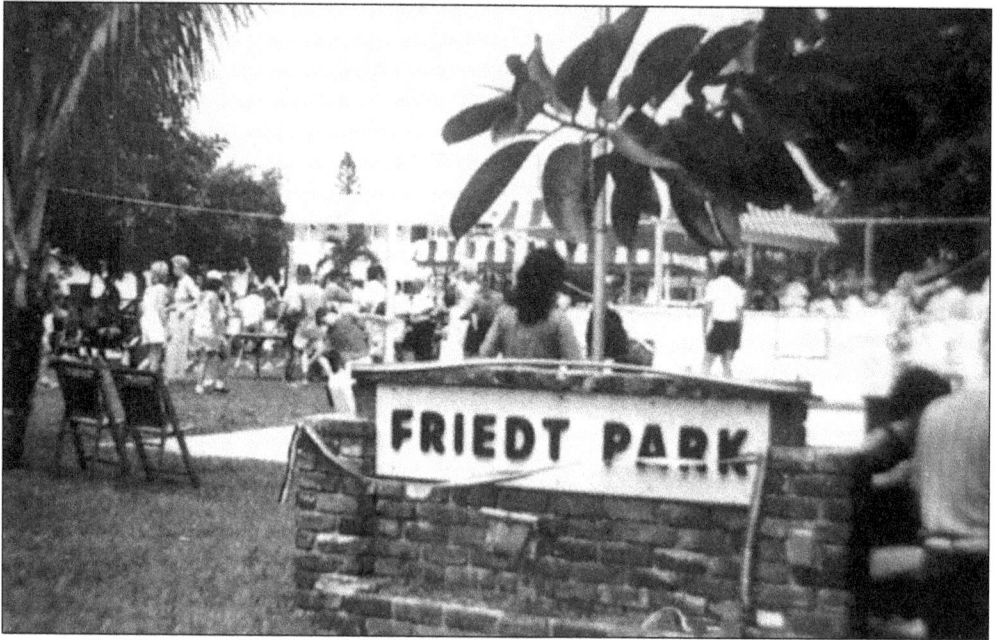

Behind the town hall is Friedt Park, a favorite gathering place for residents. It has served as a traditional site for celebrations and recreational activities. This scene depicts the 1989 Fourth of July festivities organized by the volunteer fire department.

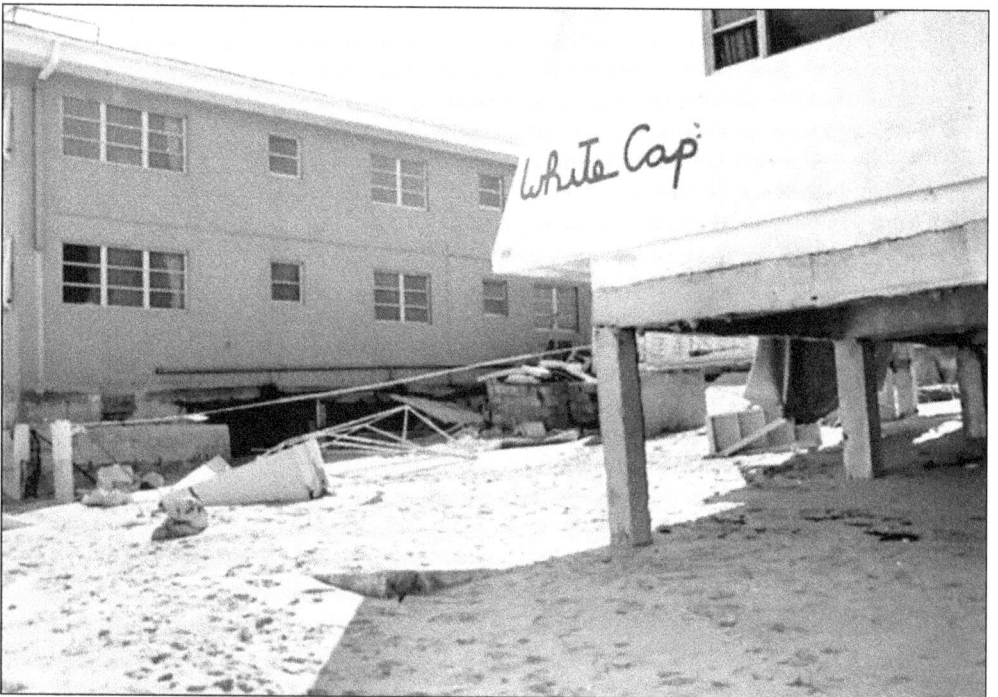

The White Cap Motel on 4608 El Mar Drive, directly on the ocean, was hit hard in 1970 as a result of a tropical storm. The high tides and winds eroded much of the sand, exposing and weakening support columns.

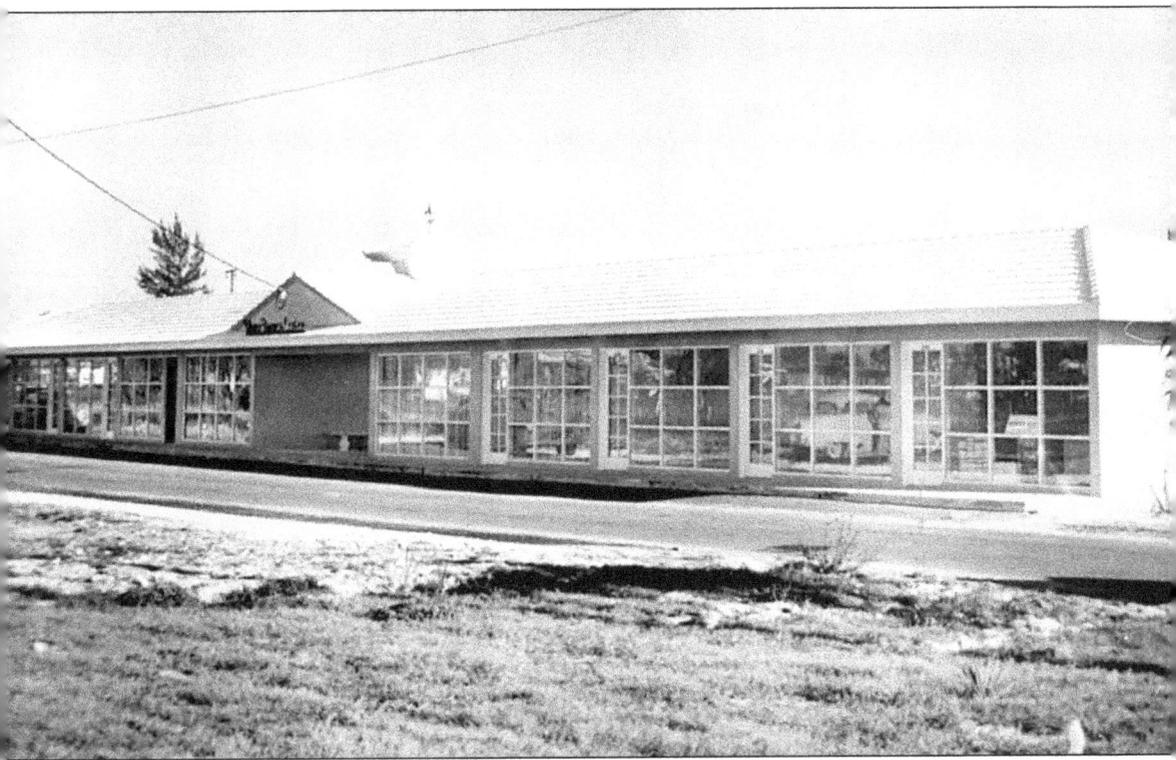

The Silver Shores Center (above) was built on Basin Drive, south of Commercial Boulevard, in 1953. It was an area that lacked development at the time. Five decades later, the building remains amid much economic growth. In the rear is the Silver Shores Waterway with a dock that connects to the Intracoastal Waterway. The first tenants of the basin Drive Waterfront Building were Carl A. Peterson (architect), Forrest K. Mutchler (real estate broker), a bait and tackle shop owned by John Willis Howard, and Doris May Wisler's A1A Alterations.

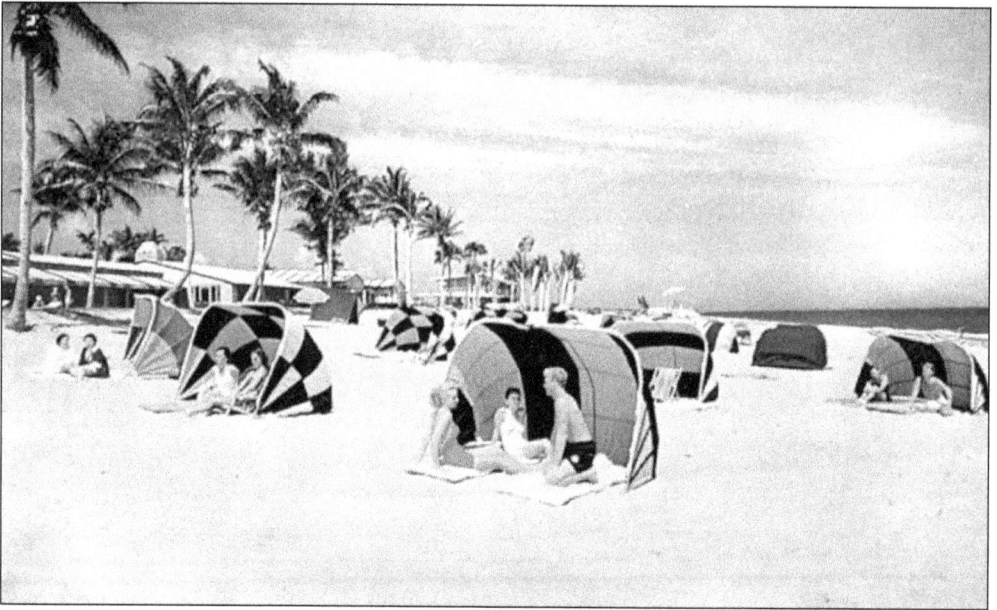

Guests of the Sea Ranch Hotel in 1950 enjoy the 1,000-foot beach on the tropical Atlantic shore, north of Lauderdale-By-The-Sea at Pine Avenue and SR A1A (Ocean Drive). In the early years the hotel was open for the winter season, but in 1959 it was open year-round until it closed in 1978. At that time, it was no longer a very profitable operation for owner Robert H. Gore Sr.

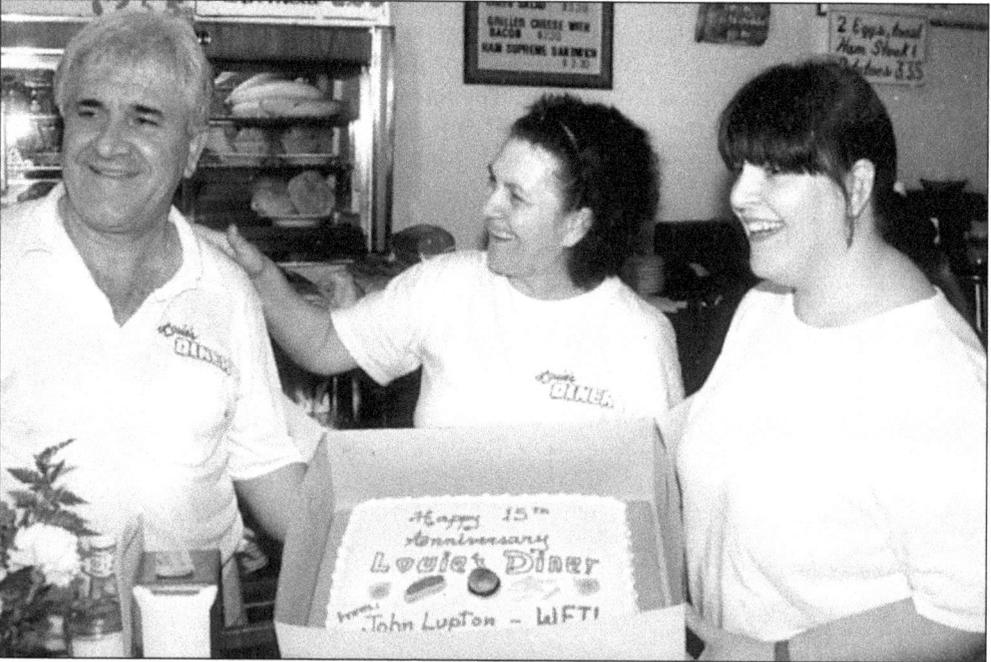

Louie Sabatini is congratulated by his wife Ollie (center) and daughter Julie for the 15th anniversary of Louie's Diner in 1990. This authentic restaurant, reminiscent of an earlier period, is a favorite gathering place for the famous, as well as the not-so-famous, who discuss town information and occasional gossip.

Louie's Diner has been serving breakfast and lunch from 6:00 a.m. to 3:00 p.m., seven days a week, since 1975. Not satisfied with the restaurant he owned at the intersection of Oakland Boulevard and Federal Highway, he sold it and moved to this small storefront at 215 Commercial Boulevard. Louie can be seen in this photograph at his usual spot—cooking at the grill.

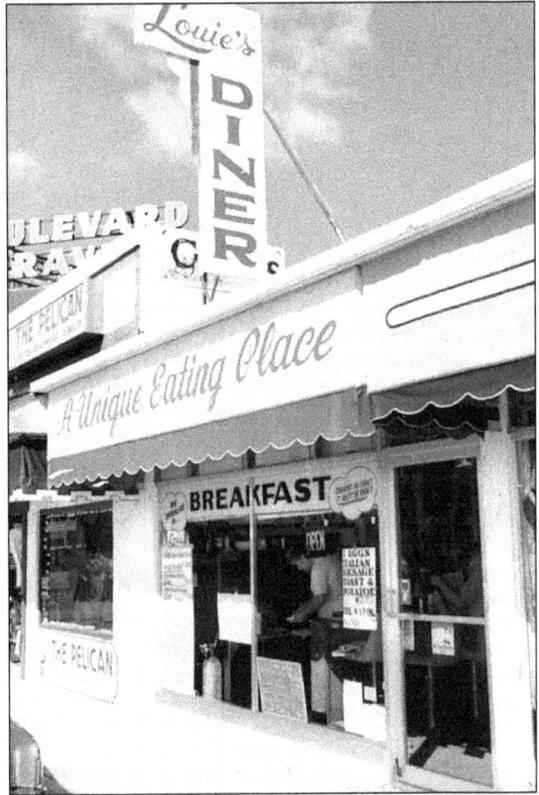

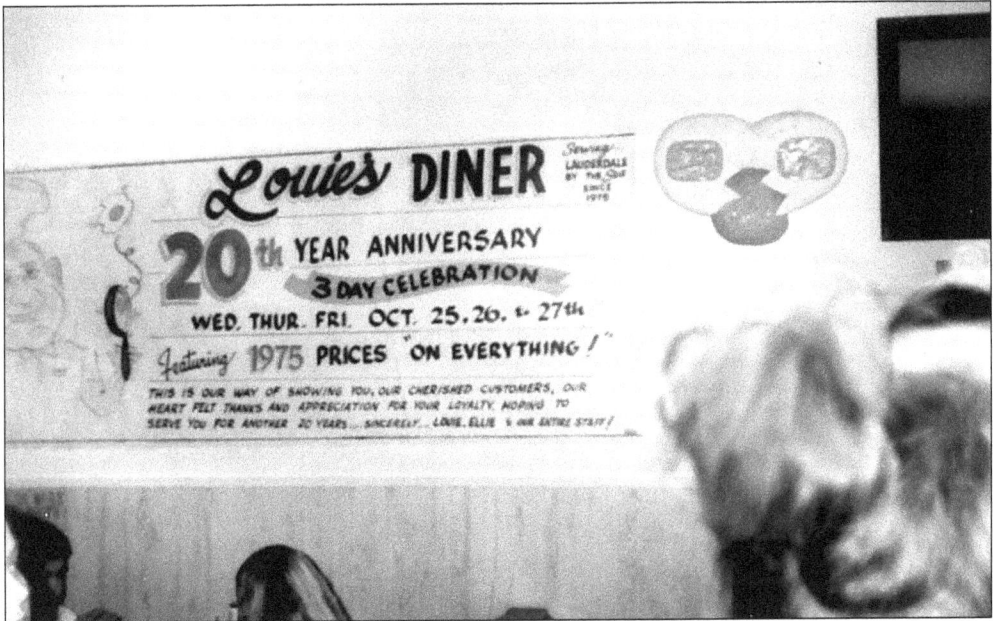

This banner advertises the 20th anniversary of Louie's Diner in 1995, which included a three-day celebration featuring 1975 prices. A much-respected individual and town icon, Louie Sabatini is a firm believer in the prevailing small-town spirit of Lauderdale-By-The-Sea, which is unique to the urban sprawl that has recently characterized the Gold Coast.

This plaque can be seen at the Chamber of Commerce site, 4201 Ocean Drive (SR A1A). It was donated by then vice mayor Oliver Parker in honor of his mother.

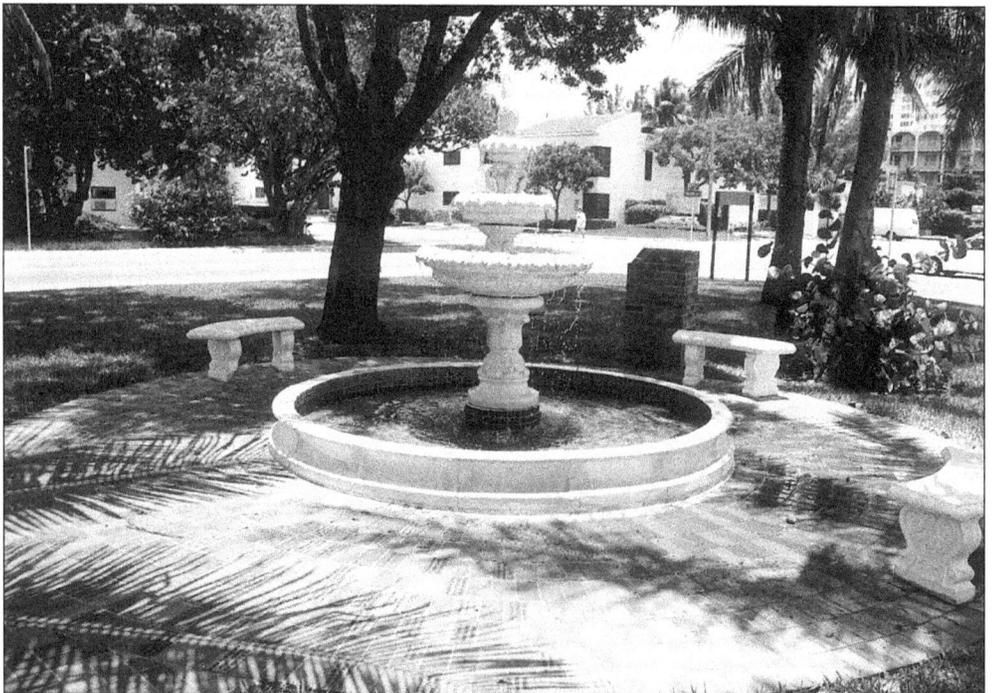

The fountain on the grounds of the Chamber of Commerce presents an ideal setting for visitors to relax. The original civic center was built here by the Women's Club in 1949 and renovated in 1995.

The Chamber of Commerce welcomes visitors and provides information to those who want to take advantage of the town's accommodations and attractions. Architect John Randal McDonald rendered the Mediterranean design of the building and grounds.

CHAMBER OF COMMERCE BUILDING

A GIFT TO THE TOWN OF LAUDERDALE BY THE SEA, FLA.
BY
MR. & MRS. ERNEST G. JARVIS
GEORGE E. WADDEY A.I.A. 1968 THOMAS J. MOORE
ARCHITECT GENERAL CONTRACTOR

Mr. and Mrs. Ernest Jarvis expressed their appreciation to the town with a contribution for the construction of the Chamber of Commerce building at Ocean and Bougainvilla Drives. The Jarvises also contributed $40,000 for the construction of Jarvis Hall, which is located next to the town hall. It was dedicated in May 1965.

MELVIN I. ANGLIN

The site for this

Chamber of Commerce Building

was donated by

Melvin I. Anglin

founder and first mayor of

Lauderdale by the Sea.

This plaque on the wall of the Chamber of Commerce acknowledges Melvin I. Anglin, who donated the land on which it stands. Anglin, who came from Indiana with his wife Sarah in 1924, purchased land, founded Lauderdale-By-The-Sea, and became its first mayor.

JOHN R. "JACK" FORREST
APR. 16, 1919 – SEPT. 17, 1998
THIS FLAGPOLE IS DEDICATED TO THE
MEMORY OF JOHN R. "JACK" FORREST.
JACK'S COMMITMENT AND SERVICE TO THE
TOWN OF LAUDERDALE BY THE SEA AS A
COMMISSIONER, MAYOR, MANAGER, VOLUNTEER
FIREFIGHTER AND FOUNDING MEMBER OF THE
COMMUNITY CHURCH WERE TREMENDOUSLY
SIGNIFICANT. JACK'S CONTRIBUTIONS LIVE ON AS
THE BASIS FOR THE CONTINUED GROWTH AND
VITALITY OF THIS COMMUNITY.
DEDICATED – APRIL 14, 2001

The John R. (Jack) Forrest (1919–1998) historical marker was placed at the flagpole south of the Presbyterian Community Church on April 14, 2001. It honors a man who served the town as commissioner, mayor, manager, volunteer firefighter, and founding member of the Presbyterian Community Church.

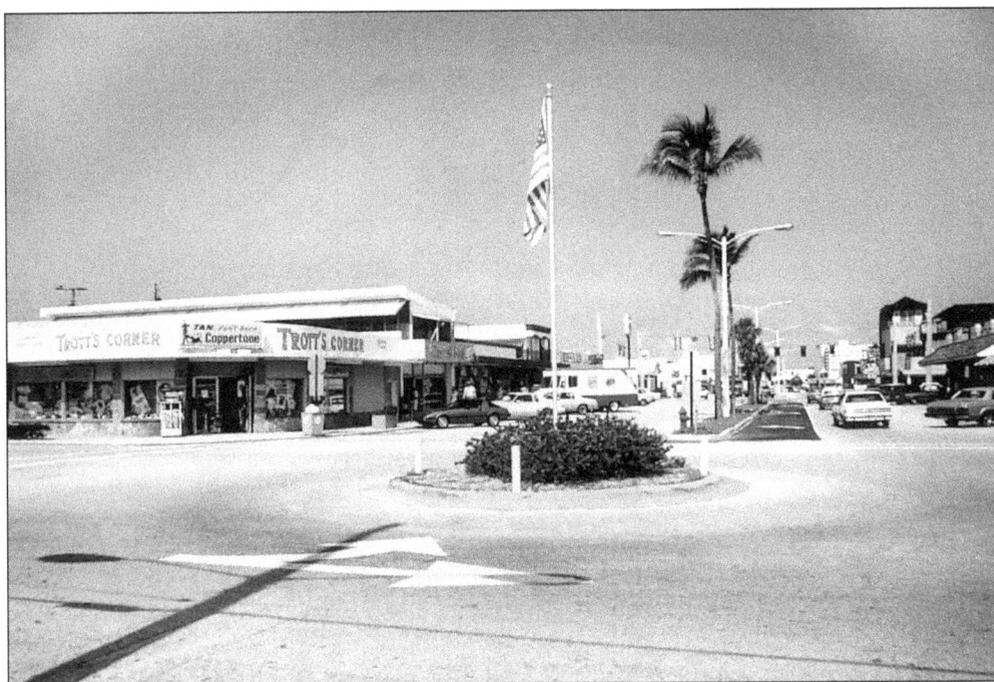

The intersection of Commercial Boulevard and El Mar Drive, shown here as it appeared in the 1980s, would become the site of Anglin/Pelican Square. The Pelicans in Flight monument was placed there in 1990 to symbolize the town's commitment to nature and its sense of freedom, characterized by its ocean setting.

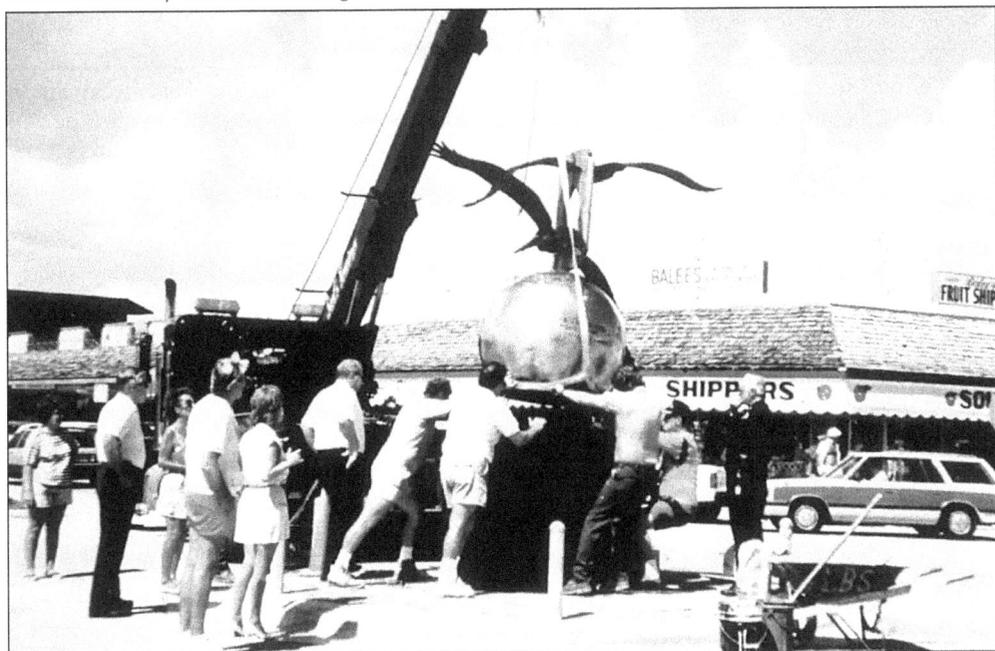

The Pelicans in Flight monument is shown being put into place by town volunteers. It took the Chamber of Commerce four years to raise the necessary funds to meet the cost of the landmark monument.

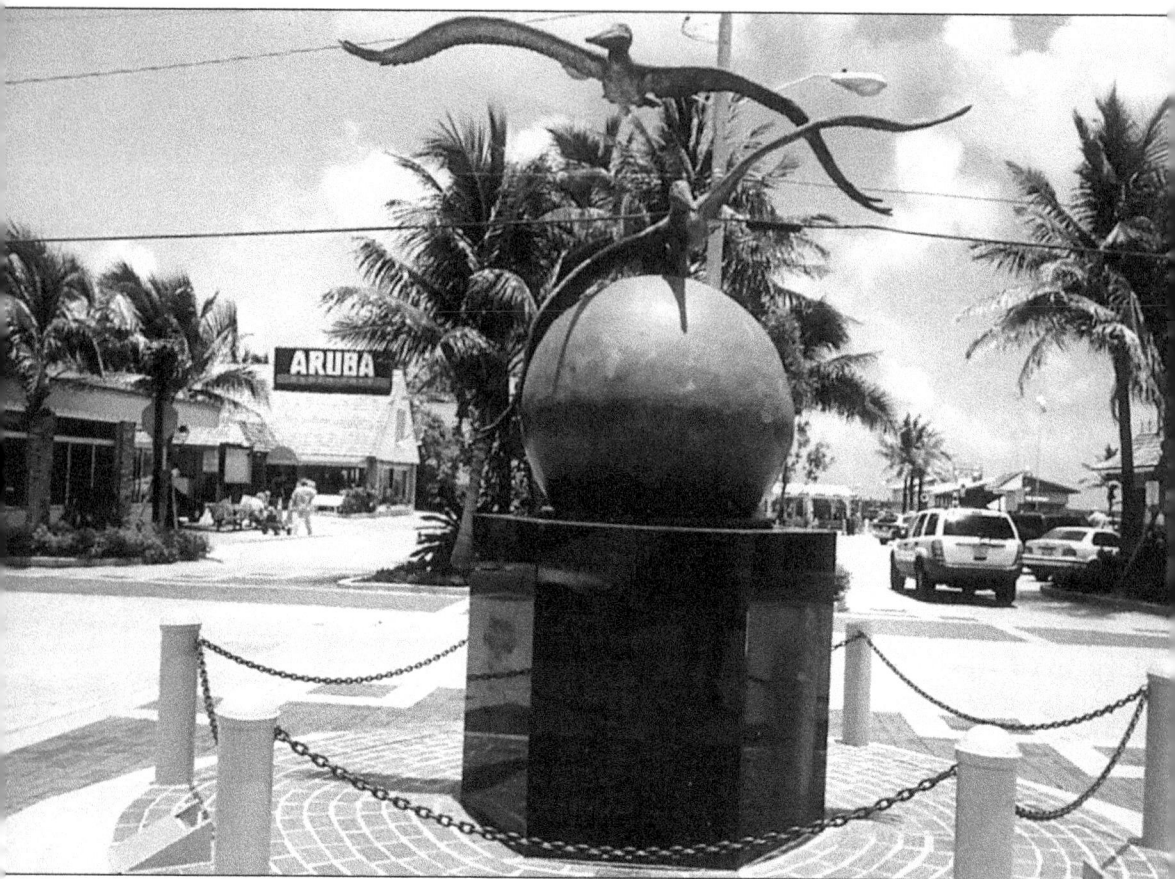

The Pelicans in Flight sculpture atop the bronze monument was placed at Pelican Square in October 1990, and has become a recognizable landmark synonymous with the town. The 200 bricks at the base honors town leader. Anglin's Fishing Pier is at the right in the background. Mulligan's and Aruba restaurants are at the left.

As can be seen, the monument displays the name of Melvin I. Anglin. It also displays two pelicans soaring over a globe, and the names of townspeople are inscribed at the left. Carl Wagner was the commissioned artist who created the sculpture at a cost of $30,000.

This is the rendering of Pelican Square that was executed in 1990. The design enhanced the intersection at El Mar Drive and Commercial Boulevard by acknowledging the town's roots, providing a more natural setting with appropriate landscaping, and controlling increased traffic.

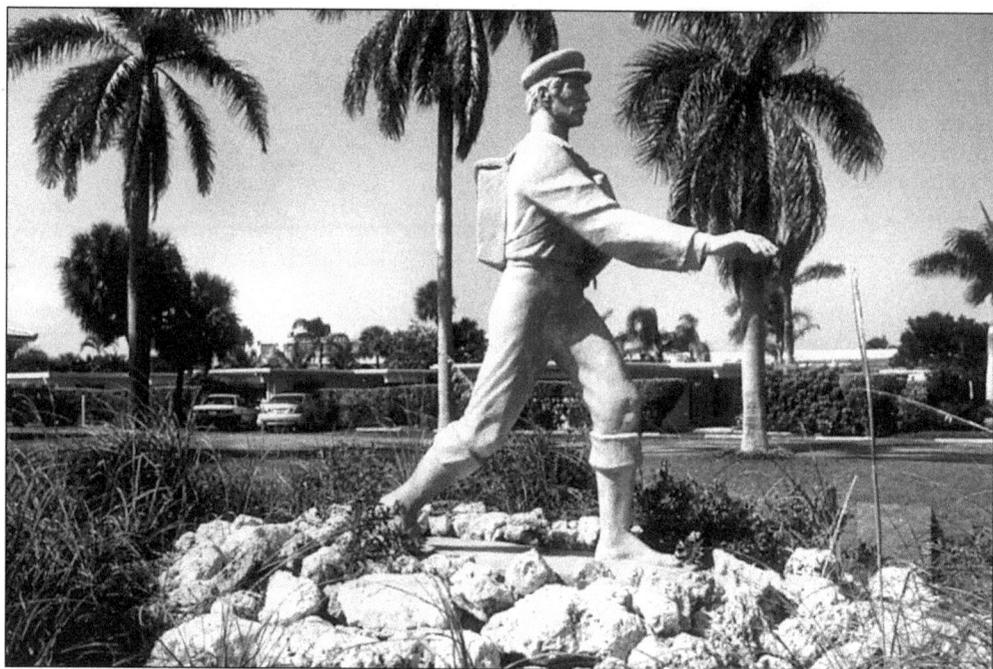

Part of the historical lore of South Florida includes that of the "barefoot mailman," who for a brief period in the 1880s delivered U.S. mail along the punishing coast from Palm Beach to Miami by foot and by boat. He also traveled through land now occupied by Lauderdale-By-The-Sea. The statue (above), at the town of Hillsboro Beach administration building a few miles north, memorializes James Hamilton, who was drowned or killed by an alligator while delivering mail in 1887.

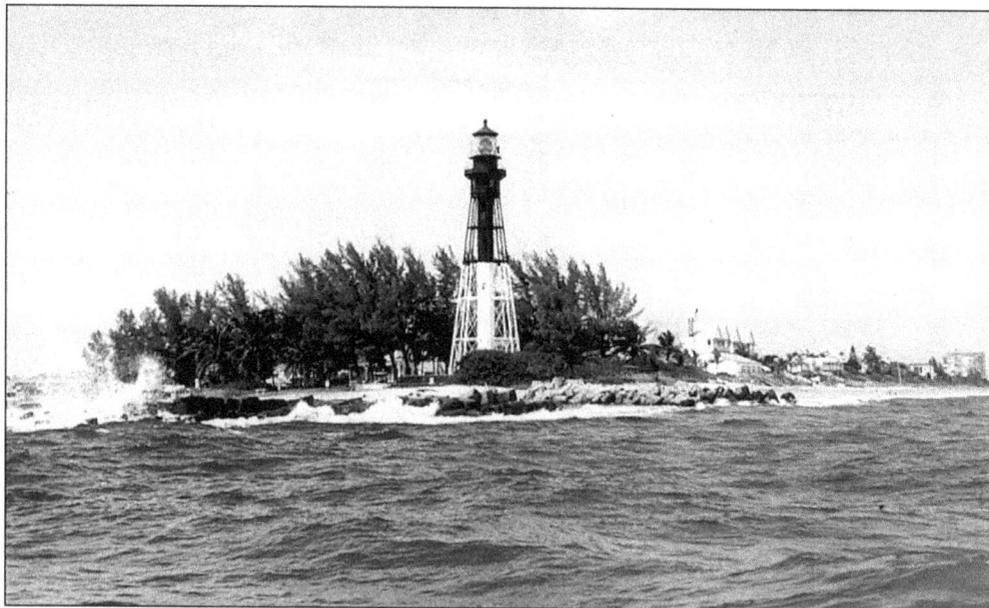

Above, boaters from Lauderdale-By-The-Sea reach the Atlantic Ocean via the Intracoastal Waterway northward to the Hillsboro Inlet. The lighthouse, originally built in 1907, continues to function as an indispensable navigational aid for ships along Florida's east coast.

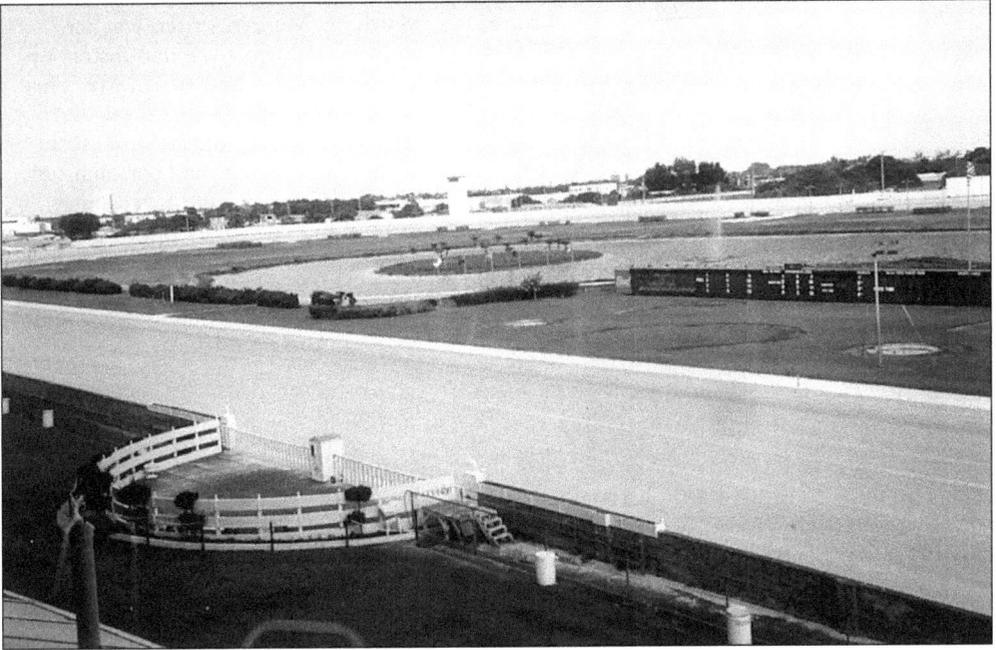

Residents of Lauderdale-By-The-Sea have enjoyed the entertainment provided at nearby Pompano Harness Track, shown above. The winner's circle is to the left and the scoreboard is at the right. The track opened February 4, 1964, and has continued to operate on a year-round basis. It features simulcast live racing and dining. It also hosts the Broward County Fair and the National Antique Car Show.

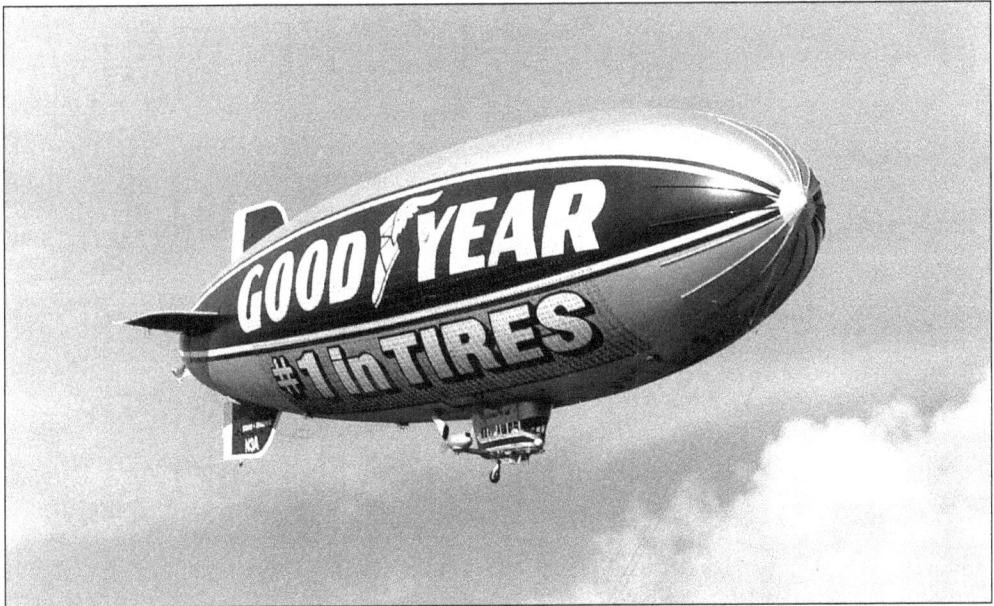

Goodyear Blimps have been stationed at Pompano Beach since 1979, and are a familiar sight to residents of Lauderdale-By-The-Sea. The most recent blimp, *Stars and Stripes* (above) is 192 feet long and flashes messages with 3780 lights on each of its sides. It also provides aerial television coverage at sporting events.

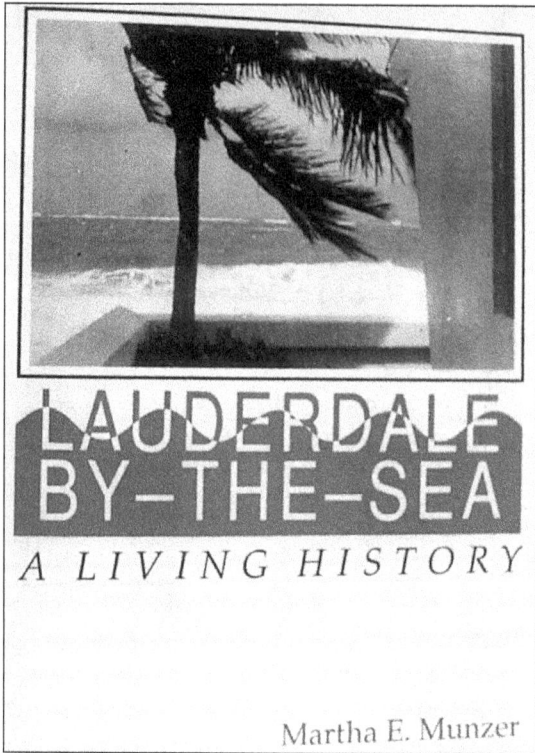

Martha E. Munzer, writer, teacher, and lecturer, wrote the first history of Lauderdale-By-The-Sea in 1989. This is the cover of the book. Though a brief 77 pages, she did capture much of the town's events and personalities. Munzer discovered and loved the town in her later years as a widow and great-grandmother.

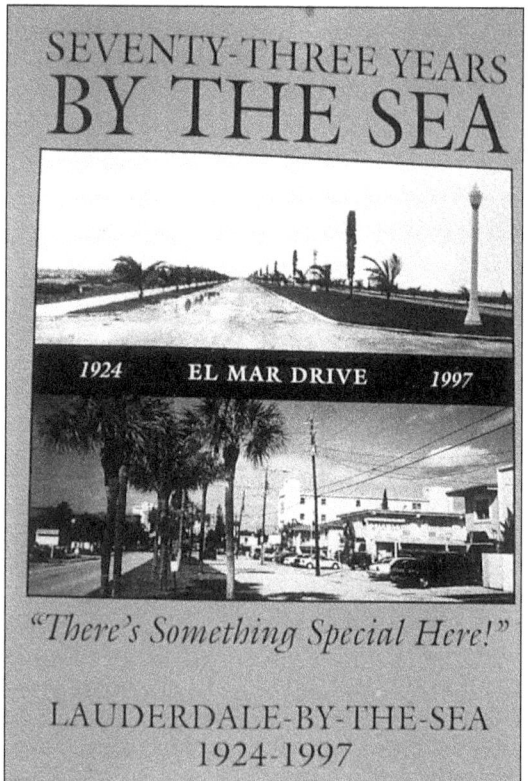

A more recent history of Lauderdale-By-The-Sea, published in 1997 by Candice Richard, is a more detailed book with 132 pages. The cover of her book (right) contrasts scenes of El Mar Drive in 1924 and 1997.

Five

LAUDERDALE-BY-THE-SEA TODAY

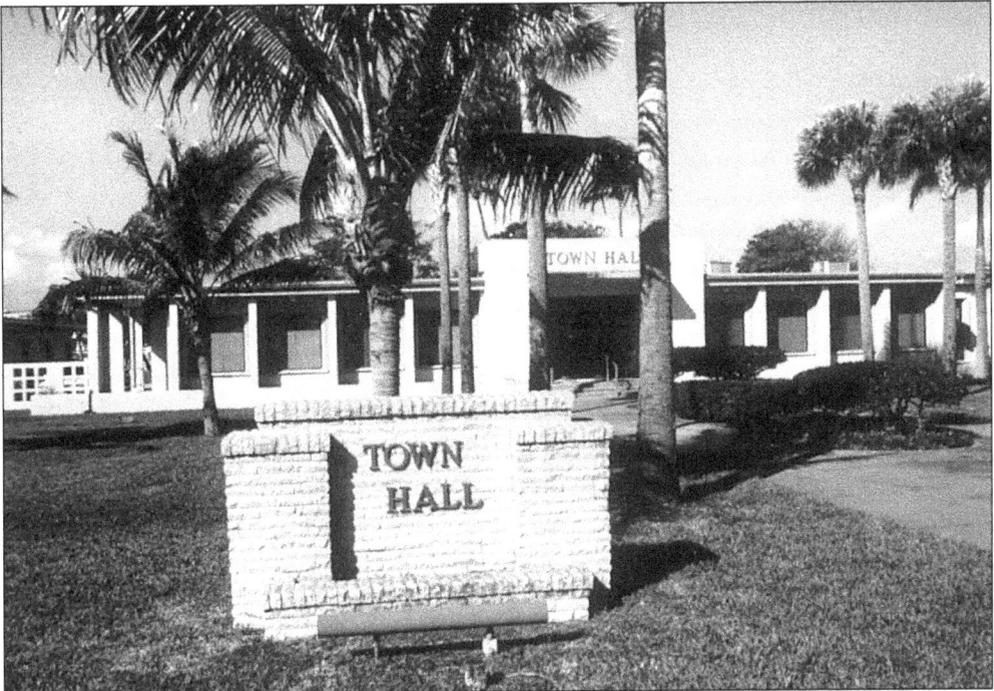

Town Hall, as it appears today, is viewed westward from Ocean Drive (SR A1A). Town Hall was built in 1956 and serves as the government center. The unassuming building and its surroundings conform to the quaint image that town leaders wish to convey.

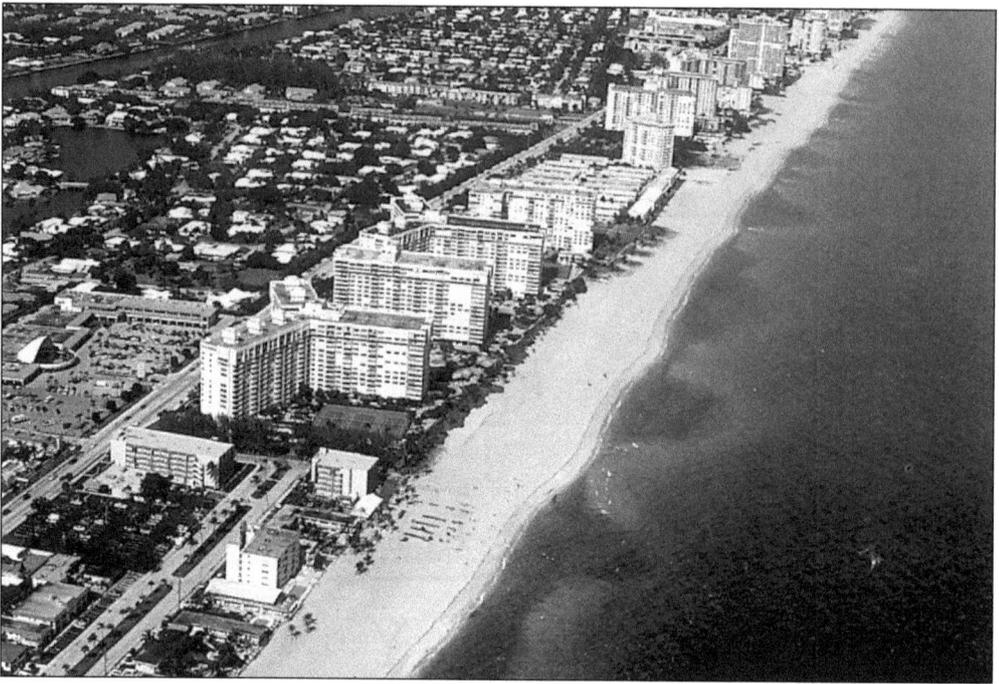

An aerial photo depicts an important section of South Florida's Gold Coast. At the lower left foreground is El Mar Drive, which swings west around the Clarion Hotel to connect with Ocean Drive (SRA1A). West of Ocean Drive, the Sea Ranch Shopping Center is clearly visible at left. Much of the area northward, including the high-rise condominiums on the beach and the Bel Air residential section north of Sea Ranch Lakes, has been annexed to Lauderdale-By-The-Sea.

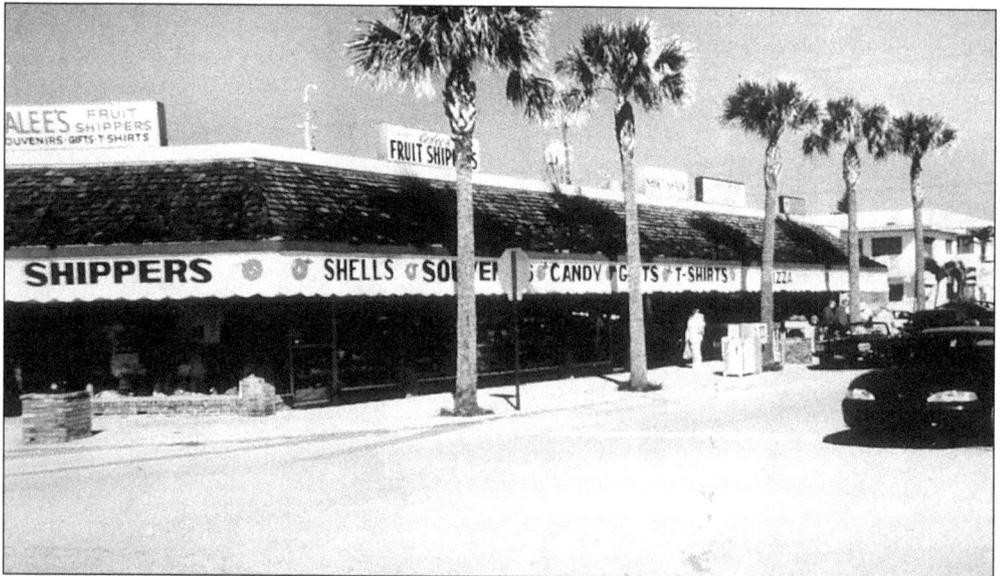

Balee's Fruit Shippers at 101 Commercial Boulevard can be seen here before it was replaced by Mulligan's Neighborhood Grill and Raw Bar in 1997. Mulligan's has become one of the busiest restaurants in town.

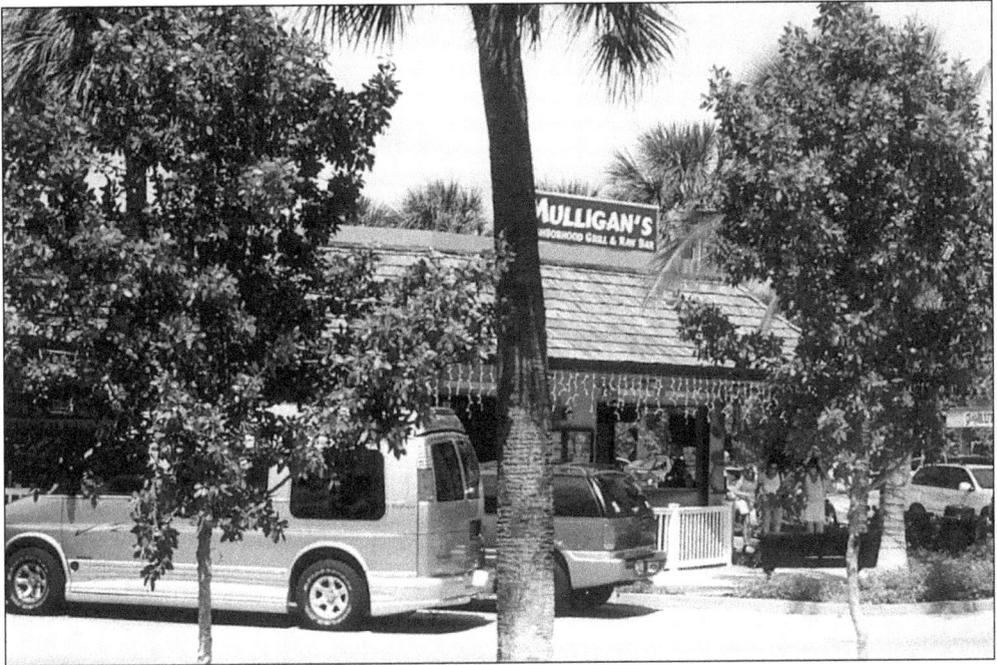

One block from the ocean is Mulligan's Neighborhood Grill and Raw Bar, at the corner of El Mar Drive. The considerable amount of daily human and vehicular traffic passing through this intersection has greatly contributed to this casual restaurant's popularity.

The Atlantic Ocean is barely visible in the distance in this photograph, taken at a rare time when the El Prado was not inhabited with automobiles and people. The parking meters were installed in 1994 and have produced an important source of income for the town.

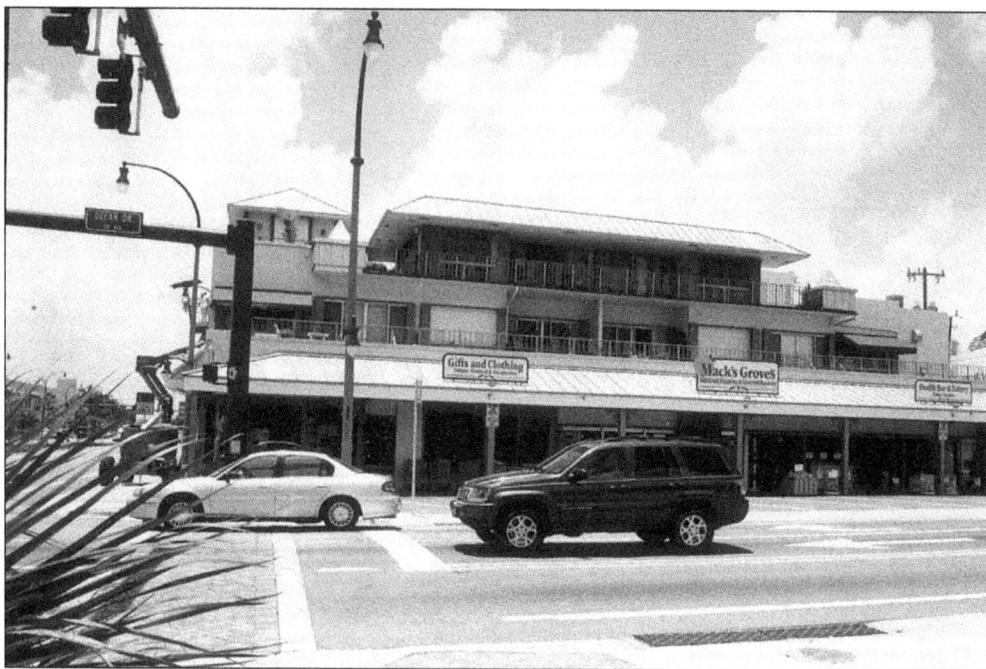

Newly designed brick walkways, lighting, and landscaping contribute to the attractiveness at the intersection of Ocean Drive and Commercial Boulevard. Mack's Groves, with its modern prairie-like architecture, dominates the view.

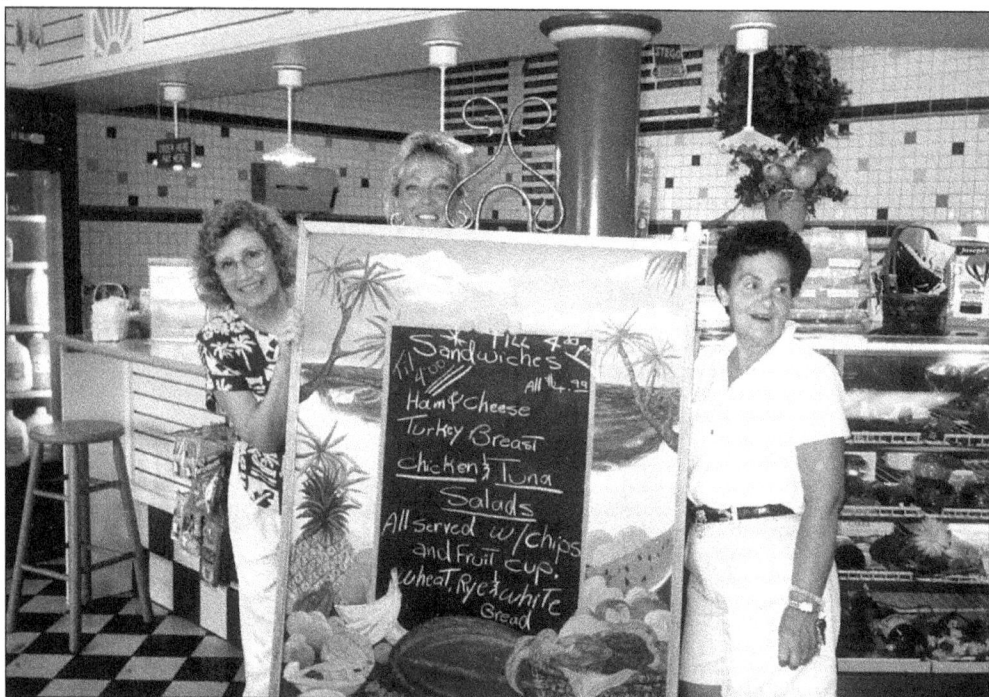

From left to right, Marilyn, Sharon, and Dottie, employees of Mack's Groves in 1997, display the special menu of the day. Mack's Groves has featured gifts, gourmet foods, clothing, home accents, and Indian River fruits since 1954.

102

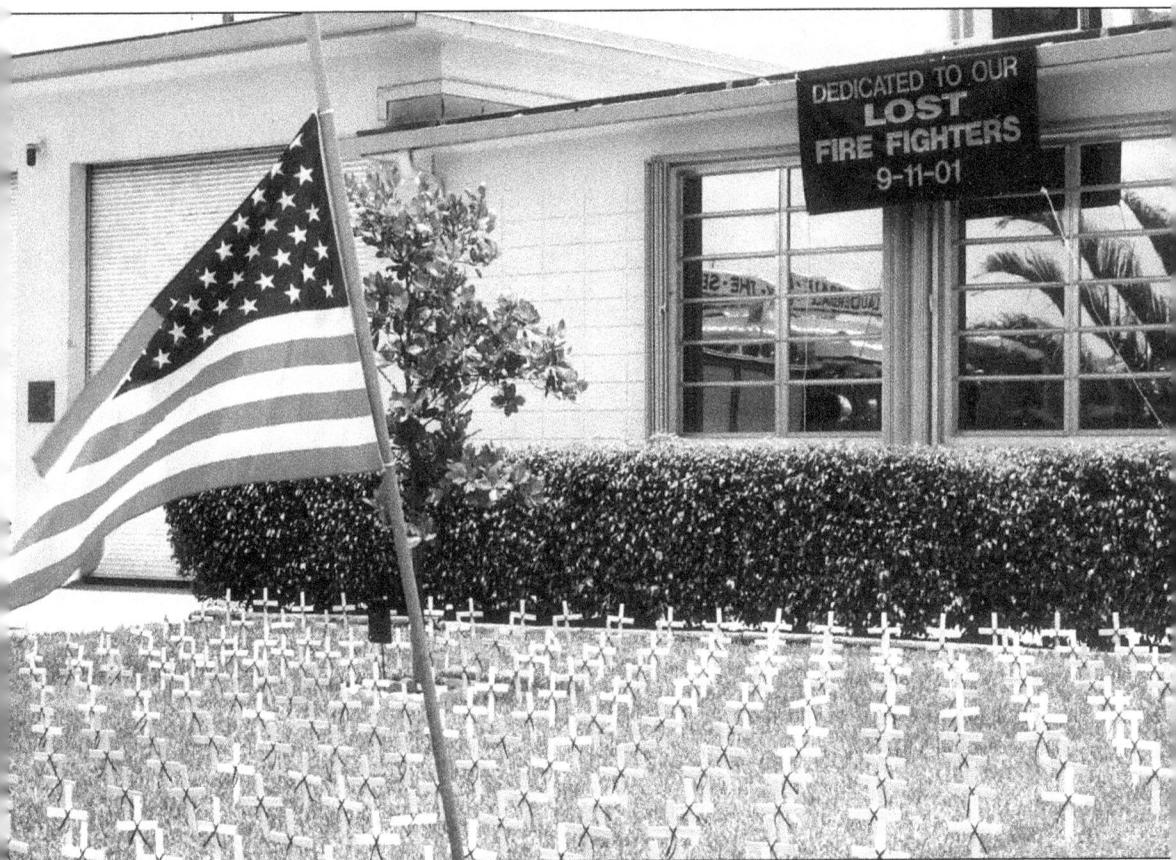

One of the 2002 Fourth of July events included memorializing firefighters who lost their lives in the tragedy of September 11, 2001. The crosses represent the dead heroes. This scene is at the volunteer fire deparment's headquarters.

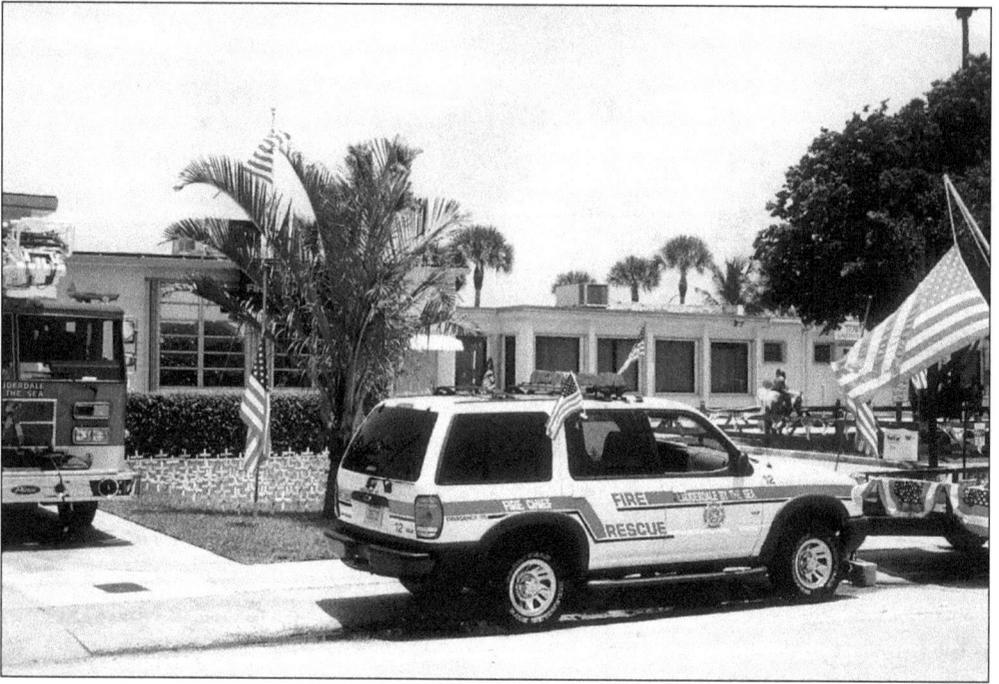

Emergency life saving equipment surrounds the firefighters' memorial amid American flags behind the town hall on July 4, 2002. The volunteer fire department started the day with a parade through town that included classic cars, dignitaries, and music.

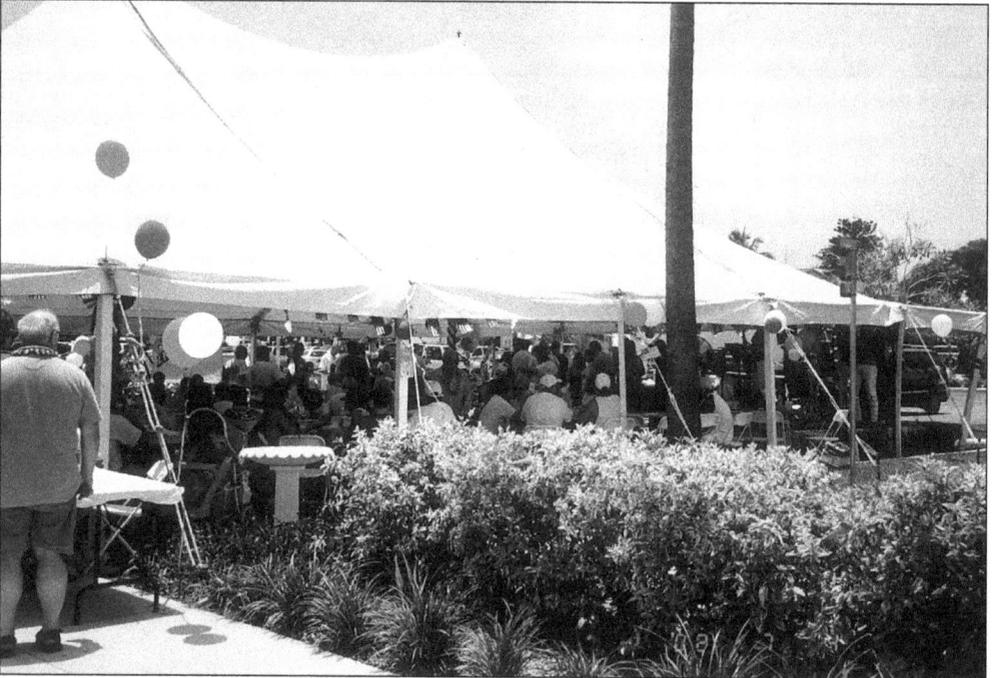

The volunteer fire department prepared a barbeque for town residents and guests under a tent on a hot Fourth of July day. The day concluded with a grand fireworks show for all at the Clarion Hotel.

On the Fourth of July, there were games and presents for children; here youngsters enjoy themselves at Friedt Park. The day was characterized by the small-town atmosphere that has been a traditional part of the community history.

Children ride ponies on a bright, sunny red-white-and-blue day during the Lauderdale-By-The-Sea Fourth of July celebration. Other events of the day included bed races, a special welcome to the new town residents, the opening of town facilities for inspection, a slide presentation, and the examination of new voting machines (with no hanging chads!).

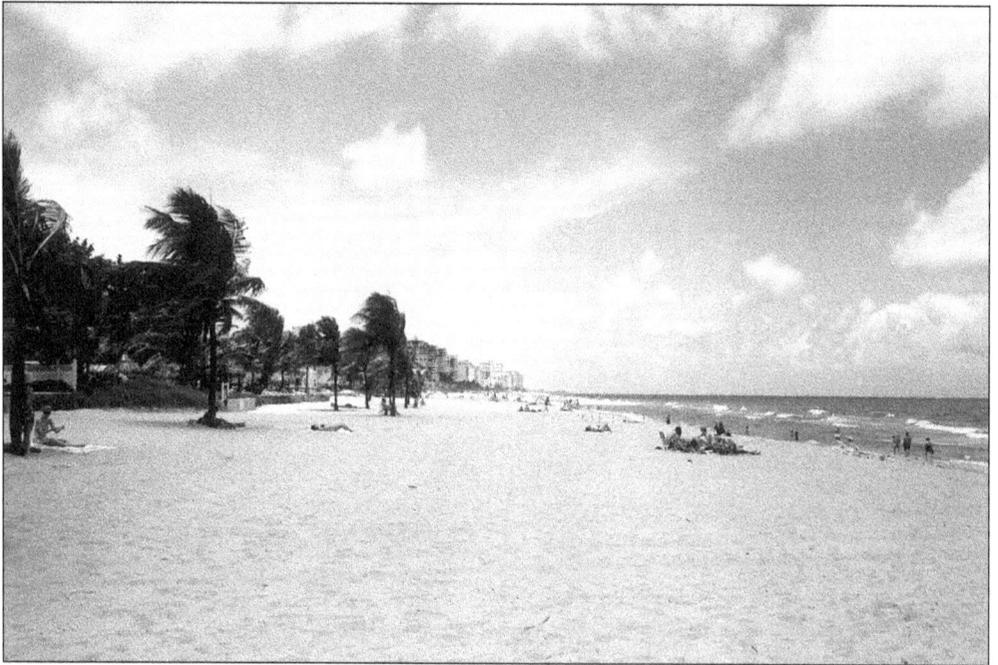

A panoramic view looking north from the Anglin Fishing Pier captures the natural beauty of the beach at Lauderdale-By-The-Sea. At left, not shown, is the popular Aruba Beach Café. In the distance are high-rise condominiums that were annexed to the town.

The Pier Point Resort Hotel, above, replaced the original Pettit's Riviera Hotel (built and run by Charles Pettit) at El Mar Drive, south of Commercial Boulevard. The Riviera Hotel was sold and expanded, and its name was changed to the Pier Point Hotel, as the Anglin Fishing Pier and beach are in back of the building.

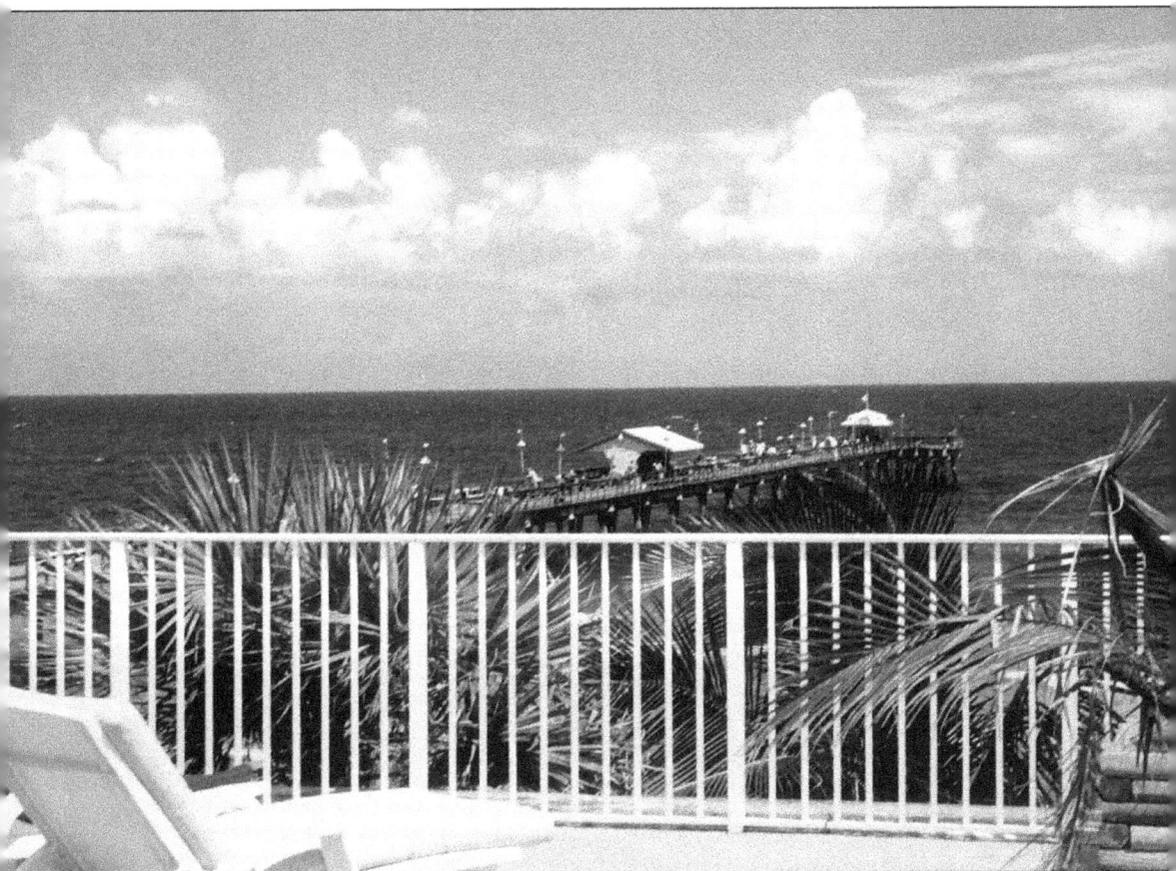

The Anglin Fishing Pier can easily be seen from the Pier Point Hotel on a very busy weekend. The original pier was built and completed by Melvin I. Anglin and his two sons in 1941. Sold in 1963 to Frank Myatt and Everett Sorensen, it was extended to 876 feet out to the ocean, forming a "T." Tom Anglin remembered rebuilding the original pier three times with "12 by 12 timbers, 4 by 8 joists, and a lot of decking."

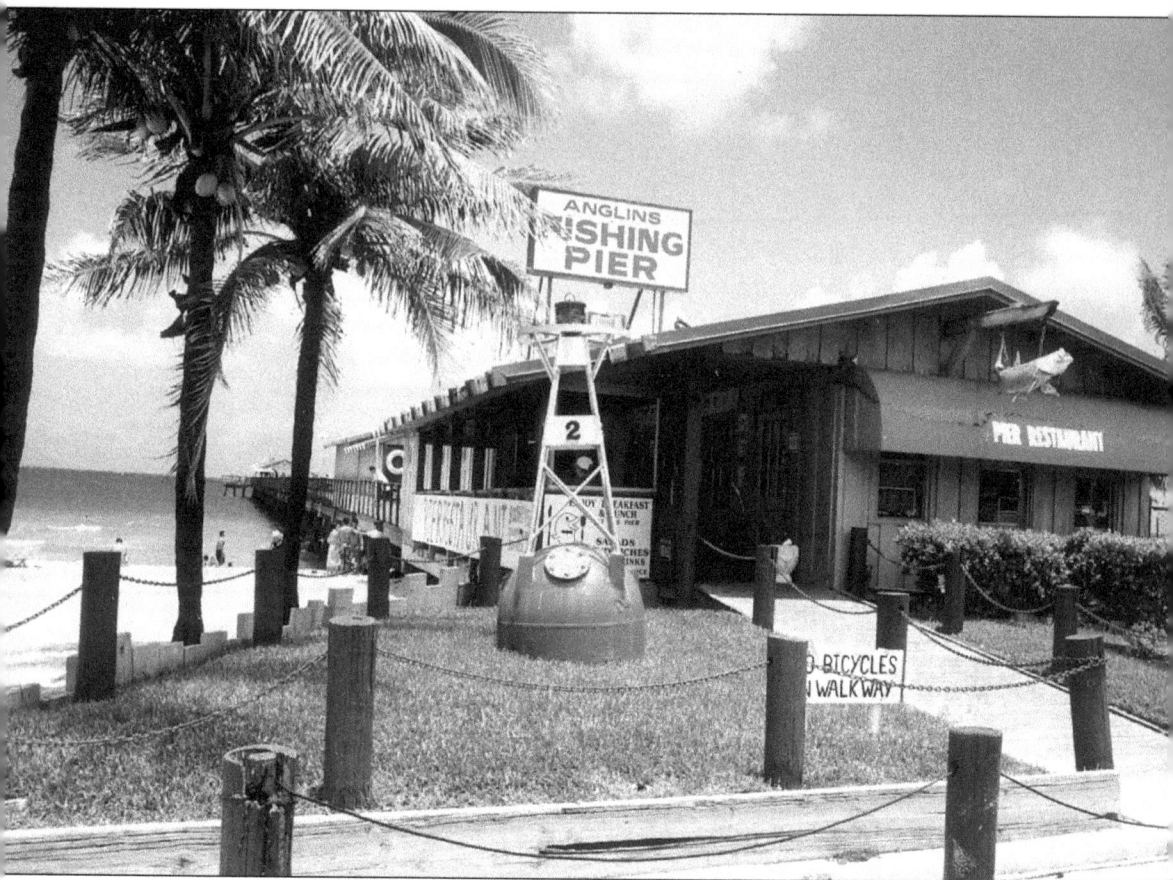

The entrance to a more modern Anglin's Fishing Pier is shown looking eastward towards the Atlantic Ocean. The buoy was used to guide ships. Melvin I. Anglin wisely chose this spot to build his pier because fish were plentiful where the coral reef lay. The pier has attracted sports people from all over the world and is the center of tourist activity. It is now open 24 hours a day.

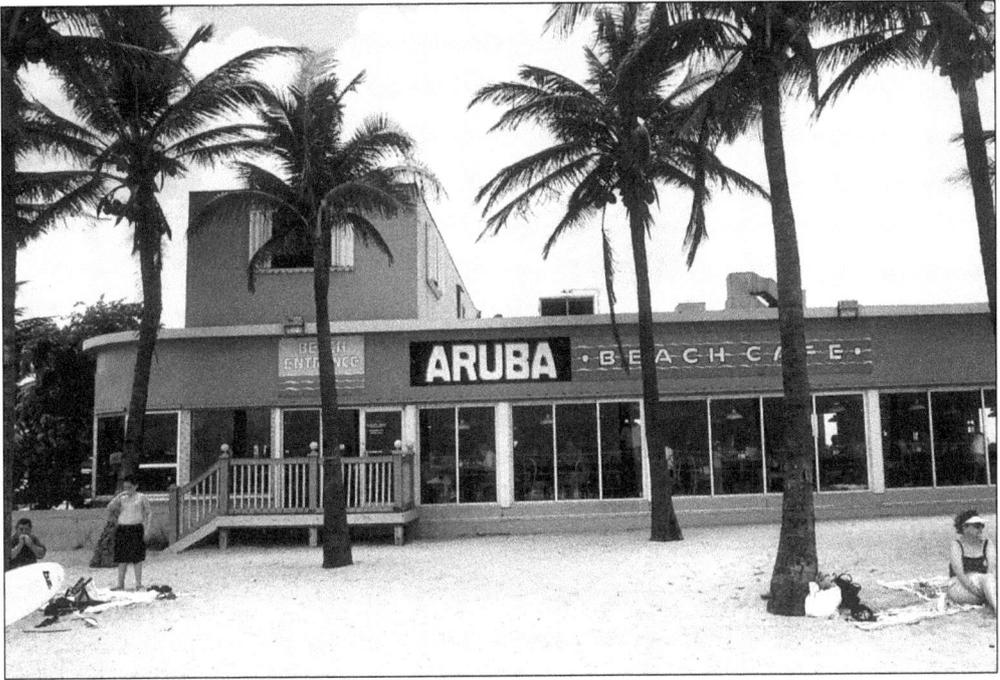

Guests can dine and view the ocean from the Aruba Beach Café. In 1954 the Anglins built the Ocean Pier Restaurant, blocking the ocean view from Murphy's Restaurant. In this congested location today, valet parking is a necessity

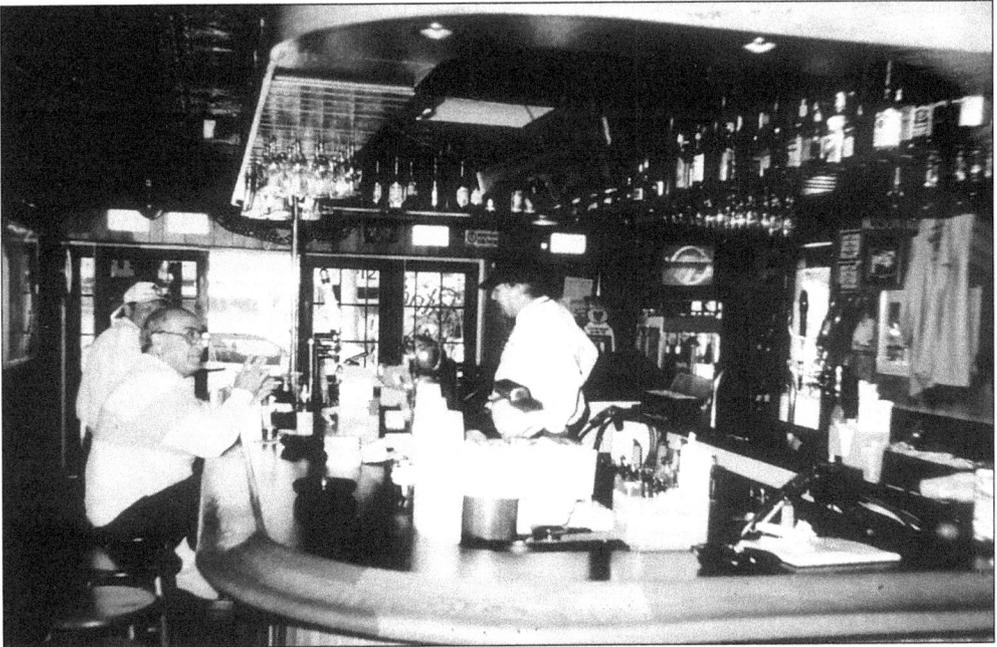

Visitors enjoy the casual atmosphere at the bar in Aruba's in January, 1997. The 1990 U.S. Census recorded 2,990 permanent residents in Lauderdale-By-The-Sea, but this seaside village witnessed an increase of more than three times its population in the winter season. Aruba's Beach Café is one of the attractions.

The original high-rise buildings, shown as they appeared in the late 1960s, stand at the southern border of the town at Palm Avenue and east of SR A1A (Ocean Drive), with Galt Ocean. In the top photo (left) is the Caribe, which opened in 1963 at a cost of $1.5 million. The $5 million Fountainhead (right) opened two years later. Annexation of areas north of Pine Avenue in 1999 and 2001 added more high-rise buildings to the town. The photograph at the bottom shows the Caribe (right) and the Fountainhead (left) as they appear today.

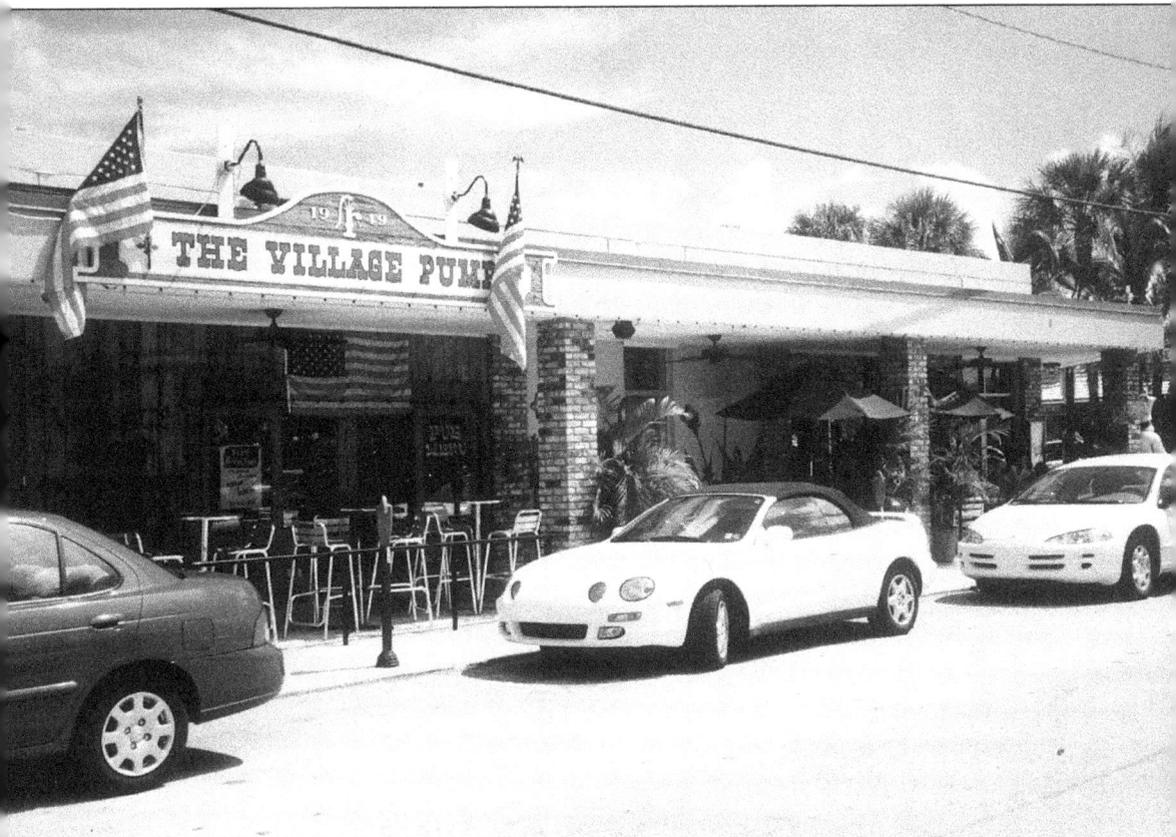

.Jerry Brinkley built the Village Pump in 1949. It remains a bar and package store to this day, and is located on El Mar Drive. When the old Murphy's Restaurant was open during the winter season, guests waiting for a table went to the Village Pump for a cocktail.

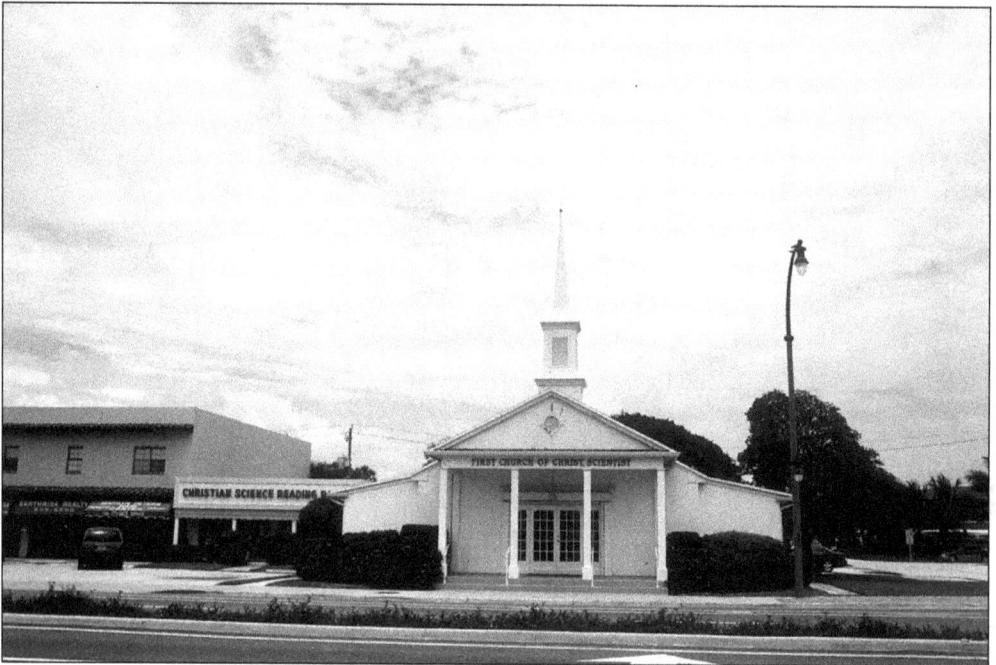

The First Church of Christ Scientist is located at 251 Commercial Boulevard, on the north side. The Reading Room is at left. It is one of three churches in Lauderdale-By-The-Sea; the other two are the Presbyterian Community Church and the Assumption Catholic Church.

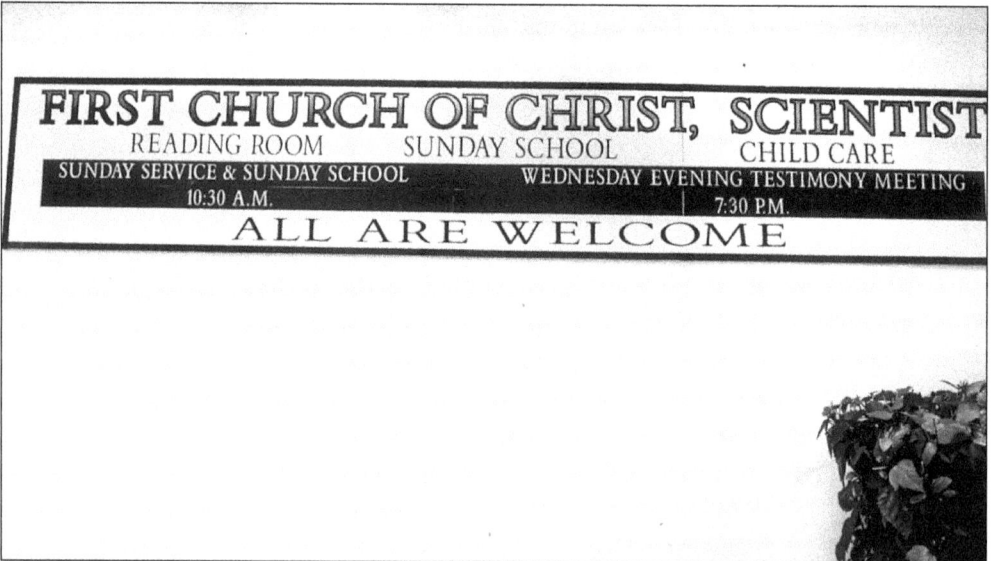

This sign at the side of the First Church of Christ Scientist offers such services as a reading room, Sunday school, and childcare. There is also a Wednesday evening Testimony meeting. The church was founded by Mary Baker Eddy in 1866.

At the southern end of town, where Allenwood Drive meets Hibiscus Avenue, boats can be seen in a view to the north at the boat basin. The canal leads to the Intracoastal Waterway. This section remains a quiet neighborhood and little visited by out-of-towners.

Ray Anglin, a descendant of the Anglin family, stands at the end of Marine Colony in the 1990s. He likens growing up in Lauderdale-By-The-Sea to living in a frontier town. He also remembered that Jade Beach, across the way from today's Assumption Catholic Church, was a hangout for teenagers.

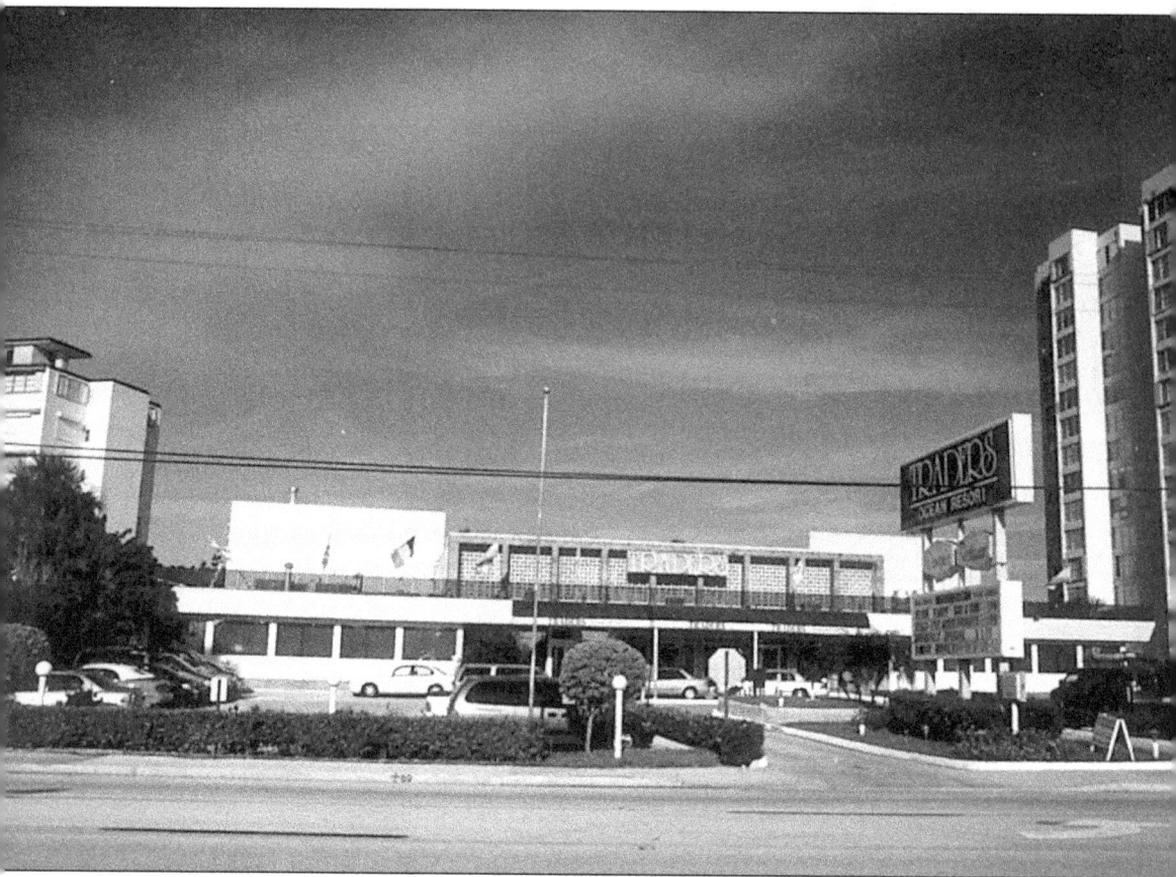

Traders Ocean Beach Motel and Restaurant at 1600 Ocean Drive was a popular resort. It was torn down and replaced by the upscale 23-story Aquazul condominium and apartment complex, where units range from $800,000 to $2,000,000 each. Despite the town height limit of three-stories, the Aquazul was granted the right to build this high-rise condominium by Broward County before the area was annexed by Lauderdale-By-The-Sea. To the right is the Ocean Colony condominium, and to the left is the Ocean East condominium.

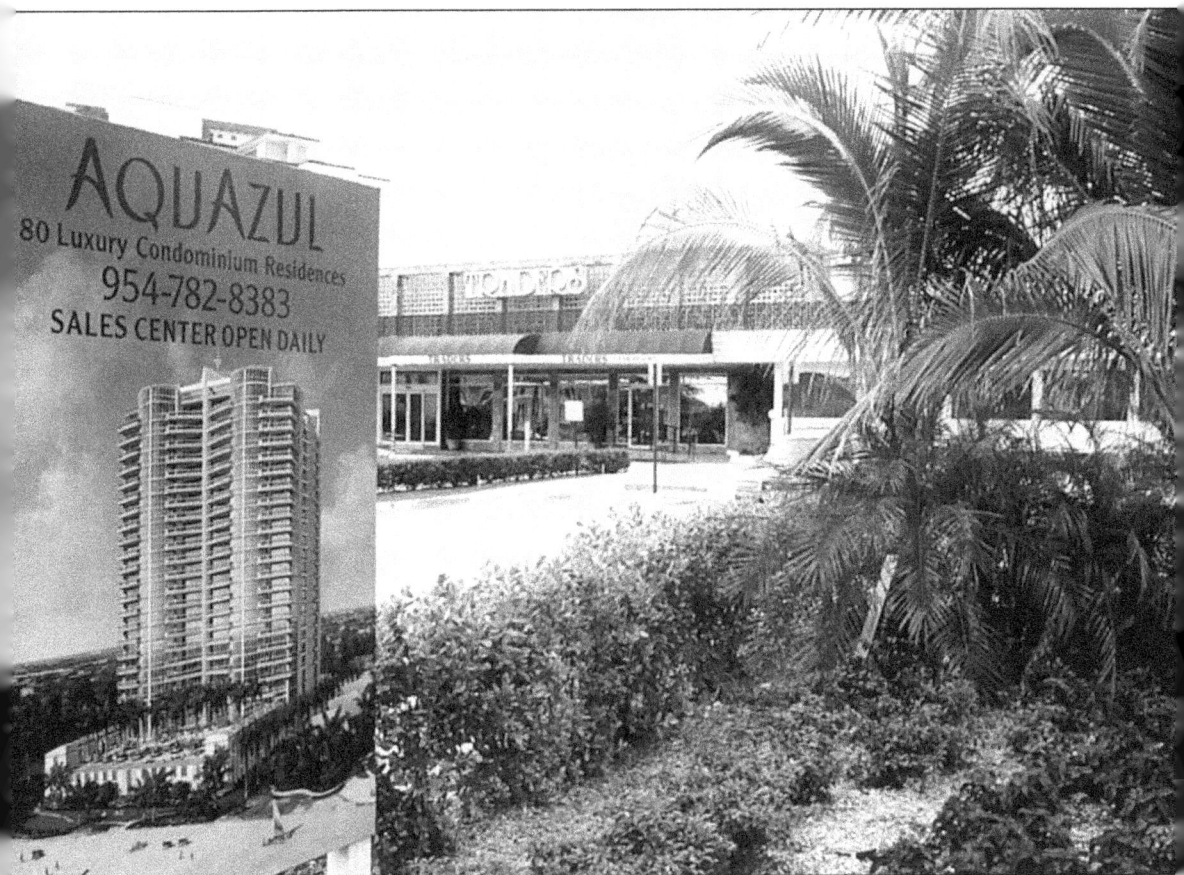

The tall sign at the left announces and presents the luxury condominium that, upon its completion, will replace Traders in 2004. Traders is partially hidden in a view that combines the old and the new, the past and the future. The changing skyline of Lauderdale-By-The-Sea has been received with mixed feelings from residents within the original town limits.

Lucke Ricciuti, manager of Mack's Groves, beams in her colorful tropical dress as she displays the week's featured menu in 1995. The lunch counter is in the background.

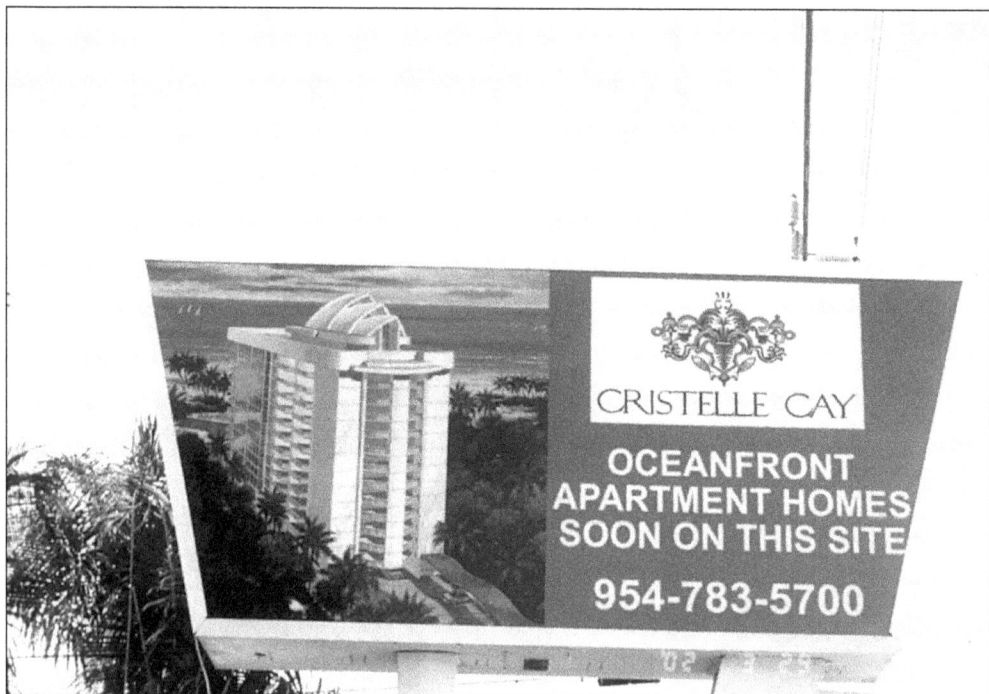

Another sign of change on SR A1A is the arrival of the Cristelle Cay luxury condominium containing two apartments on each floor. It is located at the north end of the newly annexed section of town, and joins other high-rise buildings, both old and new.

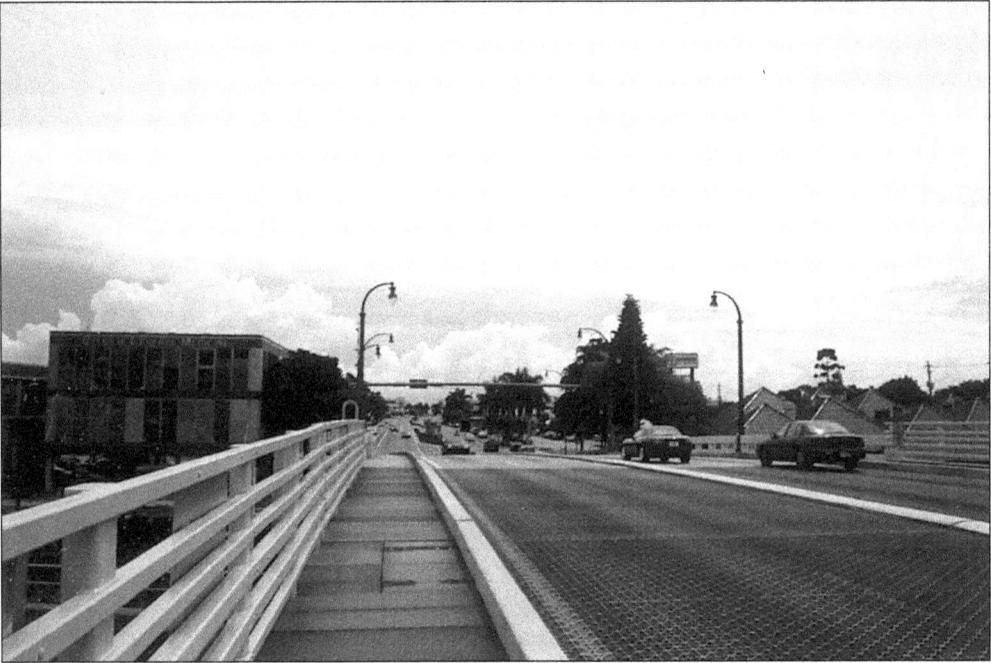

An image of Lauderdale-By-The-Sea from the Commercial Boulevard Bridge over the Intracoastal Waterway projects a view eastward towards the beach. To the right is the Japanese Benihana Restaurant; to the left is the Bayview General Medicine Building.

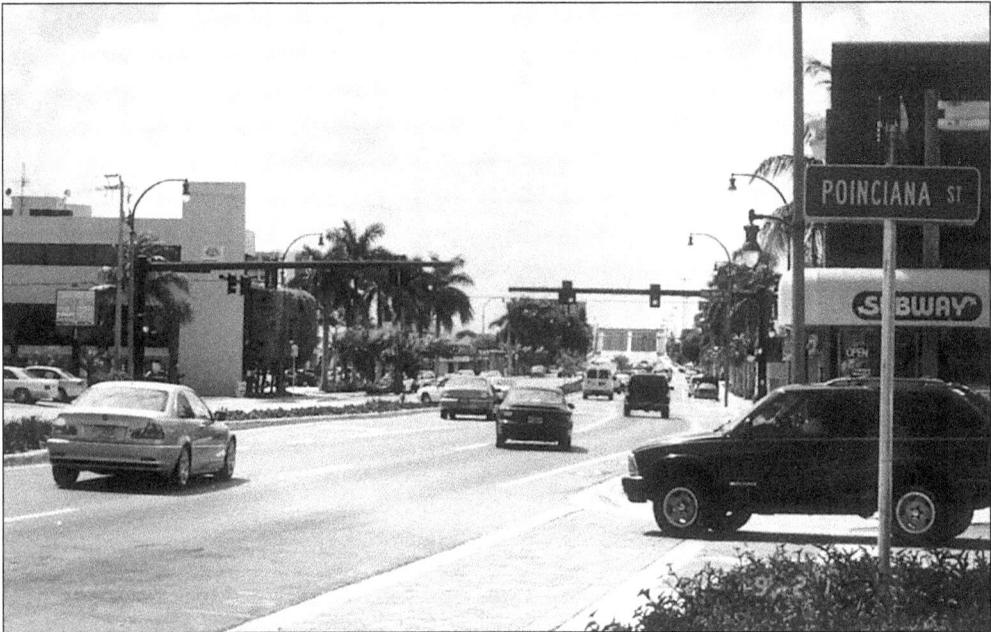

Looking west, the Commercial Boulevard Bridge rises to allow tall boats to move along the Intracoastal Waterway, and vehicles begin lining up to await completion of the bridge's opening and closing cycle. In extremely heavy traffic conditions, automobiles sometimes back up all the way to SR A1A on the east side and all the way to Federal Highway on the west side of the bridge.

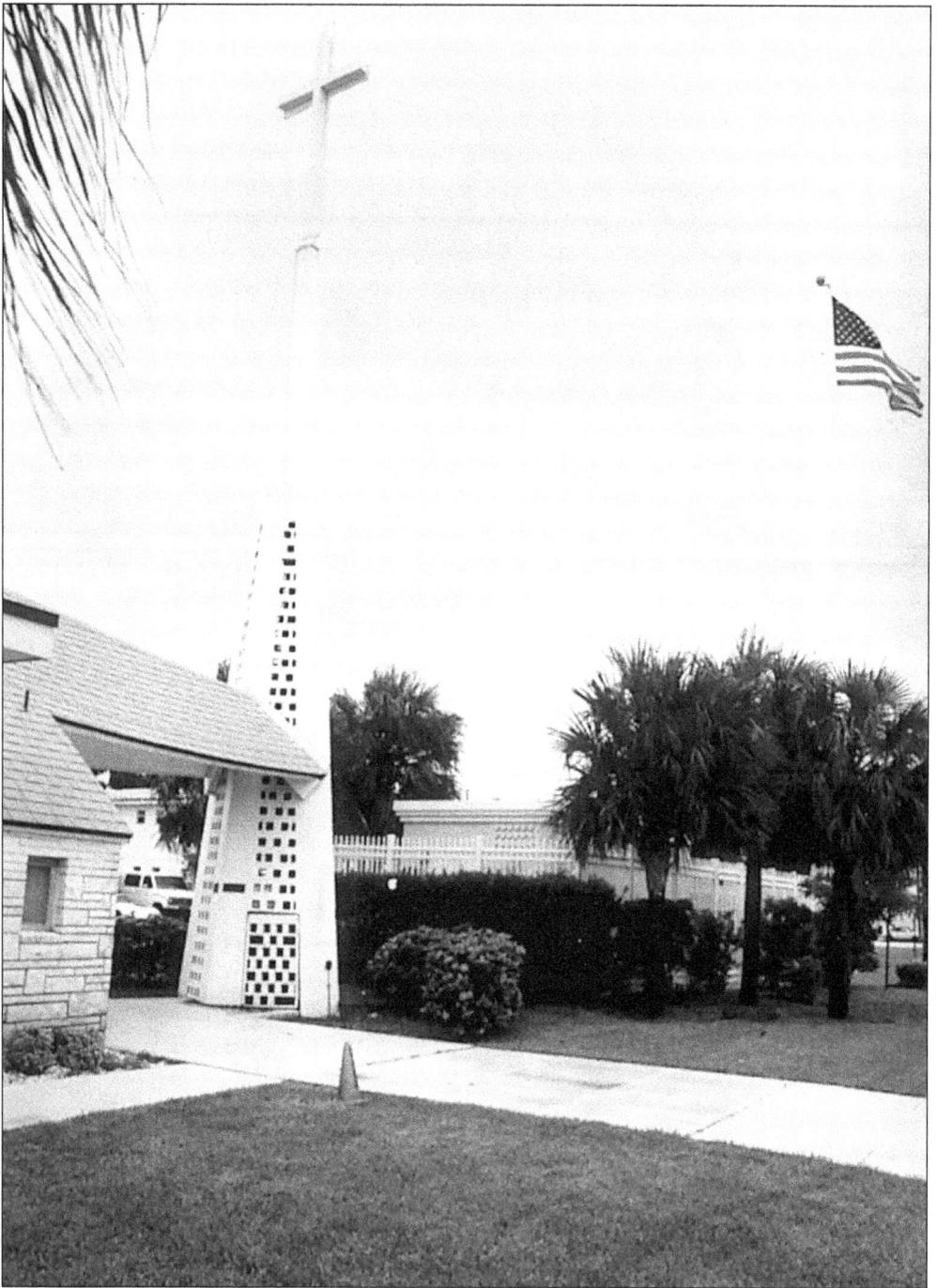

A contemporary scene of the Community Church of Lauderdale-By-The-Sea depicts the dominating steeple at the church entrance with the American flag in the background. The church is part of a compact neighborhood where Bougainvilla Drive joins Poinciana Street at a triangle just north of Commercial Boulevard. The church, built in 1960, rests on a site that is 400 feet wide at the north end and 50 feet wide at the south. Three churches serve this village by the sea, but there are no libraries or schools.

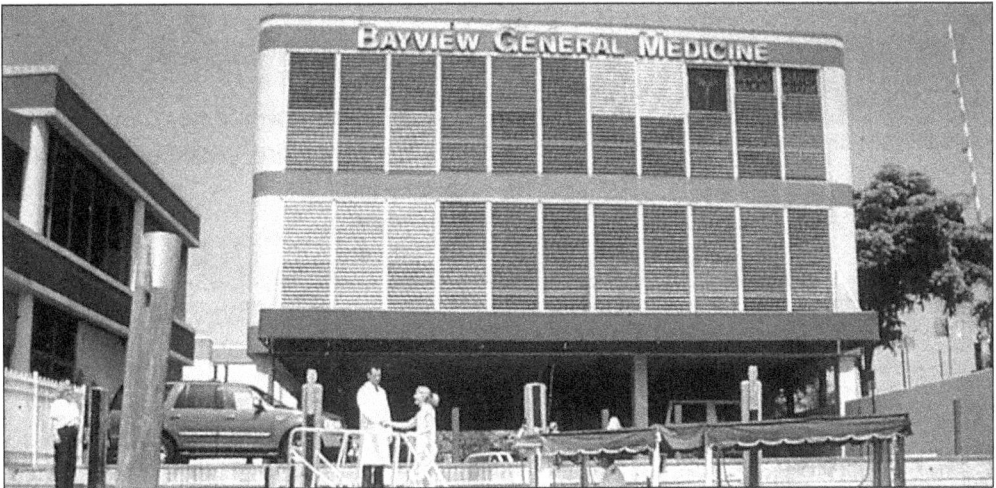

Dr. Richard Blanchar greets a patient in front of the Bayview General Medicine building at West Tradewinds Avenue, considered a "high" building. Medical services are provided to domestic and foreign tourists who might encounter sudden illness or injury while vacationing. Since it is on the east side of the Intracoastal canal, patients find it easily accessible.

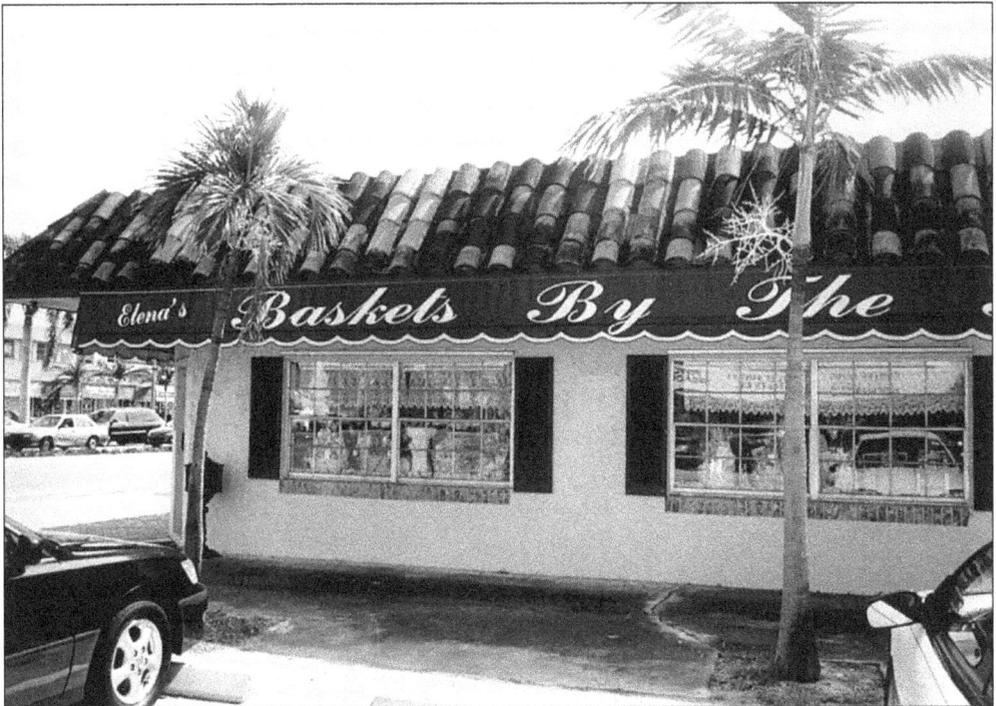

The quaint Elena's Basket By The Sea shop offers special gifts for all types of people in South Florida. At left, automobiles can be seen lining up as they wait for the Commercial Boulevard Bridge to open.

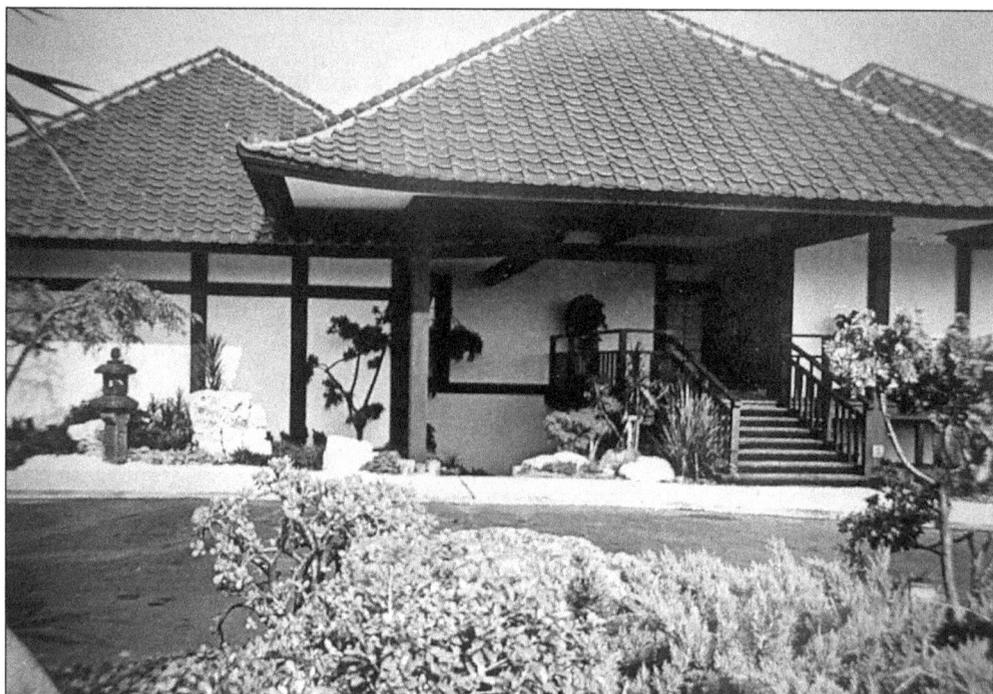

Architect Arthur N. Hosking designed the historic Japanese Benihana Restaurant with its twelve-peaked ceramic, barrel-tiled roof at the Intracoastal Waterway in 1969. The roof tiles were imported from Nagoya, Japan, and the restaurant can be seen by all who cross the bridge.

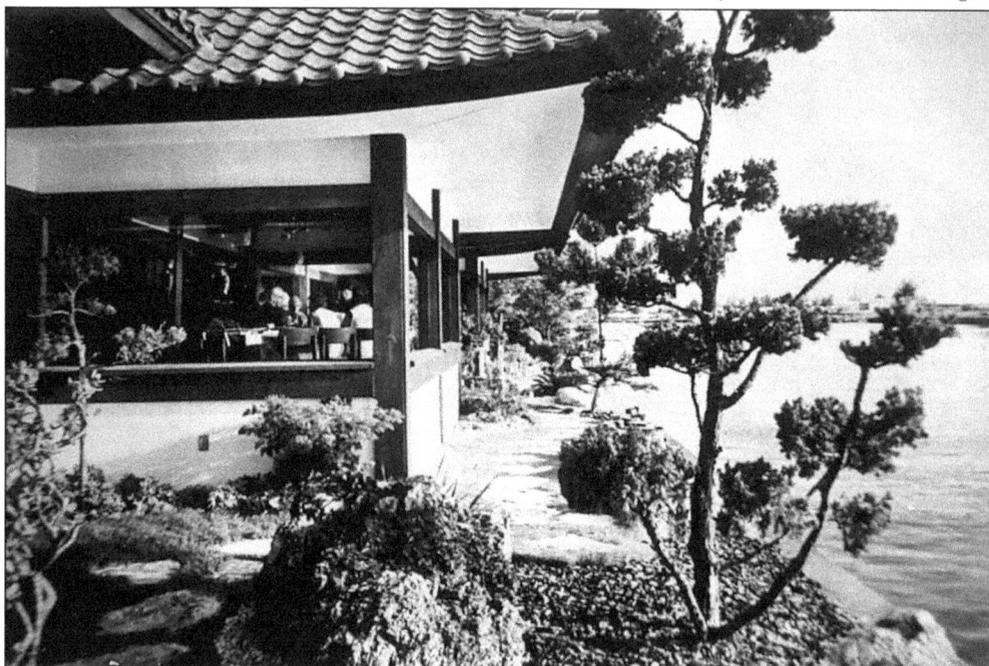

Trees, shrubs, and boulders from California are part of the landscape arrangement at the Benihana Restaurant in Lauderdale-By-The-Sea. The scene replicates a traditional Japanese garden, which provides natural beauty and tranquility for those who visit.

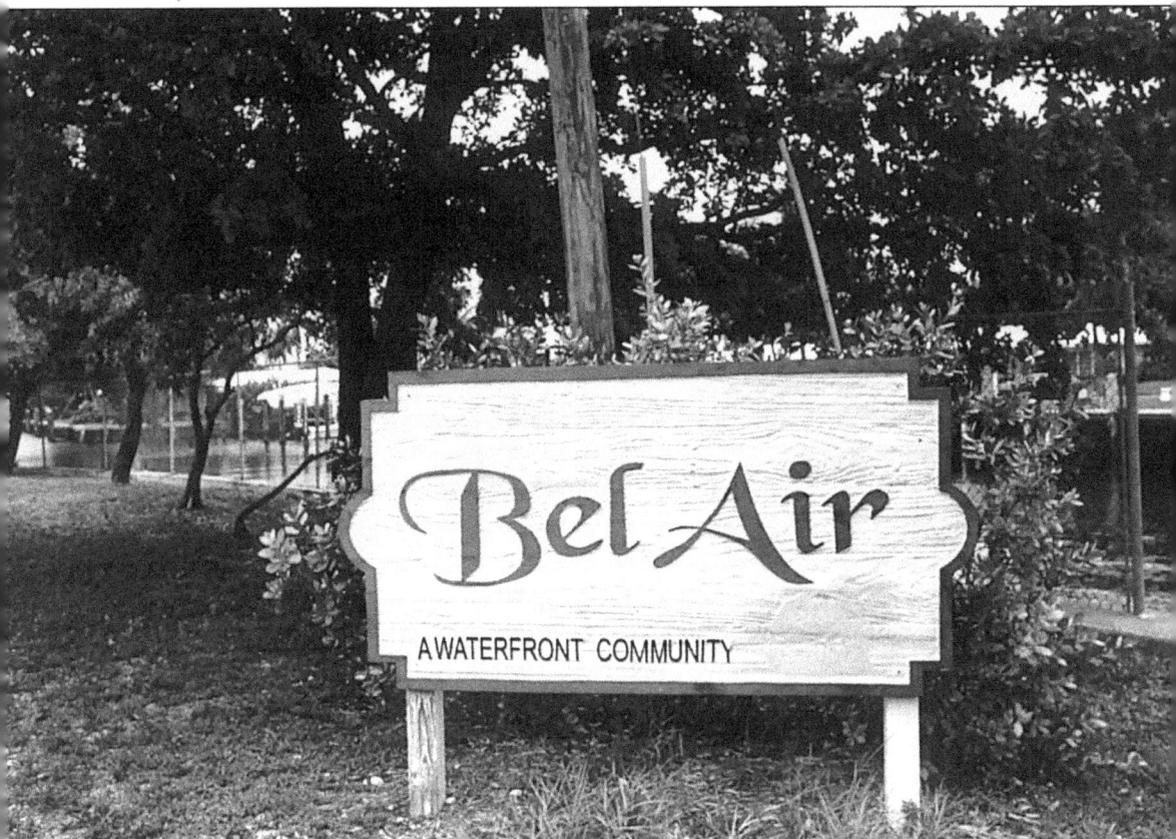

Once an unincorporated community of Broward County with a Pompano Beach address (west of SR A1A), Bel Air is now part of the newly expanded Lauderdale-By-The-Sea. This sign at South East 15th Street announces the entrance to the neighborhood as "a waterfront community." It is at the Spanish River.

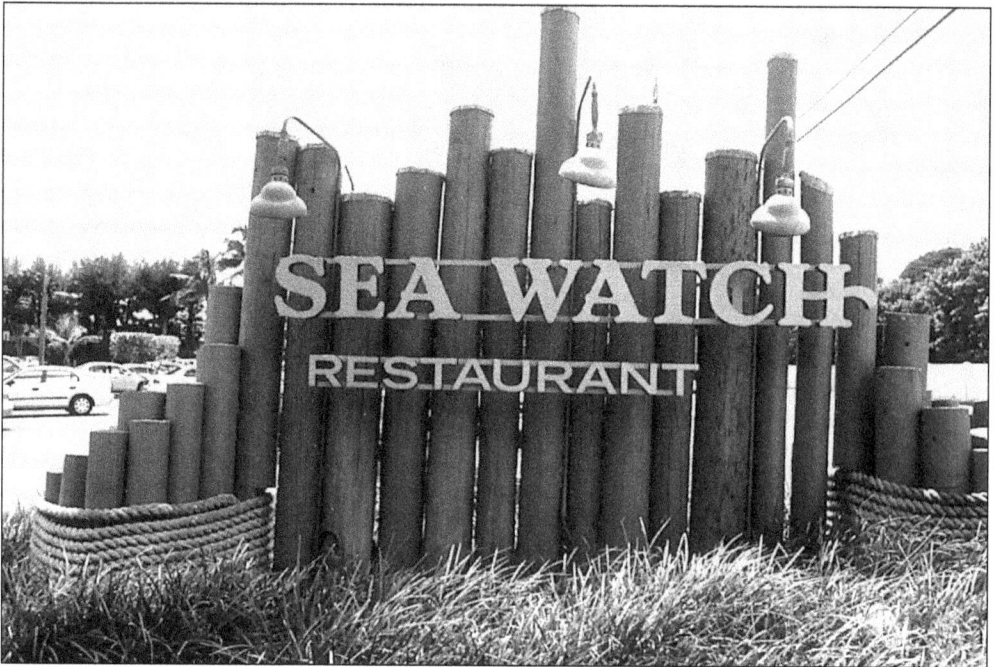

A familiar contemporary sign on SR A1A is the one announcing the Sea Watch Restaurant. At one time, this highly rated restaurant had a Fort Lauderdale address. Today it is located in Lauderdale-By-The-Sea north of the old town boundary. It is famous for fresh native seafood, Maine lobster, and beef items.

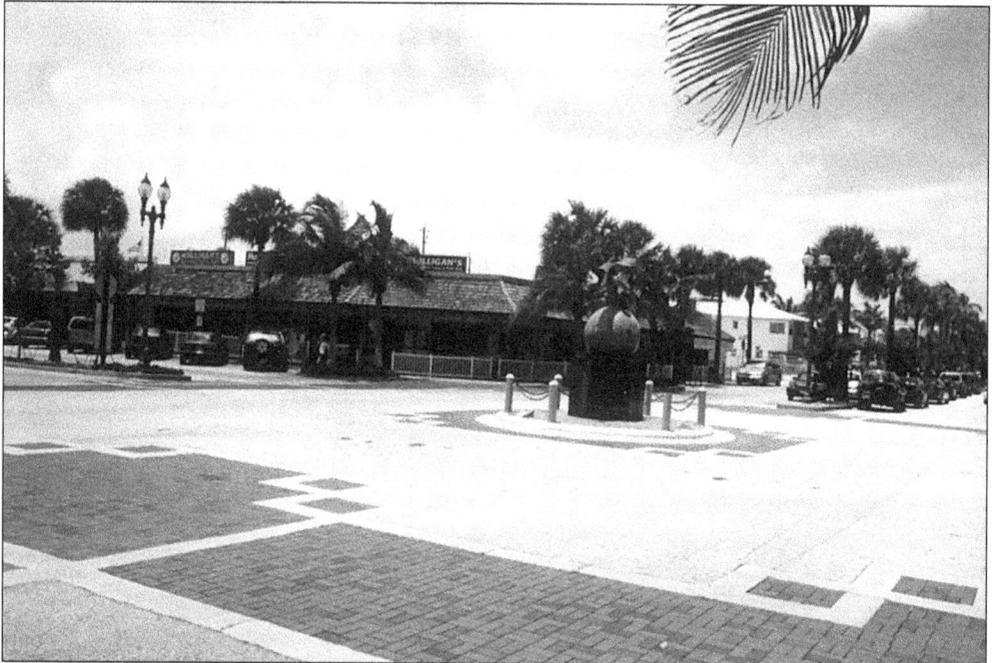

The intersection of El Mar Drive and Commercial Boulevard contains the Flying Pelicans monument at Anglin Square. Mulligan's Restaurant dominates the background. New landscaping and modern brick walkways contribute to the attractiveness of the area.

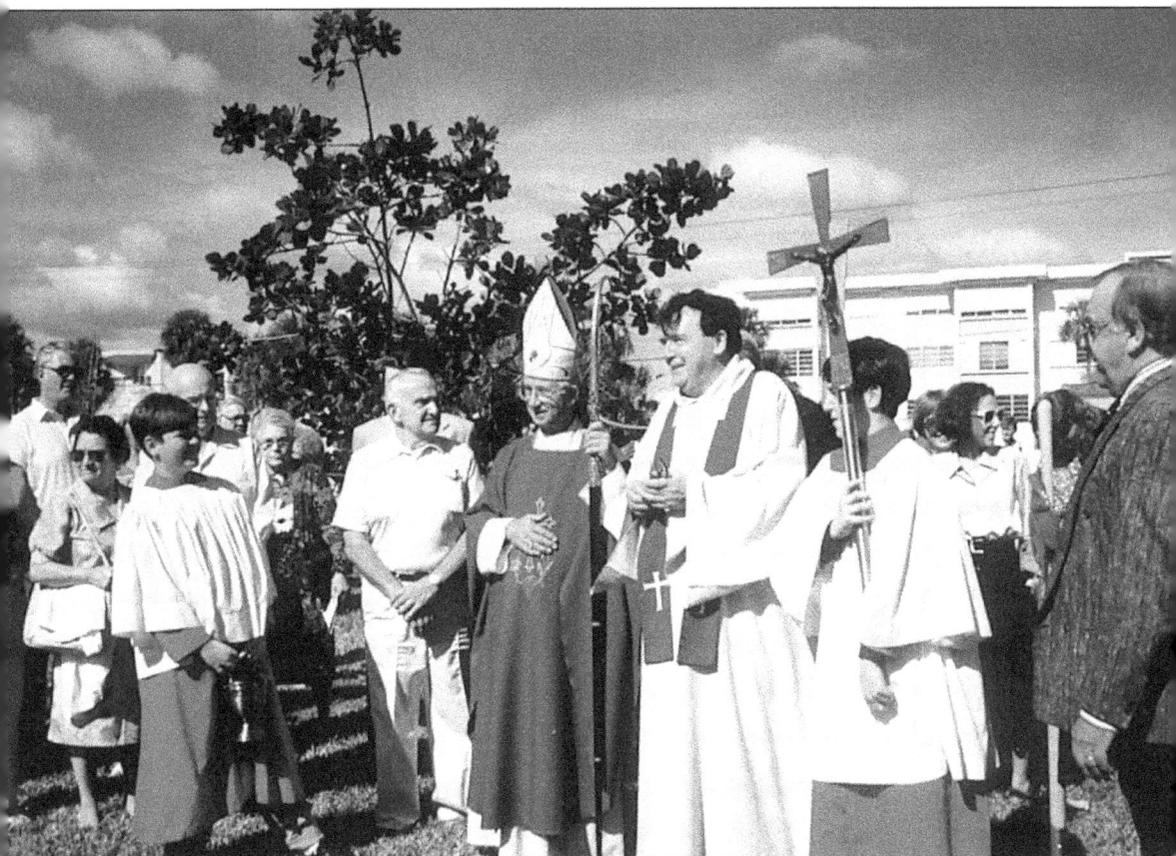

Groundbreaking ceremonies for the new Assumption Catholic Church at 2001 South Ocean Boulevard took place on December 20, 1992. The Rev. Martin Cassidy stands to the left of Bishop August Roman while parishioners look on. The parish was established in 1950 and was served by the following pastors: Fr. John Cotter (1950–1951); Fr. M.J. Fogarty (1951–1959); Fr. Patrick D. O'Brien (1959–1964); Msgr. Thomas O'Donovan (1964–1968); Msgr. Robert W. Schiefen (1968–1970); Msgr. Rowan T. Rastatter (1970–1991); and Fr. Martin Cassidy (1991–).

This July 23, 1993 photograph shows that land has been cleared and construction of the Assumption Catholic Church has begun. Here the ground is being prepared for the laying of the foundation. The building would take two years to complete.

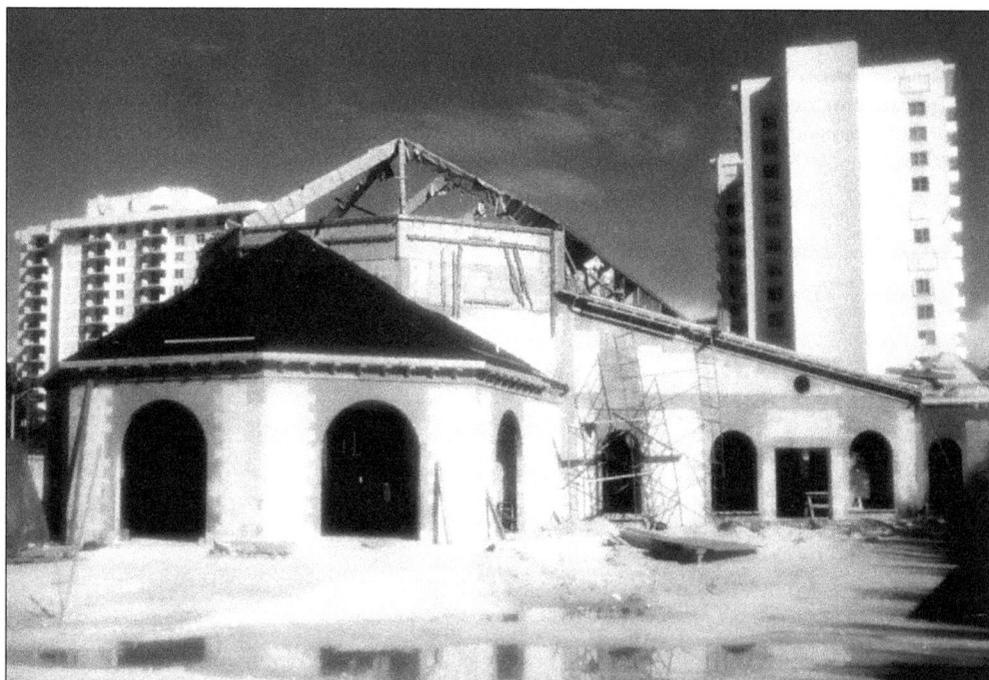

Here the Assumption Catholic Church is under construction, November 25, 1993. Looking westward, the Kensington building is in the left background across from SR A1A, and to the right is the Royal Coast.

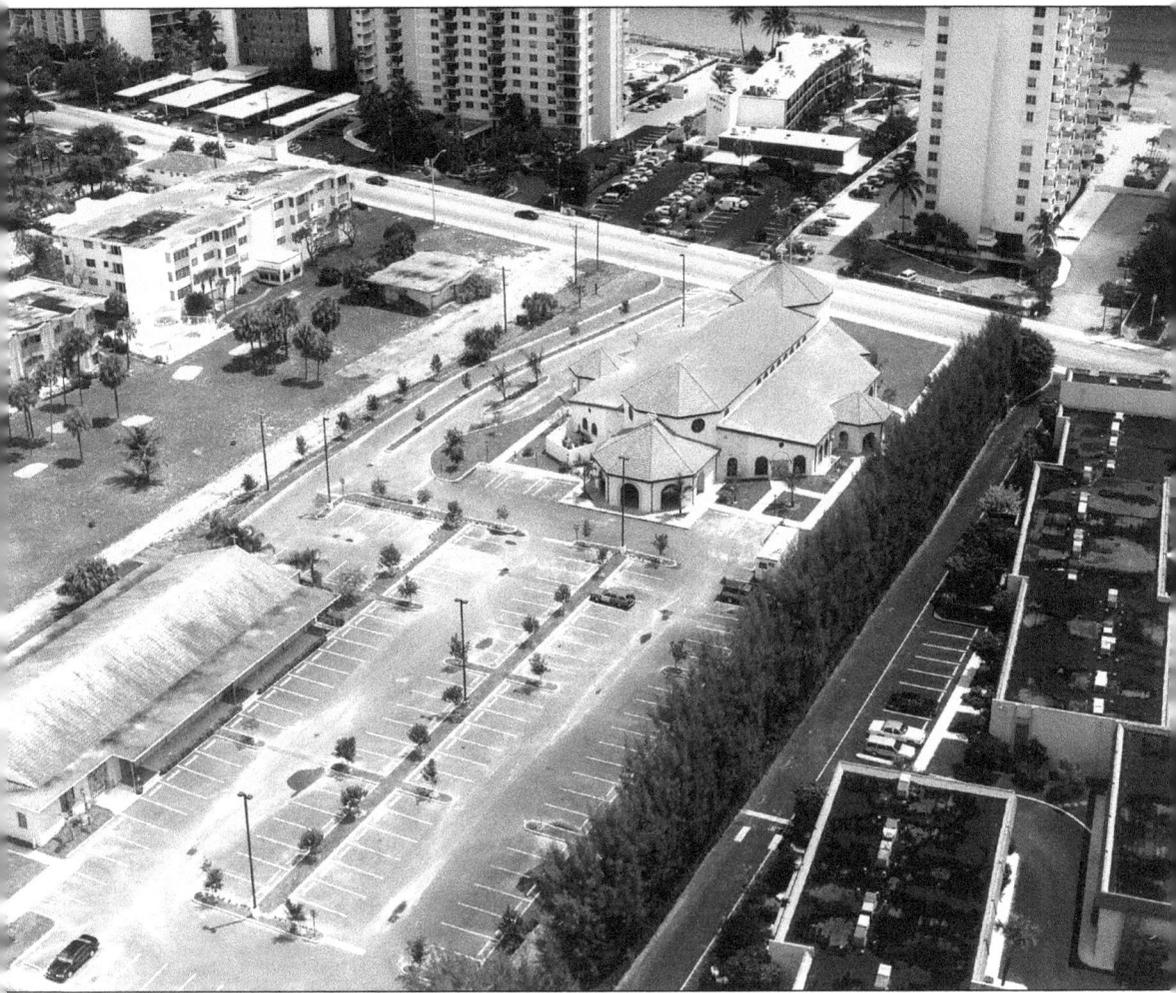

This is a panoramic aerial view of the completed Assumption Catholic Church and its environs, taken immediately after the dedication. The old parish church/auditorium (left) was torn down soon thereafter. SR A1A can be seen at the top of the picture. The Royal Coast Condominium is directly across the street, and beyond it in the extreme background is the beach. (Courtesy of Dillon-Reynolds Aerial Photography.)

The Priests and Parish Family

of

Assumption Catholic Church

cordially invite you to participate in the

Dedication Ceremony

of our new Church

Saturday, the twenty-third of April

nineteen hundred and ninety four

10:30 A.M.

The Most Reverend Edward A. McCarthy

Archbishop of Miami, Florida

will celebrate Mass

The Most Reverend Joseph Cassidy

Archbishop of Tuam, Ireland

will give the homily

After the church was completed, a dedication ceremony took place at the 10:30 a.m. mass on April 23, 1994. The Most Rev. Edward A. McCarthy, Archbishop of the Miami Diocese, celebrated the mass. The Most Rev. Joseph Cassidy, Archbishop of Tuam, Ireland, gave the homily. The invitation for this inaugural event is shown above.

Those who enter Lauderdale-By-The-Sea from the north on A1A at Sunset Lane are welcomed by this sign. There are two other signs, one at the southern end of A1A at Galt Ocean Mile and the other at the western end of Commercial Boulevard. The newly annexed section to the north of the original boundary has doubled the size of the town.

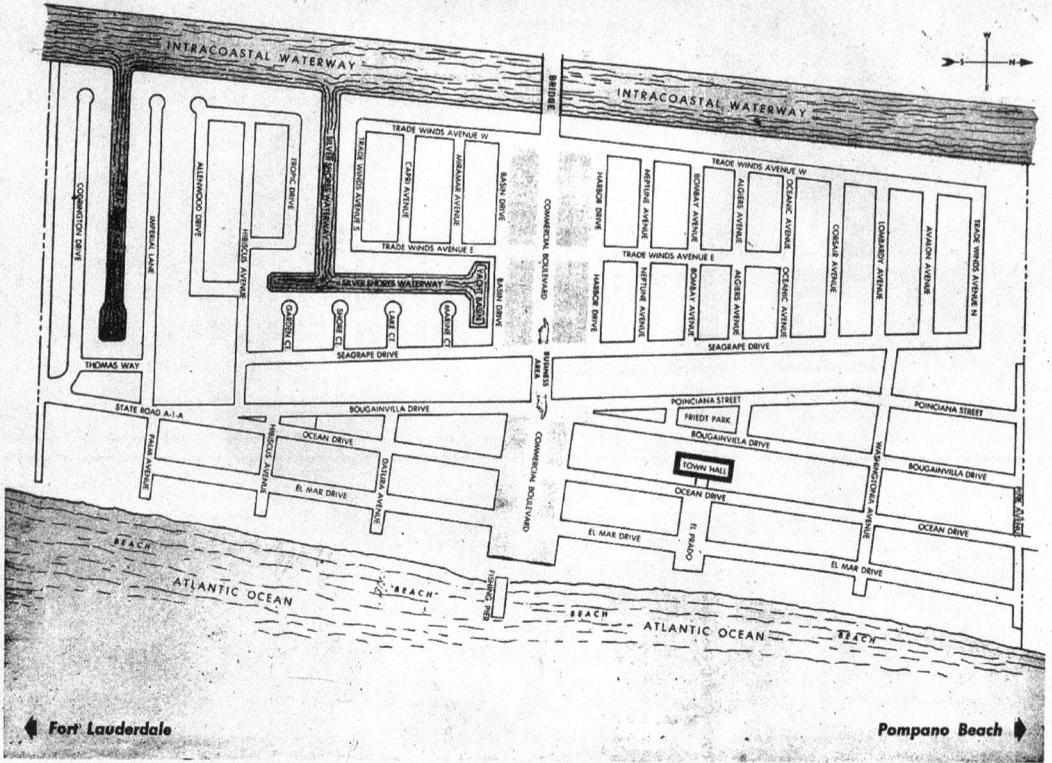

Lauderdale - By - The - Sea

This is the original map of Lauderdale-By-The-Sea before the area north of Pine Avenue was annexed. The Intracoastal Waterway is at the top. The beach is in the foreground, with the fishing pier extending eastward from Commercial Boulevard out into the ocean. Codrington Drive is to the south at left.

Visit us at
arcadiapublishing.com